OIL PAINTING
TECHNIQUES
AND
MATERIALS

BY

HAROLD SPEED

DOVER PUBLICATIONS, INC.
New York

CONTENTS

Published in Canada by General Publishing Company, Ltd., 30 Lesmill
Road, Don Mills, Toronto, Ontario.

Published in the United Kingdom by Constable and Company, Ltd., 10
Orange Street, London WC2H 7EG.

This Dover edition, first published in 1987, is an unabridged, slightly
altered republication of the second printing (1949) of the reissue (first
printing: 1944) of the first edition originally published in the "Universal Art
Series" (edited by Frederick Marriott) by Chapman and Hall Ltd., in 1924
under the title *The Science & Practice of Oil Painting*. For reasons of space,
some of the illustrations have been relocated and several pages of text have
been repaginated in the present edition. The frontispiece has been omitted,
since it was an exact duplication of Plate 34.

Manufactured in the United States of America
Dover Publications, Inc., 31 East 2nd Street, Mineola, N.Y. 11501

Library of Congress Cataloging-in-Publication Data

Speed, Harold. b. 1873.
 [Science & practice of oil painting]
 Oil painting techniques and materials / by Harold Speed.
 p. cm.
 Reprint. Originally published: Science & practice of oil painting.
London : Chapman and Hall. 1924. Originally published in series:
Universal art series.
 Includes index.
 ISBN 0-486-25506-9 (pbk.)
 1. Painting—Technique. I. Title.
ND1500.S7 1987 87-16627
751.45—dc19 CIP

PREFACE

IT was with some hesitation that the uncongenial task of attempting to write a book on painting was accepted ; it is so much more fun to be painting, than writing about it. But at this time, there is such a lot of confusion in the minds of young students on the subject of how and what to study, that an older student, who has had more opportunities of learning in the hard school of experience, may be of some use in suggesting a path. Having already written a book on drawing,* that part of the subject has not been gone over again ; although it cannot be too much insisted upon that painting is drawing (form expression) with the added complication of tone and colour. But there is quite enough to say on the subject of tone and colour, and the handling of the difficult medium of oil paint, to fill another book. And also, while drawing is being well taught at present, the same cannot be said about painting. The fact is that since the impressionist movement the whole course of study in our schools needs recasting, so as to include the new vision that this movement has given us. And it is hoped that the course of study here suggested, is one that can be followed, no matter what form of expression in paint the student may afterwards wish to adopt. And that it is one. that will train his powers of observation and expression by easy stages, taking one thing at a time,

* " The Practice and Science of Drawing." Seeley, Service & Co. (Dover reprint)

in a way that will be helpful, whatever he may eventually undertake. A chapter on " Modern Art " is included, as the subject cannot be ignored in these revolutionary times. And it is hoped this and other chapters will be of interest to the general reader as well as the art student. I wish to take this opportunity of thanking Mr. Roger Fry, Mr. Clive Bell, Mons. Picasso and Mr. Wyndham Lewis, and the Editor of "Wonders of the World" for permission to reproduce Plates 2, 3, 4, 6, 8.

VELASQUEZ' PORTRAIT OF PHILIP IV IN 1949

[refers to the text and pictures on pp. 170–73]

Alas ! The thin final painting, with its warm scumbles and pearly films of paint, that I have been trying to describe, and which was so delightful, alas ! it is no more.

Science is now the unquestioned authority ; and our National Gallery is in the hands of learned men, with the best intentions and wonderful scientific instruments to do their perceptions. Apparently they are allowed to do whatever they like with the nation's pictures.

The subtle things I have been trying to describe are, however, outside the perceptions of scientific instruments, or scientific minds ; and have not, unfortunately, survived their treatment.

By all means get the dirt off the pictures ; but stop before any of the original varnish is reached. Subtle filmy finishings and glazes become incorporated with the varnish and come away with it ; as, alas ! has happened in this case.

Look carefully at these two reproductions under a

magnifying glass, and notice what has been removed. Look at the size of the iris of the eye, how much larger it was before the finishing film of paint was removed with the varnish in the drastic process of cleaning it has undergone. See its upper edge against the eyelid, how much firmer it was drawn by Velasquez in the final refining. Notice the mark of one of the outer hairs of his long-haired brush, how it has strayed over the dark of the eye in one place. Then notice particularly how in the last painting, this looseness on the edge has been painted over, in enlarging and refining the shape of the iris. Since the recent cleaning, this loose light touch over the dark eye, has come to light again ; the last painting, which has covered it for 300 years, having been removed. A proof, for all the world to see, that the final film of paint has been removed in the cleaning.

Another finishing touch that has come away, is the more refined shape of the tone forming the under eye-lid. Instead of being the jagged edge it now appears, it had the more definite shape that can be seen in the photograph taken before the cleaning. If you measure it from the top right-hand corner of the iris against the eyelid, you will find it was wider than it is at present, the left-hand edge of the under eyelid having been more to the left.

What is here illustrated in detail, has, I fear, happened over the whole head ; and what is now left, I can no longer call " one of the last and most beautiful things Velasquez ever painted."

LIST OF ILLUSTRATIONS

LIST OF ILLUSTRATIONS

LIST OF ILLUSTRATIONS

LIST OF ILLUSTRATIONS

PLATE I

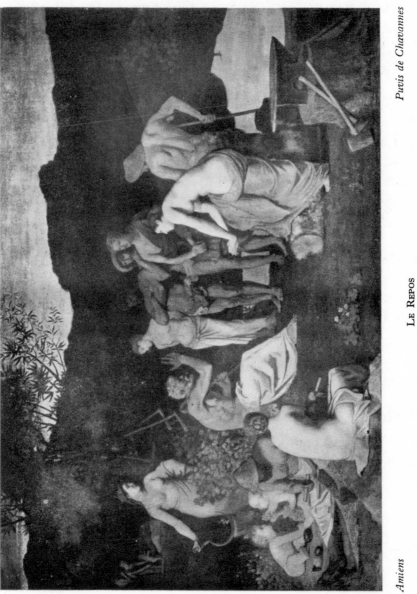

Amiens

Puvis de Chavannes

Le Repos

A very perfect example of tone and line design

Photo : Braun

CHAPTER I

INTRODUCTION

THERE are two ways of teaching art, one is to teach and the other is not to teach. One is to train the faculties and perceptions that art employs by hard drilling, so that the student may be a thorough master of the means of expression, and have his perceptions trained to accurate observation ; and the other is to leave the student to the guidance of the intuitive impulse that is impelling him to be an artist, letting him rub along by himself and stumble upon a means suited to his needs. Great artists have been produced by both methods. The danger of the first system is, that he may become so absorbed in the technical side of his art, which is very engrossing, that he may stifle his native perceptions ; the expression of which can alone justify him as an artist. The artist must master his technique before he can express what he wishes to, but he may in gaining this power become so enamoured with it, that he may be prevented from launching out into any newer forms of expression (which are always at first rather crude, demanding some sacrifice of technical accomplishment), and be content to dazzle by the display of his ability. If one is too exquisite about the means of expression, one often ends by expressing nothing in particular.

And the danger of the second method is that his intuitions may not be sufficiently strong to carry him very far. He may be bursting with artistic matter

seeking expression, but inadequacy of means may prevent him producing anything effective. Although it is surprising how rapidly the artist of strong intuition picks up the knowledge necessary to expression. There are advantages in both methods, and I think it is possible to combine them. The childish attempts that are made by the young artist, it is usual to put aside when he enters upon a course of training, as he is always very shy about them ; and the art school systems in the past have given him little encouragement to continue them. For here you cannot teach ; but you can encourage and praise whenever any evidence of the real thing, however slight, begins to show itself. And this side of his development should never be allowed to be neglected, but he should be encouraged to continue attempts at expressing the pictorial matter that will be bubbling within him if he is an artist, and told not to mind if the result is halting and very immature at first.

There is at the start of every work of art a nebulous—let us say " idea " for want of a better word, in the mind of the artist. And it is the clothing of this nucleus with appropriate form, tone, and colour, the giving it expression, that is the business of the artist. His technical training is necessarily concerned solely with developing the means by which this can be done in the most complete manner. It is not necessary in these days to explain that by " ideas " one does not mean any such ideas as can be expressed in literature, for which art is used as a form of illustration ; motives would perhaps be a better word than ideas in this connection.

INTRODUCTION

Literature is often quoted as the so-called subject of a picture, but this is not really so, the real subject being a new set of ideas connected with form and colour that are incapable of any other expression. The expression of these "ideas" will be very halting for a long time, but this will improve as training develops and it should never be neglected. And the student should keep in mind the fact that his training is only of use to him as it gives him a more adequate means of expression ; and that however perfect a technique he may achieve, it is only of account as it enables him more adequately to convey in his work the things that are moving him. If this is well understood, and the time given to training is not allowed to interfere with the free exercise of his fancy and imagination in any direction it may prompt him to take, there is little danger in a very thorough training. And there is every advantage to be gained by it, for however strong your intuitions, a thorough knowledge of the craft of painting will alone enable you to create a complete work of art. But we are all somewhat lazy and like things done for us, and it is so much easier to do the tasks set by a master than to create something from within. And the results are so much more impressive to one's friends and relations. But do not be deceived, no school teaching can take the place of the natural impulse which must develop from within.

Artists have always been conscious in doing their best work of something outside the range of consciousness that was, as it were, taking the matter in hand for them. The influence upon our actions of the subconscious mental activity that goes on within us is very

important, and it is undoubtedly from this source that the artist draws his main impetus to creative work. The best definition of a genius I have seen, is that in which he is described as the man most under the influence of these mental uprushes from the subconscious. The activity of the intensely conscious mind tends to shut the door against these influences, and this is not the state of mind that produces a work of art. The genius is the man whose subconscious is continually bubbling with a rich stream of matter that he is the means of expressing.

After a spell of painting in which " something has come " the painter awakes to the realisation that he was not fully aware of what he was doing, not so fully aware as when he has been working badly. Self-conscious painting is not to be compared to the spontaneous quality that is the mark of all good work. This must not be taken as an excuse for lazily whiling away the time until an inspiration comes. These moments of inspiration, as they may be called, in which the subconscious and conscious work in perfect harmony, come more frequently when at work than when idling, and seldom come to those who wait for them.

It might make my meaning clearer if I took an analogy from the game of golf, which most people play in these days. There are an innumerable number of things that have to be thought of in learning to swing a golf club, but when one is playing well the conscious mind is no longer aware of them, the control of all the movements has passed to the subconscious.

Or take the musician ; with what conscious labour does the pianist practise the control of his fingers on

the keyboard. But when he comes to play well this control is still there, but no longer by the conscious mind, it has passed to the subconscious. It is not until he can control his fingers unconsciously, or rather, subconsciously, that he can play well. And it is so with the painter. He builds up his technical facility and develops his perceptions by laborious training, fully conscious of what he is doing ; but when he comes to doing good work, his conscious mind is centred on what he is trying to express. The control of the means of expression has become almost automatic, has passed to his subconscious.

We are beginning more fully to realise that our conscious mind is not by any means the sum total of the mental happenings that go to make up our life. Consciousness itself may be considered as one of the many processes that the divine creative urge within us has developed in the course of our long evolutionary march. And it may well be that in those uncharted regions of the mind, are perceptions and faculties whose scope immensely transcends that of our ordinary consciousness. Perceptions that are not amenable to the narrow process of conscious expression, but that may find an outlet in the wider scope offered by intuitive artistic expression.

Art is like religion in that it is one of those things " no sensible fellow talks about." One can talk about points of view, as one talks about creeds, because the sensible realise that the sacred gist of the matter is safe from harm in such discussions. Art at its best lifts the veil that obscures reality in things seen, and gives us a glimpse of things more harmonious and

permanent than the fleeting images that pass upon our retina. More permanent because they satisfy the deeper and more permanent elements of our being, in much the same way that the deep correspondence set up by religious ecstasy does.

No artist can claim to do his work consciously. The conceptions of it are thrown up in his mind from some mental source outside his conscious control. If he is an author, sentences will come into his conscious mind as he is walking along the street or sitting on the top of a bus, or lying half awake in the morning. The musician finds themes running in his head at the most inconvenient moments. And the painter in like manner will find motives for his work surging up in his mind more or less unformed. Let him early acquire the habit of attempting to put something of all this down. It is a habit most young artists have, before they take up systematic training, but which many drop afterwards. Any medium that is congenial should be adopted, and little heed given to completeness. The general emotional flavour is the important thing to grasp in these early attempts. They will help to develop the habit of composing pictures in the mind, and may be useful later on to stimulate the inventive powers when ideas do not come so readily. The same idea will probably occur at intervals with added development. The nucleus of a fine picture often occurs quite early in an artist's career, although it may be years before it arrives at the state of development when the picture results. It is this capacity for sub-conscious working that is meant, when it is said that an artist is born, not made. No amount of teaching

will give this faculty. Although as the subconscious seems to have a more perfect memory than the conscious mind, the more one feeds on the best examples of art and nature, the richer may be the product.

The sources of art are, as the sources of all things, hidden from us, and it is not for the artist to bother about them. But while conscious of the rhythmic vitality that sustains all life and art, this " music of the spheres," and that his concern is not to inquire into the mysteries of æsthetics—to dissect the lily—let him sustain himself reverently in the simple receptive attitude of mind, that alone will enable him to catch some echo of it in his work. Perfecting his powers of expression, and observation, so that he may more worthily give expression to whatever it may be given him to express. But knowledge will not take the place of intuition in art.

Having been asked to write a book on the art of painting, I feel it necessary to make this quite clear at the start, and not to hold out any hopes that anything that can be taught, particularly in a book, will be of much use except to those already running over with natural ability. Nor, in speaking about art, is there much hope of being understood except by those who have already experienced what one is trying to talk about. It is something like talking about the taste of sweetness, you are only likely to be understood by those who have already experienced it, and they won't listen to you. So I shall confine myself in the following pages as far as possible to the subject of the craft of the painter, where there is more hope of being of some use.

OIL PAINTING

Most people have some artistic instincts in them, and it is the misfortune of this age of machinery, that the exercise of this faculty, which should be given scope in most occupations, now practically only finds an outlet in what are called the fine arts. The fact that this is the only field open for the exercise of this widely distributed faculty, tends to crowd the ranks with those whose capacity might have been sufficient to infuse the artistic impulse into many of the minor crafts, but is not adequate to the production of those flowers of the crafts, pictures and sculpture and the finer forms of architecture. So that the instinct of the fond parent who discourages the idea of an artistic career is quite sound, and every obstacle should at first be put in the way of the aspiring artist, as it is only those you cannot discourage who are worth encouraging.

I commenced these introductory remarks by stating that there were two ways of teaching art, to teach and not to teach. But both are necessary, and it is only when what can be taught, is working in perfect harmony with what cannot be taught, that a work of art results.

CHAPTER II

MODERN ART

IT is impossible to write on the art of painting at the present moment without saying something about the crop of strange works that have arrogated to themselves the name of " modern art." I can call to mind no time in the past history of painting, when any considerable body of artists have deliberately set aside the traditions of *fine craftsmanship* in order to express themselves more freely; or when there has been such a fashion for the crude methods of savages and primitive peoples. There was the archaistic period in Greek sculpture, but the work was always beautifully wrought, and never crude in the sense that so much of this so-called modern work is. It was a return to the severity of treatment of earlier work; a protest against the enfeebling influence of too much naturalism. There is something unique about the modern outburst in its rebellion against fine craftsmanship that demands some inquiry at the outset.

I propose to give a hurried glance at the Social and Technical Influences that have brought about this state of things.

Social Influences : The evolution of culture is an interesting subject of inquiry that has not yet received the study it deserves ; but it is enough for our immediate purpose to know that there appears to be a dominant cultural note in every age, and that it would

9

seem to follow along lines of some logical evolution. It is possible that the type of authority governing at the time, may have had some influence upon it. In the early days of the Renaissance in Italy, when the Church was the great power in the land, the art of the period is a reflection of this influence. And the art of Holland, which grew up with such rapidity on their establishing a republican government, is a reflection of the home life of the people. Coming nearer our own time, there has been a fairly logical development since the eighteenth century, which has roughly followed the evolution of political power from the aristocratic classes to the masses. In the eighteenth century the cultural note was aristocratic. These were the spacious days of the Grand Manner in art. The life of courts is everywhere reflected in the art of these times. Following on this, we have the nineteenth century, with the rise to political power of the middle classes. The realistic movement in art may not unfairly be set down as a middle-class movement, with its practical desire to get at " real facts," and its suspicion of grand manners. The other nineteenth-century movement in art, the romantic movement, is not perhaps quite so easy to bring home to the door of the middle classes, although it is possible it received its greatest support from them. It is interesting to note as a characteristic of the English temperament, with its love of compromise, that the Pre-Raphaelite movement is a combination of both the realistic and romantic movements.

And what of the twentieth century ? The political power is passing from the middle classes to the masses ; we have now universal suffrage. And the cultural note

that we would expect in art is that of the masses. And there seems little doubt that a great deal of the unrest and fretful violence that is disturbing the traditions of culture in all directions, is due to the coming of this new cruder element into the cultural feast. The added vigour in all this is a great gain, but the danger is in the amount of destruction that may be unwittingly wrought, before the perceptions of this crude element are developed sufficiently to see the beauty of what they, in their ignorance, would destroy.

There is another modern fact of great significance. For the first time in the history of the world the masses are articulate ; they can read and write in a great many countries. When only certain more leisured classes could read and held political power, the culture of the time was apt to centre in those classes. Now nobody waits until he has developed his mind before expressing an opinion, sure of a large audience on his own level of understanding. The effect of universal education may be to give opportunity for many more individuals to rise in the scale of intellectual culture, but at the same time it creates a demand for the cruder forms of expression that could never have thriven in more exclusive times.

Democracy has so enormously increased the size of the stage of public life, that it is only those whose work shouts at you, who have much chance of any immediate notice. The quieter performer whose work is destined to have the longer life and reflects more deeply the spirit of the age is difficult to find in all this hubbub. For, as Joubert says, " Violent sects have the most immediate appeal, but the quieter sects last the longest."

A loud-voiced manner is undoubtedly the popular one at the moment, and these crude voices are naturally intolerant of what they do not comprehend, and the more cultured manners of expression are hateful to them. I am inclined to think that large communities are against the development of the best artistic ability in them. The greatest works of art have been produced by small communities, such as existed in Athens and the independent cities of Italy in the Renaissance. The exceptional man of artistic ability is more conspicuous, and his powers are given more scope ; whereas in large communities he is apt to be swamped by the mass, unless his genius takes some violent revolutionary form that attracts attention. So that violent and peculiar expression is apt to be unduly encouraged.

The use of swear words by ignorant people is quite excusable, because they have not the wit to use, or the knowledge of, just those words which would forcefully express what they want to say. And failing to give their expression the force they desire by the legitimate use of words, they throw in some nasty expression of entirely alien association, like a bad smell, but calculated to give a shock ; which gives them the satisfaction of having made a forceful remark. The violent use of colours and forms adopted by much so-called advanced art nowadays, is just like these swear words. They want to create a sensation, and not having the wit to use the wonderful instruments of expression that are at the disposal of the modern artist who is prepared to follow the straight and narrow way, they would destroy the restraints of tradition and rush to the use of swearing yellows and screeching reds, of

clashing lines and jarring planes, in lieu of anything really forceful to say.

The shocking tactics as a means of attracting attention were started by artists in Paris at the end of the nineteenth century. But at that time the shock was in the subject selected for the picture. The most talked-of picture of the year at the Salons, was the picture with the most atrocious subject. I remember on my first visit to the Salon seeing a picture, quite twenty feet across, of anæmic people painted life-size drinking the blood of freshly killed bullocks, which was the picture of the year. There you had the bullocks being slain, already slain, being tapped, and a group of anæmic females drinking. But that field soon got exhausted, and the shocking tactics were transferred to the technical treatment of the picture. The decencies of technique were now flouted, as the decencies of subject matter had already been. And this process is still in being, although it is fast dying ; since one has become so habituated to it, that it no longer shocks, but only bores. Violent expression ceases to be effective if used continuously. You can shock once or twice, but you cannot shock all the time.

Another sign of the times, and the dislike of a refined technique, is the prominence given to primitive art and the work of savages, as well as the art of children.

An institution that has undoubtedly a great influence on art is the Press, which does the thinking for so many people in these days. The very modern artist lives much in the world and particularly in the Press. In a great many cases, I fear, the art column is written by the lady in charge of the social tittle-tattle

department. But let us take the case of the paper that boasts the services of one especially set aside for so-called art criticism. Let us assume he is one excellently qualified to understand the work of a large variety of artists of varying aims and temperaments. Even when you have secured the services of this superman in matters of taste, one sufficiently catholic to comprehend, and sufficiently young to be fresh, what can you expect from him under modern conditions ? Art critics were all very well when they had only the Annual Exhibition of the Royal Academy, with, later, a Grosvenor Gallery or New Gallery to speak about. But in these days, when there are exhibitions of pictures every week of the year, and often many in the same week, what can you expect but artistic dyspepsia ? Supposing you set aside men to eat dinners and give you their opinion on food. All might be well as long as they only ate one a day, and took enough exercise. But what would happen if they had to eat a dozen a day, and had time for little else ? The first thing that would happen would be a loathing of all wholesome food. " Away with this dull academic cooking ! " would be their cry. Nothing but queer, exotic, subtle flavourings would excite any interest in such jaded palates. After a time these also would begin to bore and they would look to the other extreme, and a yearning for cruder flavours, something with bite in it, would dawn upon them. Horse-radish, onions, mustard, coarse bread, and raw meat. And this is very much the history of modern art criticism in recent years.

In order that the reader may judge for himself, I

have reproduced Plate 2 and Plate 3, two illustrations with the remarks upon them by one of our most sincere and distinguished writers on art, who has supplied the ideas for most of the " modern " art critics in this country; without one of whom no up-to-date journal now considers itself complete.

When I first began to take notice of things, the fashion was for the exotic. Whistler, Aubrey Beardsley, Conder, and the exquisite decadent art of the *fin de siècle* was the fashionable note. This has been followed by the craze for Cézanne, Van Gogh, Matisse, Picasso, etc., about as violent a change of front as one can well imagine.

Every extreme movement generates its opposite, and so the pendulum swings backwards and forwards on either side of the line along which the art of the time is evolving. And these extreme movements naturally monopolise the attention of the journalists who are asked by harassed editors to write something about art ; as they are full of " copy." And indeed many of the recent extreme movements need the support of much fine journalism, to give them any dignified existence at all. Much of it quite interesting literature, too.

I am not at all sure that the columns of literature it has produced, are not of much greater value than the works of which they are supposed to treat. And it may well be that the more clumsy and imperfect in expression a work of art is, the better it may serve to generate a symphony of ideas in the mind of the critic ; for there is less to get in the way of the free play of his imagination. One is naturally dumb before a fine

OIL PAINTING

" We have the habit of thinking that the power to create expressive plastic form is one of the greatest of human achievements, and the names of great sculptors are handed down from generation to generation, so that it seems unfair to be forced to admit that certain nameless savages have possessed the power not only in a *higher degree than we at this moment, but than we as a nation have ever possessed it**. . . . I have to admit that some of these things are great sculpture—*greater, I think, than anything we produced even in the Middle Ages.*"—ROGER FRY.

* The italics are mine (author).

16

PLATE 2

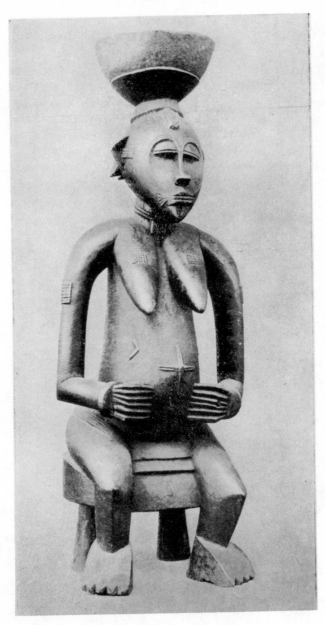

Collection Guillaume
NEGRO SCULPTURE
Plate III, " Vision and Design," by Roger Fry
An example of " Modern " Art Criticism

PLATE 3

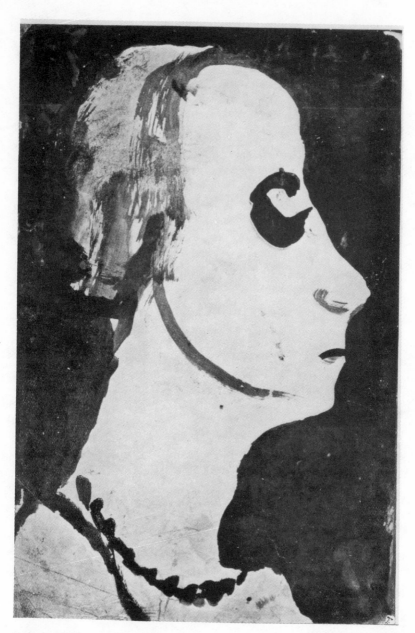

Georges Rouault

"PROFILE"
An example of "Modern" Art Criticism

" At least one French artist of great merit was unrepresented at the Post-Impressionist Exhibitions—Georges Rouault, a fellow pupil with Matisse of Gustave Moreau. He stands alone in the movement as being a visionary, though, unlike most visionaries, his expression is based on *a profound knowledge of natural appearances*.* The profile here reproduced (*see* Plate) will give an idea of his strangely individual and powerful style."—ROGER FRY.

* The italics are mine (author).

17

work of art, and it is not a good subject for literature, being its own complete expression. I think it was Burne Jones who said that the greatest compliment people could pay a picture was to say " Oh!", just " Oh ! " when they saw it. And that is all there is to say, anything more is apt to be as dull as a dissertation on the beauty of a flower.

The old masters, about whom the critics have to write a great deal, supply all the wholesome food in the way of art that the ordinary man can assimilate; so that when they come to modern art, they expect to be supplied with cocktails and savouries, or something much more piquant and amusing than good wholesome food, or they will not take any notice of it, or will treat it with positive contempt. Art Criticism is a branch of literature, and I do not see why one should expect more than one could if literary criticism were a branch of painting. But it creates a very unhealthy atmosphere for art to thrive in, nevertheless, as so many people now take their thought ready-made from the Press. Home-made thinking went out of fashion with home-made bread.

The great influence the Press has on modern life has brought into existence a new variety of artist, one who ministers to the demands of art critics. For years we have been accustomed to the picture-dealer's artist, the one who exists to supply the demands of the trade ; but the art critic's artist, the one who exists to supply the demands of the critic's profession, is a new phenomenon of the times. And he supplies the critics with exaggerated examples of the theories that are being run at the moment, and gives them

something to write about. In return the critic gives them the notoriety of the Press. Having obtained this, the wiser men settle down to serious work on more traditional lines; in the same way as the showman, after beating the drum to attract attention, goes on with the real performance.

The art critics have much strengthened their position recently by the control they have been able to exercise upon the purchasing departments of our public galleries. The authorities fear to buy anything that will not have Press support, and may be the subject of much Press abuse, as it would bring them into discredit with those to whom they are responsible, and put them in the awkward position of having to explain the reasons for their choice. So it saves a lot of bother to take the critics' advice in such matters.

The large, silent body of artists only adds another smile of contempt to those with which it already regards the actions of municipal authorities in matters of taste; but attempts nothing more effective.

In the best periods of art there was no professional art criticism, but art was linked up with the crafts. Painters started as goldsmiths, sign-painters, or craftsmen of some sort or another. Painting and sculpture took their rightful place as the flowers of the crafts— flowers whose roots and branches were in all the works of man—and good craftsmanship was the basis of all painting. Not that craftsmanship is art, but good craftsmanship is a healthier soil for art to grow in than fine theories about æsthetics. Nowadays art is like a flower cut off from its roots and branches, a curiosity, a stranger to the ordinary economy of life, something

precious to be collected and shut up carefully in museums, an exotic to tickle the tired palates of jaded critics and dilettanti.

When our ordinary commodities were made by independent craftsmen who carried their tools on their backs and took a pride in the work they did, and everywhere the spirit of the craftsman was alive in the land, the artist was not such a curious phenomenon, but developed naturally out of an environment into which he fitted perfectly. But since the introduction of machine tools, far too expensive to be owned by a simple craftsman, and too complicated to be managed by him, the whole control of production has passed to a different set of individuals, commercial men, whose chief interest is not in the quality of the work done, but in the amount of profit made. We are beginning to realise all this, and to see that something will have to be done to connect the things we manufacture with the art ability there is in the nation that should be directing these new machine tools as it formerly directed the hand tools.

Modern life is so much engrossed by intellectual pursuits that the inner emotional life to which art appeals is starved, and the appeal is vain. The only relaxation we allow ourselves is sport. And although this offers some outlet for the craftsman spirit which the commercial spirit of the time has so much supplanted, it is a poor substitute for the æsthetic experience we need. And in an intellectual age such as this, when interest in knowledge is so much greater than interest in feeling, the " point of view " of a painting is the thing that excites most notice, and the quality of the expression as

feeling is ignored, if not flouted. The whole weight of this intellectual interest is being concentrated on pictures painted in extreme manners ; as they offer much more for the intellect to bite on to, than pictures whose distinction is solely in the quality of the emotional expression.

Technical Influences : The technical influences that have led to the position of modern art, are the outcome of the extreme impressionist movement. The product of an age of scientific discovery, it for the first time put the vision of the artist upon a scientific basis. The retina picture was recognised for what it is, as colour sensations on a plane surface. For the first time the field of vision was considered as a field of colour sensations. Looked at in this way, putting aside every other association but the one overmastering idea of light and colour, a new visual world was opened up. Aspects of nature that had been hopelessly unpaintable on the old formulas, were found to lend themselves to expression in colour. Everything was colour, and when seen as such one effect was not so different to paint than another. A wonderful freshening up of the palette followed, and a light and gaiety was introduced that has been a great gain to painting. Another instrument had been added to the orchestra at the disposal of the artist.

But in so far as its activities were concerned with giving the true view of natural appearances, it did not lead art very far, and had no possibilities of development. If at last art had embraced the whole visual picture, there was no further advance possible in the direction of discovering fresh visual truth. Bit

by bit truths of natural appearance had been added to the painter's knowledge, as new instruments are added to the orchestra of the musician ; first outline, then a little shading, perspective, full light and shade, aerial perspective, and so forth. But when you arrive at the realisation of the full visual picture on the retina, the whole of the visual facts have been incorporated, and no further advance along that line was possible.

It soon became apparent to the extremists, that in cutting with tradition and going baldly for the visual picture alone, something that made traditional work more expressive had been lost. By association, a great deal more is conveyed to the mind by the eye, than the mere visual picture as colour sensations. The sense of touch, and all that the expression of fine form had meant in the art of the past, was a fine instrument of expression that the extreme impressionists had cast aside.

This sense had, of course, never been lost sight of by the artists who worked on more traditional lines. In differing degrees, all the vital artists of the period were engaged in adding the new material, thrown up by the impressionist movement, to the more traditional stream of art. But these are days when only extreme positions are discussed. Among the extreme impressionists, among those who had entirely cut with the art of the past and hoped everything from the new point of view, was a very unsuccessful painter (luckily blessed with a small competence), who perceived that by ignoring tactile considerations, the look of bulk and solidity in things, and concentrating upon the flat, visual impression alone, the impressionists were missing

PLATE 4

FROM THE PICTURE BY MONS. PICASSO
One of six reproductions illustrating Mr. Clive Bell's book, " Art "
An example of " Modern " Art Criticism

PLATE 5

Detail from Titian's Picture, La Fecondità, in the Prado
Showing persistence of the outline system of designing at a late period

Photo : Anderson

something of vast significance ; and that the new visual truths of impressionism had to be combined with the expression of form, bulk, and mass. And so Cézanne, in his somewhat uncouth manner, fumbled along, ploughing his lonely furrow and trying to find a method of expressing his fine sense of the bulk and weight of things, without returning to the traditional point of view. There is something about Cézanne, something about his uncompromising attitude towards all the softer graces of expression, and his love of un-couth directness, that makes him particularly attrac-tive to a very large body of young painters, aflame with the fashionable revolutionary zeal. In him they hope to find the basis of a new school of painting ; short-circuiting the old tedious traditions of the schools, that they feel are out of date since the impressionist movement. They find in his lifelong struggle with the problem of form expressed in terms of impression, the hope of a future development in the art of painting. This is the only direction in which a new advance from the extreme position taken up by the revolutionary impressionists, was possible. So that Cézanne naturally looms larger in the vision of the art critic interested in the psychology of the subject, than in that of the artist craftsman interested in the work accomplished. It is not that he accomplished much, but that his work pointed a way for the impressionist movement to get out of the impasse into which it had got, and opened up a line of advance. He was deeply concerned with the third dimension in painting, while the impres-sionists were solely concerned with the two-dimensional retinal picture.

There was another important quantity that most impressionists had ignored in painting, and that was line rhythm in design. The painters of the past may have been content with fewer truths of visual appearance to work with, but they were pre-eminent in the magnificent rhythmic expression of their pictorial designs. Now the new extremists could not very well go back and try to graft the impressionist vision and the new facts of colour on to traditional design, because that was exactly what the more moderate artists of the time had been doing. There was hardly a painter working along traditional lines who was not influenced by the discoveries of the impressionists. Even so traditional a painter as Watts, in his use of broken colour, owes something to the impressionist movement. So they set about trying to do for design, what the impressionists had done for vision, namely, find new design matter as they had found new visual matter. But it looks as if design had been more thoroughly worked out by the older masters than vision, and so far the harvest has not led one to expect such new matter in design, as the impressionists gave us in vision. The new formula of design that is being worked very hard in many quarters, is not so much a new one, as one that on account of its violence was used by the old masters only on very rare occasions, and then in small quantities. Their pictures were almost invariably founded on rhythmic curves, linking up the different parts and uniting the whole, contrasted with vertical, horizontal, and transverse lines to steady the composition. The form of pattern they used more sparingly may be called the kaleidoscope or streak

lightning scheme of composition ; sharp angular lines and masses jabbing into each other in chaotic violence. This is the so-called new scheme of design, as it is apparently the only thing left over by the traditional masters (*see* Plate 4). As the impressionists applied the scientific spirit of the age to vision, and studied the anatomy of light, creating a formula which ended in the mechanical excesses of the Pointillists ; so the Post Impressionists are studying the anatomy of expression, and are trying to get at the basic science of form in art, which lands them when relentlessly pursued into something very like the mechanical science of solid geometry.

But however much science may aid the means of expression, art depends on perceptions that transcend the gropings of science in the material world ; emotional perceptions that open up the vision of a world " charged with spiritual values." Our reactions to the physical world without, affect us emotionally as well as intellectually ; and it is these emotional perceptions that the artist is concerned with, and which make him so incomprehensible to the type of scientific mind that is concerned solely with the purely intellectual. Art, like religion, holds that these emotional perceptions, put us in touch with things transcending the material world, and open up a correspondence with the world of ultimate realities ; and that such evidence is none the less worthy of respect because it cannot, like scientific evidence, be registered by a mechanical instrument ; but, on the contrary, is proved to be of a higher order by this very fact.

But the more complete science of the impressionist way of seeing things does offer a fresh aspect of

phenomena from which to select matter for the construction of new pictorial design. Design in the past has been founded on the tactile sense. Objects in space conceived in outline or mass light and shade, have been arranged against appropriate backgrounds. The basis of the design has been separate objects as individual solid things. Primitive compositions consist entirely of outlined objects ; the outline satisfying the mental idea of the boundary in space that all solid objects have when felt. And on this basis pictorial design was founded. A very powerful instrument of design was introduced when Leonardo da Vinci formulated the principles of light and shade, and started the great schools of painting that made the latter part of the sixteenth and the seventeenth and eighteenth centuries so memorable. But no matter how near the full realisation of visual phenomena was approached by the greatest masters of those times, the basis of design, with few exceptions, was still the object in space (*see* Plate 5).

The impressionist's way of seeing the visual picture, in which objects and background, colour and light and shade, are all considered as one thing, as one symphonic texture of varying colour sensations, does offer a new field for selection to the pictorial designer.

This modern movement is perfectly sound at the core. And no doubt the lurid advertisement given by the extremists is something we have to live through. This return to the consideration of design as the first concern of painting is excellent. The perpetual concern with truth to natural appearances, " the true view of nature " that we had dinned into us by the last lot of extremists, had to be violently shifted in this

age of violence. But the sooner it is over and we settle down to serious work along the new lines, the better. For many of the pictures hung at the Salon des Indépendents have about as much relation to art as a Salvation Army local band. Because we have had wearisome cultured expression with nothing in it, I suppose we must have a period of earnestness of expression with no culture, in order to stir us up to better things. But it is to be hoped we are nearly through with it.

There is hope that the movement may lead to a wider appreciation of art. The average person, whose art interest in the past has been confined almost entirely to the so-called subject of a picture, and the representation of nature, not being able to find anything of this in the crude expressions of the ultra moderns, is led for the first time to take notice of other things in a painting. In the same way as a person to whom food was without any flavour might be led to the perception of this quality by being given something with a very strong pronounced taste—one who could find no flavour in China tea might notice the flavour of onions. And one notices at exhibitions of the more violently modern kind, an interested public, pleased with itself for having taken notice for the first time of the expressiveness of form, tone and colour. This expressiveness is of course no new thing, but has been the gist of the whole matter of art from earliest times. The new thing is the crudeness and rawness of its presentation, which for the first time brings it to the notice of the mass of people. And this newly awakened interest in the expressive side of art, may eventually

lead people on to the perception and appreciation of the real artistic qualities of subtler and more refined work ; and popular standards of judgment may be very much advanced thereby. At any rate it is turning people's attention away from the truth to visual nature standard, that the impressionist movement in the nineteenth century did so much to foster. The present mistake is the assumption that this expressive quality only exists in art, when given in its most raw and anatomical forms, unclothed in any of the gentler graces of natural appearance that the finest work of the past has always given it. The excuse for this violent modern reaction is that in the immediate past, the real expressive matter of art has been over-dressed in a garment of natural appearances ; and in the extreme cases we have had the dress without any real expressive matter at all.

This is an age when all things are being dragged from the mystery and glamour of the Romantic obscurity that our forefathers were content with, and brought into the hard, cold light of intellectual perception. And these cruder forms of art, and primitive art generally, offer more for this intellectual curiosity to get hold of than the more subtle refinements of greater art ; which is likely for long to evade the crude processes of intellectual analysis, when applied to things of the spirit. Great works of art still remain outside the world of pure intellect, and are best comprehended by the simple attitude of mind that drinks in the impression with only a long Oh ! to express its appreciation.

There is something of Puritan austerity, a love of destroying pleasing things, and a dislike of seeing things going on too comfortably, in many of these

modern movements. The desire to destroy the joyous covering of graceful natural appearances in which art had become arrayed, and to strip things to the bare walls of uncompromising expression. To strip painting of everything but what is barely necessary to support the expression of an austere æsthetic note. And there is healthfulness in all this. The complexity of modern technique at the end of the nineteenth century, when the whole subtle facts of visual appearance were brought into use, made it a very difficult instrument for any free expression. The technical atmosphere was getting very stifling ; and the desire to break through and get back to simpler conditions where greater freedom might again be possible, is a good thing. But it is a pity that the early stages of good movements are so often monopolised by a precious, superior-minded type, who take a secret pride in being misunderstood and, if possible, persecuted ; who rush in and occupy the most extreme positions in any new movement, and are apt to blind one to the genuine original truth they may contain.

But although æsthetic expression is the chief glory of a work of art, surely painting, like architecture, need not disdain other fields of usefulness. Pictorial art is the nearest thing we are ever likely to get to a universal language, and it is a language capable of expressing many other things besides the æsthetic. In the greatest periods the content of a work of art has been rich with many ideas and associations other than the purely æsthetic. Painting served a useful purpose in those days, expressing to the people the noblest ideas of Church and State.

OIL PAINTING

The modern analytical mind loves to track things to their elements, and this spirit applied to art has produced that modern criticism which is so proud of having tracked the æsthetic content of a work of art to its dissociation with every other consideration. This attempt to isolate the æsthetic content is at the back of much recent art criticism. This modern habit of specialisation, the concentration upon one idea to the exclusion of all others, applied to building has produced the jerry builder. Only it is not the æsthetic content of his building that is the idea concentrated upon, but the making of profit. Nothing is done that does not minister to this one dominating idea, and everything is left out that will not minister to its immediate realisation. And so it seems to me in much of this so-called modern art, the æsthetic content is the sole idea concentrated upon, to the exclusion, nay, to the open flouting of every other consideration. Jerry-made pictures are the result. Pictures so shoddily put together that they prevent all but the few from perceiving that they have any æsthetic content at all, underlying their obvious slovenliness of execution. And most of the extreme modern " istic " movements are concerned with one form or another of æsthetic expression to the exclusion of every other consideration.

And in the same way that the jerry builder often defeats his own ends of profit-making by the singleness of aim with which he pursues it, as the largest profits in the building trade are not made by jerry builders ; so in painting, those people who pursue with singleness of aim the æsthetic consideration alone in a painting, are not those who best succeed in conveying it in their

works. Painting, like building, is a craft, a highly skilled craft, as well as an art, and fine craftsmanship cannot be ignored without every other consideration that is built upon it suffering. Many of these so-called modern pictures are so shoddily made, that were they buildings they would tumble down. And the shoddiness of their make is so aggressively apparent that to many it is the only impression they convey, and so they are treated as curiosities and puzzles, a new form of problem pictures.

I am inclined to think that every age has the art it deserves. What art is suffering from at the present time is the lack of a proper place in the social economy, and a place in the affections of the people. At a time of crowded communities, when the struggle for the material means of existence necessarily occupies so much of our time, our chief energies tend to be concentrated and absorbed by this problem. And interest in " earning a living " tends to swamp all interest in the quality of what we do or make to earn it ; with the natural result that there is an all-round deterioration in the quality of almost everything we make, except machines. And even here quality is threatened by transatlantic methods of mass production. We are gradually substituting the making of money for the making of good things to buy with it, and are fast heading for the time when machines and " antiques " will be the only good things worth buying.

The mass of people do not easily recognise ability superior to their own, and even when it is brought home to them, put it down to educational opportunities which they have not had. But they do recognise superior

wealth, hence wealth tends in democratic countries to become the standard of values by which alone ability is recognised. Art, that should be directing the quality of our machine-made productions as it formerly directed the hand-made, is thrust aside in all this commercial rush, except in so far as it may, by attractive advertisements, aid the unloading of indifferent wares upon an unsuspecting public. Art, as I have already said, is the flower of a tree whose roots and branches should be in all the things we make. It cannot be produced of a vigorous, healthy quality alone in a vacuum, cut off from the sustaining roots and branches of fine craftsmanship in the ordinary things of life; and unwarmed by any atmosphere of appreciation and affection in which alone it can freely blossom. A crop of freakish productions is naturally one of the results of these unhealthy conditions.

A work of art is a living thing, with a body as well as a spirit. The creating of a work of art is the giving body to the spiritual perception that moves the artist. And the quality of the expression is tied up with the quality of the body which is its means of expression. To neglect the body for the sake of the spirit is as unbalanced as to neglect the spirit for the sake of the body. Our having had such an overdose of the representation of nature in art during the nineteenth century may explain, but hardly excuses the way it is now the fashion to flout the representation of nature and overstep her modesty in every direction. For you cannot get away from the facts of visual nature if you set out to give visible form to anything, as we have no knowledge of visible things apart from nature. The attempts to create an abstract language of visible expression unconnected

PLATE 6

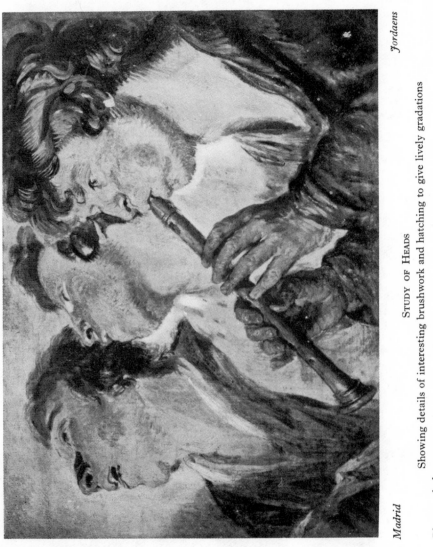

Madrid

Jordaens

STUDY OF HEADS

Showing details of interesting brushwork and hatching to give lively gradations

Photo : Anderson

PLATE 7

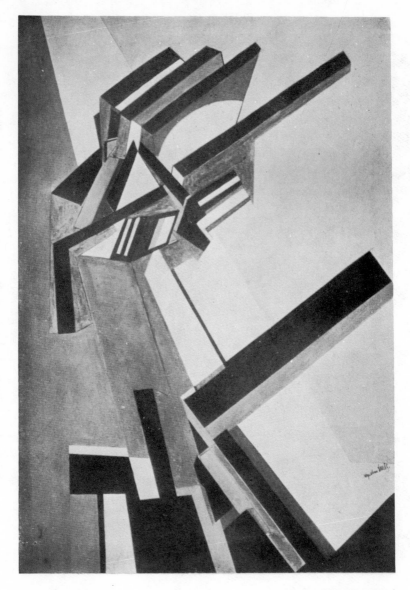

Wyndham Lewis

PORTRAIT OF AN ENGLISHWOMAN
An Attempt at Abstract Drawing

with natural appearances, leads to pure geometric forms. And even here you have not shaken off nature, as geometry is but the science of form, and geometrical forms will be found at the basis of most natural objects.

And further, because there are formulas at the basis of all good artistic design, to present a formula in the raw, is not to create an artistic thing; for the life of a work of art is not in the formula. Art is capable of vitalising almost any of them, but like all live things it escapes all formulas. The search for new forms of design, if pursued singly, lands one into the academic; which in its over-concern for correct forms, always misses the spontaneous life which is the secret of the whole matter.

The accompanying illustration from a drawing by Mr. Wyndham Lewis is an extreme example of an attempt at abstract drawing. But our eyes' natural habit of referring everything seen in a picture to natural appearances cannot well be got over, as we have derived all our knowledge of expression in appearances from this source.

There *is* some expression in abstract lines, tones and colours ; that is lines, tones and colours not directly connected with natural appearances. And these qualities are the source of the expressiveness of architecture, decoration, and craft work generally.

In much the same way that the facts of phenomena observed by the intellect, are found to be related to certain fundamental laws that run through the universe, such as gravitation, etc., so the facts of phenomena observed by the emotional perceptions are found to

be related to certain laws governing their emotional significance, which the science of æsthetics is as yet barely aware of; but the existence of which artists have always had subconscious knowledge of; and have always had an instinctive feeling against dragging into the cold light of the intellect, realising that they belonged to a different order of perception. You may make more or less geometrical diagrams illustrating these things, such as I have done for some of the pictures illustrated in this book and more fully in treating of drawing elsewhere; but such diagrams are not works of art but exercises in the anatomy of composition. And that is all that abstract drawing unassociated with anything but itself, can arrive at.

It is undoubtedly a fact that vertical lines express something, let us call it anspiration; horizontal lines, let us say repose; and lines jarring into each other, violence and unrest; while curved lines express varying degrees of energy according to the amount of their curvature, etc., to crudely state some of the more obvious. But all such ideas are in harmony with natural appearances if not actually derived from them by the association of ideas. And they gain their full significance in painting and sculpture, only when associated with the representation of nature. Unassociated with anything but themselves, such abstract lines, tones or colours become mere geometrical diagrams—a matter of science. The science of expression if you like, and interesting psychologically, but not the live work of art itself. And without the title, " Portrait of an Englishwoman," I doubt whether Mr. Lewis's drawing would have suggested to anybody even the

most violent and revolutionary of ideas on English femininity; but might have left them still puzzled whether it was a design for a new sort of magic lantern, or a railway signal after an accident.

Attempts at abstract drawing free from the exacting conditions of representation are a sign of the times. There is a widespread desire to break with all restraints, that the individual may express himself more freely. Perfect freedom is a thing only conceivable, for one individual, in one universe. If there were more than one, their desires might clash and all would have to give up their freedom to the one. But even one individual endowed with unlimited freedom, would be enough to upset the smooth working of any universe. This desire for absolute freedom, this anarchy, is a destructive not a constructive tendency. And in art it is everywhere destroying but nowhere creating. It is so much easier to destroy than to create, so much more effect can be got for your effort. And to those not capable of the long-sustained effort creative work requires, destroying is very tempting as a substitute. One seems to be doing so much, and certainly attracts more attention.

The values that art expresses have to be brought within the reach of the beholder by something that is already understood. The representation of nature in the pictorial arts, supplies this universally comprehended starting point, from which they are led on to the higher experiences that it is the real object of a picture to convey. Whatever so-called subject-matter the artist may select, is only a sort of scaffolding upon which he hangs the real subject-matter of æsthetic expression;

which is the thing he usually doesn't talk about. The expression of his inner sense of the underlying real values that peep through the appearance of things seen.

There is, strictly speaking, no modern art any more than there is any modern truth. There is just Art and Truth. There is good and bad art, as there is truth and untruth. There is trivial and profound art, as there is trivial and profound truth. You cannot scrap the edifice of the traditional art we inherit, and start to build an entirely new edifice, any more than you can scrap the edifice of truth that has been built up during the ages and start an entirely new one. When it is necessary to put an adjective before truth, as Catholic truth, Protestant truth, scientific truth, etc., you have marked it down as second rate. Truth when it is profound enough to be truth, can stand alone. And it is the same with art, which is the same in essentials in all ages. When you put adjectives before it, as Modern Art, Post Impressionist Art, Futurist Art, Vorticist Art, etc., you are but writing it down as second rate. An unconscious acknowledgment of this can be seen in the vehemence with which the champions of these causes pursue their advocacy. The fanatic by his fanaticism, shows that he subconsciously doubts his own cause. The deep conviction that truth always gives, and the feeling that it will ultimately triumph, suggest quieter methods of controversy. Ruskin by the fierceness of his attack upon Whistler, showed that he had an uneasy consciousness that there was more in the pictures than he was aware of. Had he thought them as contemptible as he said, he would not have troubled to say it, but have ignored them altogether.

His praise of Turner was of a much more persuasive order, as it was founded upon a deeper conviction.

What makes this age more advanced than the stone age is not so much any very marked difference for the better in the average person, but in the rich heritage of culture and knowledge we possess ; which we owe to the superior intelligence of exceptional individuals that have lived since that age. If modern labour was confronted with the task of transporting and hewing the stones of Stonehenge, with only the tools and knowledge of that period, I doubt very much if they would make as good a job of it. The rich heritage of accumulated knowledge—this tradition which we now possess—enables us to do more than could have been accomplished without it. There are no doubt points to do with the vigour of body that a hard out-of-door life gave our ancestors of the stone age, from which we might well learn. But it is not necessary to throw over all the heritage of traditional knowledge, and go back to a cave-dwelling life in order to correct this weakness in modern existence. And similarly in Art, the vigour and directness of expression one finds in good primitive art may be the thing we need in these days, but the scrapping of all the traditions of fine painting and going back to a crude primitive means of expression, is not the only way of reinculcating it.

New ideas in art are always a stimulant, but with some they act as intoxicants. The same type of mind that in the nineteenth century saw nothing but " the true view of nature " as the be all and end all of art, and pursued impressionism to the dead end it led to if pursued alone, will now have nothing to do as far

as it can be helped with the representation of nature ; and is all out for the discovery of an abstract form of expression independent of natural appearances— another dead end in the opposite direction.

The true advance in art is along the middle lines, in tune with a tradition of natural truth. For you will notice that it is not the extreme work of any time that one afterwards values. It is not the vast compositions in the grand manner of the eighteenth century, that we now prize, not the numerous historical pieces in the manner of Raphael, that were thought so much of and which were so characteristic of the time ; but their quieter portrait work much nearer to simple natural truth. And in the nineteenth century it is not the work most extremely characteristic of that middle-class time, such as the " Kiss Mammy " school of domestic subjects that were so popular, and so well done, that we now prize. And so in the future we shall look at many of the hobnailed-boot paintings of so-called modern art with the same boredom with which we now look at the picture of a little girl putting a piece of sugar on a dog's nose in the best middle-class manner of the nineteenth century. Art has a life superior to any passing fashions of the time, a still small voice that is recognised and heard by all sincere artists, but is difficult to talk about. And while influenced by the currents of fashion, it is seldom found in the extreme positions. And amidst all this turbulent violence and primitive crudeness of expression the traditional stream of art flows on, strengthened and stimulated to new life by these tributary influences, but never deflected far from the medium line. Carried on by men believing

in evolution rather than revolution, and content to do their work as well as they honestly can under the guidance of that inner light that first urged them to become painters ; and sparing themselves no effort to make their work better. Thinking more of sincerity than of originality, conscious that originality that is not the product of sincerity is but peculiarity, and that sincerity alone points the road to the only originality anybody is capable of. Genuine originality is often confused with peculiarity on account of its difference from the accepted ideas of the time. But this difference is due only to the fact that it has not yet had time to be recognised and incorporated into the general body of truth. For what is original is only what is true, a newly perceived truth ; the peculiar is the imitation article. And there is a very great distinction between the freakish oddity of peculiar things and the genuine original work. The original is peculiar at first, but only until its truth is recognised, whereas the merely peculiar having no basis in truth is never to be recognised as anything else but peculiar.

And there are already hopeful signs that out of all the turmoil is being born a genuine new phase of art. Severer, more austere, but stronger and more elemental in expressiveness, suited to the needs of these changed times. And I think that the sanity of the English mind is destined to play a very important part in the culture of these disturbed times, when so much Continental art is given over to violence.

Balance of mind is necessary to see that violence does not obscure what is good in the new, nor destroy what is good in the old.

CHAPTER III

THE TECHNIQUE OF PAINTING

THE technique of painting has travelled a long road since the Egyptian artist filled in his outline with a little black or red. Sight, as the accurate perception of visual things, is a faculty that has only gradually been developed by humanity in its upward march, and few people realise how little they really see of the marvellous things happening on the retina of their eyes. Sight as a faculty is not so essential to our survival as some of our other senses, such as touch. We live more by touch than sight, and the average person uses his eyes more for the purpose of giving him information about the solidity and general felt shape of things, than for the purpose of observing the colour sensations on the retina. We cannot move a yard in front of us without first knowing if there is anything solid to stand upon or something hard in front of us that we might knock ourselves against. And these are all touch ideas. But by associating touch with sight in the very early years of our bodily existence, we learn from much knocking of ourselves, and many falls, to associate sight with touch in so intimate a way that eventually the habit of seeing the touch sense in things becomes habitual; and instead of the colour masses on our retina, we see an appearance of a solid world in front of us. The perception of these touch ideas becomes so habitual and all-absorbing in fact, that it largely blocks out purely visual

40

considerations from our observation altogether; and few people see much else than this touch idea associated with vision. They hardly see the appearance an object gives on their retina at all, but see what "they know to be there," as they would put it. That is, something that would satisfy them if they went close up to it and touched it. Everybody could describe a table by the feel of it, but few people could give you an accurate description of its visual appearance. When they see the table, the idea of it as an object with a flat top and legs at the corners is called up, and they see a thing with a flat top and legs at the corners; the idea in the mind as far as its form is concerned being much the same as it would have been had they felt it with their eyes shut. They know the opposite sides of the top are the same length and that all the legs are of equal size. The fact that in a visual view of it, no two sides are the same length and no legs are the same length either (except in one particular view), does not worry them at all, and is in the majority of cases totally unobserved.

Touch is much more associated with our ordinary idea of reality than any other of the five senses from which we obtain all the knowledge we have of the material world outside ourselves. We talk of a good solid fact, not a good smelt, tasted or visual fact, when we want to carry conviction as to the reality of something. I am not sure that an animal might not say a good smelt fact, as smell seems to occupy the most important place with them. Even people's ideas of the colour of objects is not the colour as seen on the retina, but the colour that they associate with its surface, the colour

they would see in a normal light if they went close up to the object. And having observed it they say, " That is an object of a certain colour," and ever after associate that colour with that particular object; whatever the aspect of light it is seen in, and whatever colour it may therefore appear on their retina. This neglect of the visual picture as such, and its almost universal use associated with other senses, is an important fact, and accounts for the surprise that greeted the first pictures of the impressionist movement, which attempted to give this visual picture unassociated with anything else.

No doubt the changefulness in both colour and shape in the appearances of objects upon the retina, has much to do with our neglect of this sense of sight except as associated with touch. It is a mental convenience to have fixed ideas of the objective world, and the touch sense gives this, while sight does not. The felt shape of an object is always the same, although its appearance on the retina varies with every angle of vision from which it is seen. Therefore our idea of the shape it really is, we take from another sense that does not vary, namely, touch. The colour that it appears when examined closely in a normal light is always the same, therefore we say that is its colour ; while the colour it appears seen under the varying aspects of light in everyday life, varies enormously.

But without going too deeply into these matters, the fact that we are concerned with here, is that it is only very slowly that humanity has perceived the facts of visual appearance, only gradually that we are opening our eyes, only very slowly that we have developed the faculty of sight. Each newly added fact being, as it

were, a new instrument of expression added to the orchestra at the disposal of the artist. After the simple outline filled in with a little local colour, we get a little shading to indicate form. And this simple formula was refined to a very high degree in the art which we call primitive, right up to the time of Botticelli; with only the addition of more refinement in the rendering of the outlines, including a knowledge of the laws of perspective and an appreciation of beautiful tone and colour relationships. There is no strong light and shade, and only occasionally rudimentary cast shadows. Light and shade was the great technical discovery of the fifteenth century ; starting in the work of Masaccio, it was developed into a system by that master mind of the Renaissance—in science and art—Leonardo da Vinci. And this, with the addition of aerial perspective (something to account for the varying colour of objects at different distances), practically constituted the scientific knowledge of visual appearances that the painter possessed right on through the seventeenth and eighteenth centuries. Although in the work of Velasquez and some of the Dutchmen, the more complete knowledge of visual phenomena that was revealed by the impressionist movement is almost arrived at. The whole of this growth of visual knowledge started from the outlined form, which was the result not so much of any attempt to represent what was seen as to satisfy the idea of solid things outside himself man had formed from his sense of touch. The art of the Egyptians, which is the foundation of our Western art, is obsessed by this.

The accompanying illustration is a type of the Egyptian manner of drawing. And it will be noticed

that it is not the visual aspect of the figure that they are so much concerned with. The head is conceived as a solid object as revealed by the sense of touch with a boundary in space. The most characteristic boundary

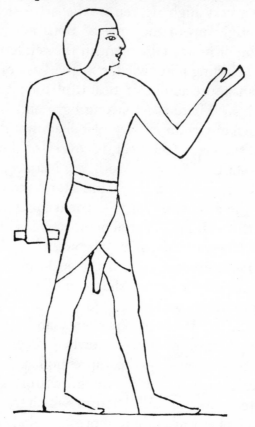

is the profile, and that is the one always selected. I cannot call to mind a single instance of ancient Egyptian drawing when the three-quarter view of a face has been drawn. Now with the eyes, it is the front view that is most characteristic when called up in the mind. And so they unhesitatingly place a front face view of the eye in

PLATE 8

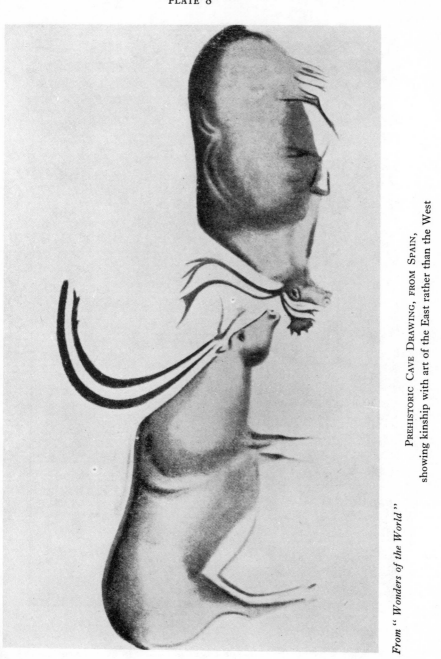

PREHISTORIC CAVE DRAWING, FROM SPAIN,
showing kinship with art of the East rather than the West

PLATE 9

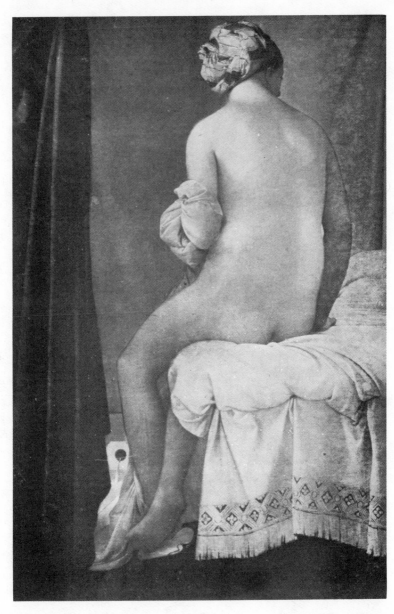

Louvre *Ingres*

THE BATHER

Example of picture depending on beauty of line for its expressiveness

Photo : W. A. Mansell & Co.

a side view of the head. With the body the most characteristic boundary in space is a front view, and this is arbitrarily stuck on the profile view of the head. The most characteristic line of the leg is again a side view, and this is attached to the front view of the body with entire unconcern for visual appearances. The whole is a sort of diagram appealing to the mind's idea of form but having only a distant relation with appearances.

There is a very remarkable early exception to this desire to satisfy the idea of a boundary in space, and curiously enough this exception occurs in some of the earliest drawings we know; those found in the caves at Altamura in Spain, possibly done 20,000 years ago. These remarkable drawings are derived from the retina picture and are purely impressionist art (*see* Plate 8).

There is a great break between this early art and the art of the Egyptians, which is so obsessed by the mental idea of form with its boundary in space. But between this early impressionist art and that of China and Japan there is no such break. The impressionist point of view, the observing of nature as a visual picture passing before the eye, is constant in Chinese art from earliest times, and Japan, I believe, got it from China. It looks as if there were some remote connection linking up these early cave drawings to the traditional art of China, a connection that does not exist in the case of Egypt, from which the art of the West developed.

Technically speaking, the impressionist movement was a revolt against the tyranny of the outlined form on which the whole edifice of technical knowledge had

rested from its early beginnings in the West. An appreciation for the first time of the visual picture on the retina, for what it is as a colour pattern. A determination to observe phenomena with the eye, and the eye alone, to build up a technique of expression from this point of view, instead of from the idea of separate solid objects in space the basic expression of which was an outline.

The extreme impressionists said there was no outline, and had no use for line drawing. But in throwing over line drawing they discarded one of Art's most potent means of expression. And so a revolution has set in and again the outline, the sculptor's drawing that gets at grips with form as a felt thing, has come into its own. And so these opposing ideas have fought with each other to the confusion of the student ; whereas they are both right, but appeal to different senses.

With the impressionist movement a wonderful new instrument was added to the orchestra with which the painter expresses himself. The means of rendering Light, and all the emotional expression it is capable of conveying, was for the first time at the disposal of the painter. More will be said later, on this interesting movement in dealing with colour. But the point to be noticed here is that this movement has revolutionised the whole point of view from which the painter approached the aspect of things seen, and has necessitated a reconstruction of the whole method of study to be pursued by the student of painting. This is a point that is not yet fully realised, and is the cause of so much of the confusion and muddle one sees in the

paintings produced in our art schools at the present time.

Instead of building up from the touch sense by means of outlined objects to which shading and colour are added, we can now approach the study of vision from the other side, from that of the full visual picture for what it is as rays of light of varying degrees of the solar spectrum caught on the retina. Thus outline, light and shade, etc., are lumped together and considered as one thing. But by discarding line drawing and all the associations the expression of the tactile sense in form gives, the impressionists threw away too much. What is wanted is a course of study that will embrace both points of view, and enable the student to study all the instruments of expression at his disposal. In the following chapter is offered a suggestion for such a scheme of study.

CHAPTER IV

THE PAINTER'S TRAINING

ALONG what lines should the training of a painter proceed? Art schools have been in the habit of dividing the subject into two sections—Drawing and Painting, the student being first set to draw inanimate objects and casts from the antique in outline, and afterwards shaded more or less elaborately; then drawing from live models was undertaken. Having arrived at proficiency in drawing and shading he was allowed to start painting, the whole system being based upon the primitive idea of outline form, to which is added light and shade and then colour, when a full realisation of the object studied is arrived at.

When the student after a long course of drawing has commenced painting, he has invariably floundered horribly; painting presenting him with an entirely different problem to drawing. With a brush full of paint in his hand a different method of expression had to be found than the one that served when he held a chalk. Some of our best schools where drawing is taught splendidly, have not got over this difficulty; and the painting is poor out of all comparison to the drawing.

Since the impressionist movement has enabled us to consider the whole of visual facts (the material with which the artist works), object, background, and atmosphere, as one thing, one visual impression, how are we to organise our study? Out of the confused

mass of knowledge of visual and artistic things from many points of view at present warring against each other in the studios, how are we to construct a systematic scheme of instruction that will not clash with the good points in any of them? Starting as we now do with the whole field of vision revealed before us, what are the separate elements in this visual matter of which works of art are composed? I think it will be found they can be divided into three : *Form*, *Tone*, and *Colour*. And it is time our systems of study were recast and these divisions substituted for those of drawing and painting. There are different expressive qualities in each, and between them they cover the whole range of technical phenomena with which the painter works. Drawing and painting as divisions of the subject are too much concerned with mediums of expression and not enough with the chief elements of expression.

There are those who would include " design " as one of the divisions of the subject. But here I do not think systematic training is much help. This is not a subject for hard drilling but something the student must be left free to develop for himself. Bringing his sketches to be criticised by the master. It is hardly a division of the subject so much as the whole unteachable thing itself. Design is that which lifts the elements of which a picture is made into that expression which is a work of art. It enters into all the separate elements : Form, Tone, and Colour. For there is form design, tone design, and colour design.

Instead of the student being trained first in drawing, and after acquiring a certain proficiency being allowed

OIL PAINTING

to start painting, as if one naturally grew out of the other, I would suggest that each of the three divisions of the subject—Form, Tone, and Colour—be studied simultaneously from the start. They do not grow out of each other, but rather into each other from three different centres of perception that cover the whole ground of visual phenomena. These three qualities in vision are the three things with which the artist expresses himself, and they have each their separate expressive qualities, and are each present in some degree in all pictures. Some artists will rely most on the beauty of form in their work, like Ingres (Plate 9), some on the beauty of tone, like Whistler (Plate 10), and some on the beauty of colour, like Monticelli (Plate 11). In the work of others the emphasis is not so markedly on any one of these qualities, but all three are combined in the whole effect.

By Form is meant not only the outlines of objects but the expression of the sense of bulk, the third dimension, on the flat surface of your work. The tactile sense that we all perceive from having early in our career acquired the habit of associating touch with sight, so that we see the feel of a thing ; we understand its form as a felt thing by merely looking at it.

By Tone is meant the relations in a scale from black to white of the pattern of masses that forms every visual picture. One mass is either lighter or darker than another, or varies from a lighter to a darker tone, etc., and all these different degrees of tone have certain relations to your extreme dark and extreme light. The study of these relations is not an easy matter, as this quality of vision is quite new to us. We all have some

idea of the shapes of the objects we see and of their colour, or we think we have. But the tone relationships over a wide field of vision is a thing unsuspected and not considered at all, except by those who have trained their observation. There are a whole range of expressive qualities connected with a beautifully arranged tone scheme that do not depend on form or on colour. The study of tone includes light and shade, and in fact all modelling that does not depend on outline. But it includes more than that, as it includes the tone of the background and any modifications in tone produced by the atmosphere through which an object is seen. It includes, therefore, what the old masters used to call aerial perspective. It is, of course, intimately connected with form, as you cannot have a tone mass that is not of some shape. And it is intimately connected with colour, as colours vary in the scale of tone as well as in hue. Even the solar spectrum can be expressed in terms of the tone scale, the yellow being the lightest colour, from which the tone gradates away to dark on either side.

The word tone is here used to express solely the degrees of lightness or darkness, not changes of hue in the colour. There are darker and lighter shades of the same colour, so that a colour may vary in tone without being said to vary in hue.

It is the fashion in some advanced quarters to pooh-pooh the study of tone altogether and say that if you get the right colour you get the right tone as well; and if by the right colour you include the right tone (a quality that is intimately associated with it), this is quite true. But you could also say with equal

truth, that if you get the right colour you get the right form. For form is also intimately associated with colour ; as your colour mass must be some shape, and if it is the right shape and the variations of tone in it are also right, then the form is right. But because all these three aspects of a painting are very intimately combined in the final result, it does not follow that they are not best studied separately. In studying any craft it is essential that the difficulties should be overcome one at a time. The mind cannot concentrate on several things at once. And in planning a course of study it is necessary to divide the subject so that the mind may be concentrated on the difficulties to be overcome, singly.

In the French schools of art that were so fashionable at the end of the nineteenth century, the study of tone was made too much of, to the exclusion of colour, in any true colour sense. And it is the reaction from this grey lifeless colouring, that has put the study of tone under a cloud for a moment.

And there is another important matter connected with the separate study of tone, and that is the fact that in painting, form is expressed by masses, not lines. The student who tries to paint by filling in the spaces between outlines will never develop any freedom of execution or much quality of painting. The painter conceives of form in terms of paint, and these terms are masses of varying shapes and degrees of tone. This mass drawing in paint can best be studied in monochrome without the aided complications of colour. The elementary student will find quite enough to overcome at first in handling paint, and getting it to

come off the brush as he wants it to, without adding the difficulty of colour.

By Colour one means colour (there is no other word for it) and all the stimulating qualities that fine colour gives. Colour has an expressive vitality of its own that many artists revel in, quite apart from form or tone. It is perhaps the most winning and popular of all the instruments of the artistic orchestra.

But at the same time as carrying on this systematic drilling of the faculties in the observation and expression of form, tone, and colour, the student should habitually let himself go in any direction his fancy may move him, and do composition and sketches. The innate desire to express himself as an artist that impels one to take up painting cannot be taught, but it can be suppressed or neglected. And this is the danger of school study. You cannot set aside a special time for making compositions and sketches in a school, as one must wait until one is moved to do such things. But every opportunity should be allowed students to do this in preference to their school work when they want to. They are naturally shy about it, as the accomplishment must necessarily be very poor in these early sketches; and accomplishment being the thing they lack, is naturally what they are rather touchy about. But accomplishment is what should result from one's school studies, and is not to be looked for in these early attempts. They should be studies in the anatomy of composition, and the eyes should always be on the look-out as one passes along the streets, or wherever one is, for interesting arrangements and groupings. Very interesting and beautiful work can be done with

no technique to speak of, as the work of children often shows. The greatest freedom may be indulged here, and the most audacious things may be attempted, that have attracted the artist's attention as offering interesting matter for a picture. If this side of a student's development is kept up, the hard drilling of school work may be indulged in without any danger of its supplanting the proper business of the artist, which is not only to express himself well, but to have some original æsthetic observation to express.

Form is by far the most important of these three divisions, and the one where hard study is best rewarded. There is no end to the study of form, and the fine artist is always drawing. Including as it does the greater part of composition and design, the highest expression that painting has aspired to has owed more to form than to either of the other two qualities.

But this subject I have tried to treat of in another book, and will therefore not go over the same ground again. Here I will only emphasise the fact that this part of your training should occupy the greater part of your time at first, and you will never be through with it.

But at the same time as you are commencing drawing I should advise you to vary your work by occasionally having a day studying tone and then a day studying colour. If the study of these are left until the eye has become hardened by a long course of severe form expression, it is more difficult to open up the development of these new perceptions. And it will be a relaxation from the more exacting task of drawing.

In the very first instance the untrained eye will have to concentrate its attention on a mechanical

accuracy in these early studies. But it will not be long, if you have the right stuff in you, before you begin to be stimulated by what you perceive and feel the impetus towards the expression of something felt. Expression implies emphasis and selection. Drawing with the idea of mechanical accuracy, is an exercise in the setting down of facts already existing on your retina. The mental effort required is a sort of mechanical one. Such exercises, useful as they are to train the eye to perceive accurately, and the hand to set down what is perceived, are not really drawing at all; for drawing is the expression of form, and such drawing has no expression. Before you can express anything you must feel something to express, and so felt the mechanically accurate photographic facts are heightened in effect; certain things stand out with more emphasis to the subordination of others. The dead mechanical facts of vision are ordered and arranged under the influence of the feelings that accompany artistic perception into a vital impression, something subtly different or crudely different according as the artistic perceptions are refined or not. The expression of this heightened perception of form, I would call the expression of *form values*. Good drawing is full of these form values, and stimulates one to experience the heightened perception that was the artist's. Every new draughtsman gives us new experiences of this nature.

What has been said about form applies equally to tone and colour. Either can be studied with the idea of merely accurately representing the tone or the colour as the case may be, with a very dull result. Or either may be perceived as something that stimulates the

æsthetic perceptions, the expression of which heightened perceptions gives us what I would call *tone values* and *colour values*.

In writing on art it becomes necessary to strain the use of words, or use new ones to express what you mean, as the English language is not very rich in terms that express æsthetic things. And I am here using the word *values* to express a quality that needs some explanation. The word as generally used in the studio applies exclusively to tone. The relations of tone in a picture are spoken of as the values. And I am here applying the term to form and colour as well. Neither am I using it with regard to tone in the manner it is generally applied. It is usual to speak of the tone relationships of a picture, whatever their quality, as tone values or values. But I want to promote the word to a more significant and exclusive use and apply it only when form, tone, or colour are used for *æsthetic expression*. Only when they have *æsthetic values*. For form, tone, and colour may be used without any æsthetic values. They may be used solely for an unimpassioned rendering of the appearance of things. Although this does not often occur, as man is a sensitive creature and it is not easy for him to stand aside from his feelings and turn himself into a mechanical instrument. But it is quite possible, and has more often been accomplished in modern times, when the difference between a photograph and a picture is so little understood.

Although it may be necessary, at the start at any rate, for the duller students to concentrate their attention on merely mechanical accuracy, as this is

PLATE 10

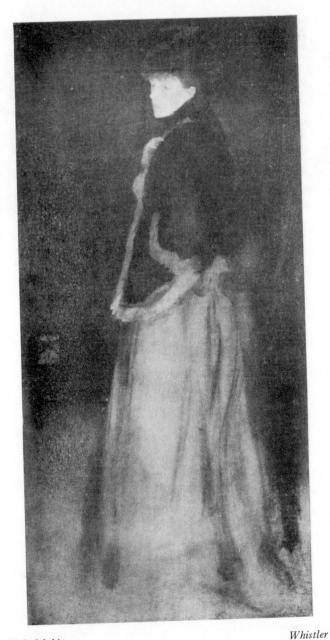

Philadelphia *Whistler*

THE FUR JACKET

Example of picture depending on beautiful tone values for its chief
expressiveness

Photo : W. A. Mansell & Co.

PLATE 11

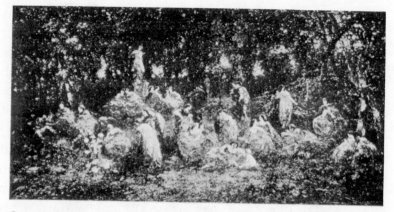

Coats Collection *Monticelli*

An example of a picture depending on jewel-like colour for its charm

Photo : Annan

quite difficult enough at first, this early stage should not be allowed to continue for long. And the expression of the heightened perceptions of the artist, which is the real business of the student of painting, should be attacked.

You will find as you advance in the study of each of these three subjects that they will help each other; the study of form will make it easier to get the shape of your masses right, and the study of tone will be found of inestimable value in judging colour. But in your form studies don't bother about the tone, concentrate on the form idea; and in your tone studies don't bother unduly about the form, select subjects where form is not of so much importance in the first instance. And in your colour studies concentrate on getting the colour vitality without unduly bothering about anything else. The great thing is to learn one thing at a time, to concentrate on one particular difficulty, and practise and practise until you master it.

The heightened effect that there is in all artistic work, and which is in a way a departure from cold accuracy, must not be made the excuse for careless and slovenly work. Intense honesty and the strictest accuracy is always needed to catch the fleeting impressions of the fine things seen by the artist; accuracy of a much higher order than the cold accuracy of a machine. Although they have not necessarily been conscious of what they were doing, and may even in a simple-minded way have thought they were slavishly copying what they call nature, nevertheless all artists in the past, following the direction of the inner light that has impelled them to be artists, have selected and

arranged the visual facts of nature, even to the slight distortion of those facts, at the dictates of their desire for expression. Western art criticism in the past has been too much concerned with the degree of truth to natural representation, and has only recently become fully conscious of the underlying rhythmic principles that give art its powerful significance. And having become conscious of this significance and that some distortion of the cold facts is necessary in all works of art that use natural appearances as a means of expression, many of the more extreme refuse to see expression in any work that does not obviously flout, often in the most violent manner, the modesty of natural appearances ; calling other works academic and dull. Whereas the variations from strict accuracy in the finest works, depart from nature so slightly, that their discovery escaped the art critics for centuries, and has only just come to light in this ruthlessly analytical age. In the East, however, rhythmic vitality has always been consciously held up as the most important thing in a work of art from ancient times, and is the first of the five principles of Shakaku,* who lived in the fifth century A.D.: " The life movement of the spirit through the Rhythm of Things."

The study of natural appearances and the means of their representation, is the object set before the student of painting, not because art consists in the representation of nature, as appearances are called, but because the eye is the source of all our knowledge of things seen. And all the wonderful wealth of beautiful things the art of the past has left us, is the work of

* Okakura, " The Ideals of the East."

men whose imagination has been nourished by their observation of the things around them, however imaginative their art. Nature contains the material with which the artist works; it is, as Whistler says, the keyboard on which he plays. The study of nature can never be neglected by the artist without impoverishing the language in which he expresses himself. Even although the work of one who expresses something vital in a poor visual language, may be preferable to the work of those who express nothing in particular in a rich one.

But although it is not truth to superficial nature, the naturalness of a picture, that makes it a great work of art, this is the quality that makes it persuasive to the beholder, gets the impression the artist wishes to make over the footlights, as it were. In the same way that the naturalness of speech and action in a play introducing such strange characters as Shakespeare's " Midsummer Night's Dream " makes the whole effect convincing, although it may be perfectly true that its naturalness is not the true standard by which its artistic quality can be judged. In these Post-Impressionist days we are apt to forget that nature is still one of our best artists, and holds the secret of the whole matter ; despite the fact that she is often made the excuse for very dull performances, by painters whose chief virtue is honest stupidity. Nature is not one of those who disclose their best to a shallow observer ; she only reveals herself fully to those who seek her reverently, when the " something within " sets up a correspondence with the "something without." It is an inner sense that arranges superficial visual appearances in tune with

this indwelling spirit in nature, in the form of a work of art; a sense intimately connected with our highest nature and of the utmost importance to the artist. But this must be innate and cannot be taught, and is what in the first instance prompted us to take up art as a calling.

The ignorance of our untrained observation is very remarkable, and quite unsuspected by the majority of people. Sight is one of the chief of the many faculties the average person takes for granted, and never inquires about, or seeks to develop.

This training of the observation and representation of what you see, is therefore the first thing you have to set about, however imaginative may be the kind of work you want to do. For if you cannot paint what you see, you will find yourself handicapped in trying to paint what you imagine.

The task of painting the object set before the student can easily degenerate into a mere mechanical perform-ance, like copying dictation, if it is not guarded against. And this is the attitude of mind students need con-stantly urging to avoid. We are all naturally mentally indolent, and easily drift into the attitude of mind that says when an object is set up to be painted, " That looks fine, I have only to copy it and I shall do some-thing that looks fine also." But the matter is not so simple as that. The perception of something fine does not remain long enough to guide the work through to completion; and is in any case not something existing outside the student in the object, that is always there to be copied as we might copy out a poem. We are all apt to think of sight as something existing outside

ourselves ready-made, and that all we have to do is to open our eyes and let it in ; whereas outside ourselves vision does not exist. What is a perception of something fine one day, may be a perception of something very commonplace another day, even by the same mind. During the work the student has to be constantly keying up the perceptions and calling up the memory of the fine things seen, and nothing should be done when nothing fine is perceived. Never work without vision, without a perception of what you want to do ahead of what you have done. You will find after working for some time on one part that the vision of what you wanted to do gets dull. Stop and go on with some other part, where you see what you want to do. Or, if you do not see anything, stop and take up another canvas, or rest. After a change of work your eye will see clearly what is wrong and what is wanted. Always turn your unfinished work to the wall so that you see it with a fresh eye when you come to work on it again.

The discovery of each new fact of visual appearance in Western art has been heralded as a great triumph of art. Even the great Leonardo da Vinci, full of the new discovery of light and shade, says : " The first thing in the art of painting is to make a flat surface look like relief." And the champions of the impressionist movement have heralded the new facts of vision they brought to light as if they in themselves constituted artistic triumphs.

These new facts are but the addition of new instruments to the orchestra with which the artist creates his symphonies. They increase the range of possibilities open to him and enlarge the scope of his work.

But they immensely increase the difficulties of composition, and have recently become so intricate and engrossing that they are apt to occupy the whole of his attention. So that the orchestration becomes the subject of the symphony, instead of its means of expression. The point is reached when the instruments of expression are too difficult to be controlled with any freedom and themselves begin to control the work. It then becomes necessary to create simpler instruments more within the capacity of the artists to control and express themselves with.

The subtlety of perception introduced into painting by the impressionist movement, including, as it did, the whole facts of visual nature with the surprising modification of objects seen under aspects of brilliant and dazzling light, had so complicated painting that the ordinary artist could only essay the simplest subjects. Primitive art with its simple formula could undertake the vastest themes. Botticelli with a simple pen outline illustrated Dante's great poem. Heaven and Hell were attempted by Fra Angelico's primitive formula. As in more recent years Blake with his simple tender outlines essayed the most immense conceptions. Vast themes seem to demand simple language for their expression, and a very ornate and subtle language would seem to have to confine itself to the more trivial. And the determined attempts that are being made by our younger painters to get back to simpler and more direct modes of expressing themselves in painting are a healthy sign.

And it is not necessary to copy the primitives. With the new eye we may possess since the impressionist

movement, new visual simplification can be discovered; if we approach our work in the direct attitude of mind of the primitive artists. This is what has given so much prominence to the often crude performances of a simple-minded man like Gauguin, who, after studying in Paris at the height of the impressionist movement, went off quietly to Tahiti to try and find a simpler mode of expression than was current at the time. And this is the direction that many feel is the only one that offers any hope for future advancement in painting.

Bear in mind, therefore, all through your school work, that the study of nature is the study of the instrument you are to express yourself with. In the same way a violinist plays his scales, so as to acquire the capacity of producing pure tones on his instrument, and train his ear to appreciate accurately the intervals between the different notes, so the painter trains his eye to perceive accurately the appearances on his retina, and trains his hand to express accurately these perceptions. Not that playing scales is music, or training the eye is art ; but because without this training we have no control of the means by which artistic things are done. If you gave a person of strong musical genius a violin to play, one who has never had any academic training for fear of spoiling his original genius, it is possible he might stumble upon some new and interesting music among a lot of noise that was excruciating. But this would be a very barbarous method of preserving originality. And the originality that is of so delicate an order that it cannot stand a course of academic training, is so poor a thing that it were better not considered. But some such

method as this would seem to be that adopted by some of our more violently modern painters. There are occasionally hints of new melodies in their work that are interesting, but mixed up with such a mass of excruciatingly jarring paint-notes horridly jumbled on, that it seems a pity even so simple a technical course as could be furnished by an ordinary house-painter as to a decent manner of putting on paint, has not been indulged in.

We owe a debt of gratitude to the Post-Impressionist movement, however, for reinstating in popular art criticism the principle of rhythmic expression as the standard by which works of art should be judged. It has also acted the stimulating part of an intellectual clown, standing all our ideas on their head and making us think about them from another point of view. This is a useful function to perform as it prevents stagnation and the hard setting of ideas, and keeps up the vitality necessary for health. This function in social affairs is performed by our social jesters, who are no longer attached to courts but write plays, which are acted before the mass of people. But woe betide the State that sets up a jester as the *New Statesman;* and in the same way woe will betide the youthful painter who attempts to found his practice on such guidance.

The really remarkable thing about the movement is the uncouth paintings that have been chosen to illustrate such excellent old-world principles. Nature—objective nature—has been too much held up as the standard by which all art should be judged ; instead of that inner nature where absolute values have their being, that the spirit of man has ever been groping after, and

of which art is an expression as realistic as the artist
can make it. For all artists are realists, but all artists
do not necessarily accept as reality the cinematograph
performance that takes place on the retina of the human
eye. The difference between the realist and the idealist
is in their definition of reality. The artists who called
themselves realists in the nineteenth century were
casting a slur upon those who did not agree with them,
implying that they were unrealists. The movement
was a natural product of the materialistic science of
the time, that was content to stop at what are called
material things in its search for truth. And in the same
way that science is now widening the borders of its
field of inquiry, and may eventually comprehend
ultimate truths; so art criticism has widened its borders,
and instead of stopping at the materialistic view of
phenomena with which so much nineteenth-century
criticism was concerned, it is pushing on into the field
of ultimate values, the expression of which has been
the real concern of the artist in all times. The rhythmic
spirit that pulsates through the universe and sustains
all life, stirs deep down in our being, and urges us to
seek relationship with the invisible reality that peeps
through the veil of things seen. And it is his perception
of this inner reality that stimulates the artist, and that
he seeks to convey in his work in as real a fashion as
he possibly can. So that in the end it may be found
that the mystic is the only realist after all. For there
is something of mysticism in that vision of the artist,
which leads him to the perception of beauty in truth and
truth in beauty; something of the religious spirit that
finds its highest satisfaction in the ecstasy of the mystic.

OIL PAINTING

The discussion between realism and idealism is fundamentally one about clothes—in what garments shall the spiritual realities that are the real matter of all art be arrayed. Whether it shall be sought for in the aspects of everyday things, or clothed by the artist in the most fit symbols his imagination can conceive. The reality is the same in the best examples of all art, whether real or ideal. It is this inner world of reality, the other side of material things, that art seeks to give expression to in material terms. The old antagonism between the material and the immaterial, between the flesh and the spirit, has too often in the past led the idealist to neglect the true aspect of things (the material with which his symbols are made), and inclined the realist to give too much emphasis to the purely material aspect of things, to the neglect of the spirit. But the more reasonable modern minds are everywhere seeking to combine these two extremes, seeking the inner realities in the meanest aspect of everyday things, instead of building in the clouds. There is, truly speaking, no antagonism between the realist and the idealist.

In conclusion, it is the business of the student of painting to seek for this inner reality as revealed in the aspect of things, by studying the beauty of Form (Form values), the beauty of Tone (Tone values), the beauty of Colour (Colour values), and to give rein to all his intuitive faculties, sketching and making compositions in any manner, and of any matter, they may suggest. In all this study being unflinchingly honest and true to himself and to his own inner vision, however unfashionable it may be.

CHAPTER V

TONE VALUES

THE particular beauty that is associated with tone values is most in evidence when the tones are large and simple, and not much disturbed by variety. Beauty of tone is like a long-sustained melody played on a violin, the quality of which depends on each note being held in great purity, and separateness, from each other note. Any scratchiness of tone or variety introduced will destroy the beauty of the melody. And in painting the quality of tone beauty depends on the evenness and sustained nature of the different tones in the picture, and their distinctness from each other; each note in the scale of values being as separate and well marked as possible. Anything in the nature of broken colour that would too much disturb the purity of tone, is against the expression of this particular beauty. One has only one scale from black to white, and the utmost economy has to be exercised in its use. This quality is best exhibited by solid painting, as a greater number of tones can be made than with transparent colour or scumbling. If you take black and white paint and by mixing them make as many different degrees of tone as you can from black to white, and then try and do the same thing with black used transparently on a white canvas, you will see what I mean. A much greater subtlety of difference is possible with solid paint than with transparent, and a much larger number of different degrees of tone can be shown.

In nature this tone beauty is best seen in such effects as twilight or when the atmosphere is heavy, and in those quiet grey windless days when the sky is a wide even tone of dull light, destroying shadows by lighting objects all round, so that each stands out as a separate tone value undisturbed by much modelling. Such effects as Puvis de Chavannes (a great master of tone values) loved to paint. The thick atmosphere of our towns simplifies tones, and is responsible for much of the beauty our artists find in such unexpected places as centres of manufacture. There is little colour, but the solemn sequence of simplified tones, that masses of buildings at different distances seen in a thick atmosphere give, has been the subject of many fine pictures. Whistler's pictures of the Thames at Chelsea owe their great charm to his subtle appreciation of the tone beauty London atmosphere gives.

While the particular quality of tone beauty is more marked in certain effects of quiet light in nature, it is not by any means confined to them. Even sunny effects may have it, but it is only brought out when the effect is much simplified. A sunny effect such as one gets in Holman Hunt's picture of " Julia, Silvia, Valentine and Proteus," from " The Two Gentlemen of Verona," where the tones are everywhere broken up by brilliantly illuminated detail, has not this quality of tone beauty. A picture may be a fine picture without using all the instruments of expression at the disposal of the artist. And tone beauty is not a very important instrument with the majority of the Pre-Raphaelite painters. Their love of excessive detail made it very difficult to realise a tone beauty that depends on large

simple masses. There are certain exceptions in the case of some of Millais' early Pre-Raphaelite pictures, passages in which are very beautiful in tone. Notably the background of " St. Isombras crossing the Ford," where great beauty of tone has been combined with very high finish in the dark landscape against a brilliant sunset sky. A beauty that does not extend to the figures in the foreground, which are harsh in tone and quite out of harmony with it. " The Blind Girl " is another picture that has some beautiful tone values. But, generally speaking, it is on colour and form rather than tone that these painters relied. Tone beauty is the latest quality to develop in Western art, whereas the Chinese and Japanese have been masters of it for many centuries. The Venetian painters, particularly Giovanni Bellini, Giorgione and Titian, had very fine tone values in their work. But the other Italian schools, after the fashion for chiaroscuro (light and shade) had set in, got rather harsh and hard in tone. The new observation of light and shade was used almost entirely to accentuate the fulness of form and make it stand out in the round, and this was a serious blow to the quieter, all-enveloping quality of tone music. Some of the members of the more northern schools, like Correggio at Palma, and Lorenzo Lotto farther north, are masters of tone values in their work. But the particular quality of rhythmically ordered tone relationships I am trying to speak of, and which I call tone values, was not a notable feature of Italian painting after the introduction of chiaroscuro.

Velasquez was the great master of tone values. The all-enveloping unity of tone is one of the great

outstanding features of his work. After contemplating the magnificent room full of his pictures at the Prado, those in the other rooms look cut up and patchy in tone. It is true he sacrificed a certain amount of colour to this quality, as most masters of tone seem to have to do. If any one of the three elements of a picture, form, tone, and colour, predominate, the others are bound to suffer to some extent. But tone and colour are so intimately associated, that when the tone is exquisite one does not miss the colour ; and it usually comes as a great surprise when, in copying, it is found that the picture is made up chiefly of blacks and has very little real colour at all. This is often the case with Velasquez, who used two blacks, a blue-black and a brown-black, and often very little else.

Plate 12 is a reproduction from Velasquez's "Aesopus" in the Prado, of which I made a copy with a warm and a cold black, burnt sienna and white only. Except for a slight touch of Venetian red on the mouth and ear. And I do not think he used any more colours.

Some of the Dutch school developed a fine sense of tone values, and one Dutchman stands out remarkably in this respect, Vermeer of Delft. Tone values are carried by this remarkable painter to a degree that has not been surpassed in Western painting. His work is built up on an exquisitely adjusted design of tones. And carried out to a very high degree of finish as they are, nothing in the way of detail is ever allowed to disturb or mar the serenity of the tone scheme. The details are all conceived as smaller tone values fitting into the larger but not unduly disturbing them ; and he never allows the idea of actuality, that is

PLATE 12

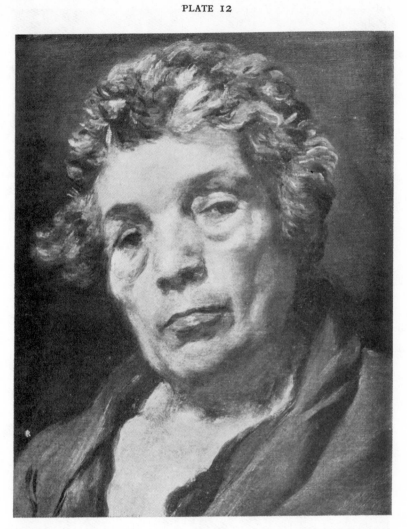

Prado Velasquez

AESOPUS

Photo : Anderson

PLATE 13

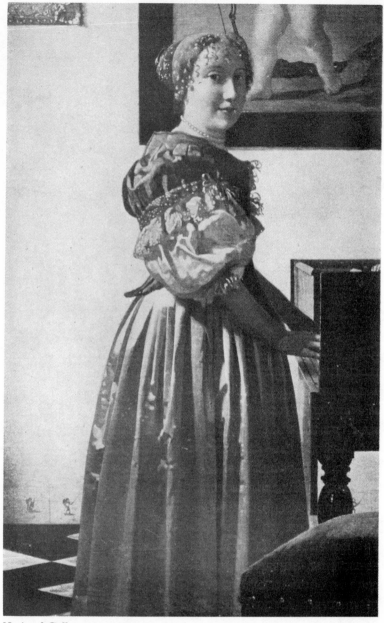

DETAIL FROM PICTURE BY VERMEER OF DELFT

apt to come with high finish, to get in front of the
music of tone relationships that is sustained throughout
the whole. It is interesting in this respect to compare
the satin dress in Vermeer's " Girl standing at the
Virginal " with the satin dress in Terburg's picture in
the same room at the National Gallery (Plates 13 and
14). And note how in the Terburg the beauty of the tone
values is marred by his having carried his work to a
higher degree of realisation; so that the real satin gets
in front of the æsthetic value of his white tones.
Notice how in the Vermeer the different tones of the
dress, are a beautiful succession of musical notes on
the scale of tone, that plays delightfully throughout the
picture. Notice how the suppression of detail and the
simplification in the tones, necessary in order to get
this quality, is balanced by a similar simplification and
suppression of detail in the edges. Notice the treat-
ment of the hair, and think what opportunities for
picturesque variety he has suppressed on the edges,
that a lesser man could not have resisted; but which
would have jarred with the sublime tone melody that
is the æsthetic motive of the picture. The appreciation
of this quality of tone values was so little understood,
and so much neglected, that this supreme master of
it had been almost forgotten, and his name allowed to
drop out of the catalogues of our galleries until quite
recent times; his pictures being ascribed to Pieter de
Hoogh. This is the more remarkable as few painters
have given us so intimate a picture of themselves and
their quiet home life as Vermeer.

A large number of his pictures are painted in his
own painting-room, a lovely little room, scrupulously

clean, with black and white marble floor and tiled
skirting, so as to protect the wall when it was swabbed
up in the morning. How well we know his virginal,
with its case painted to imitate marble (he could not
afford a very good one), and the picture on the lid that
he varied to suit the different compositions. And the
leaded windows across the whole width of the room,
some of which he sometimes blocked up to give variety
to the lighting. His picture-frames, the paintings
in which he also varied to suit his compositions ;
his Persian carpet and his map, and other properties
that occur more than once in his elaborately arranged
but apparently casual and spontaneous compositions.
And his patient wife, who not only bore him a large
family but sat for so many of his pictures. And her
beautiful little satin dress with the little blue over-
bodice that was sometimes worn and gave it the
appearance of another dress. And then, last but not
least, his string of pearls. This must have been a
serious item to the household if they were the real
article, as I imagine they must have been, the days of
imitations not having yet dawned. We know how
hard up they were, as there is evidence that the baker's
bill was run up to a large figure. But how Vermeer
loved pearls, how he loved their iridescent colouring,
and their beautiful little soft blobs of high lights.

There is something unique in the soft fused quality
of edge Vermeer got in these high lights, and indeed
in the edges of most of the little planes of tone that
he built up his detail with. It seems to be the result
of a gradual fusing of the edges into the surrounding
tone. A quality that might be got by the skilful use

PLATE 14

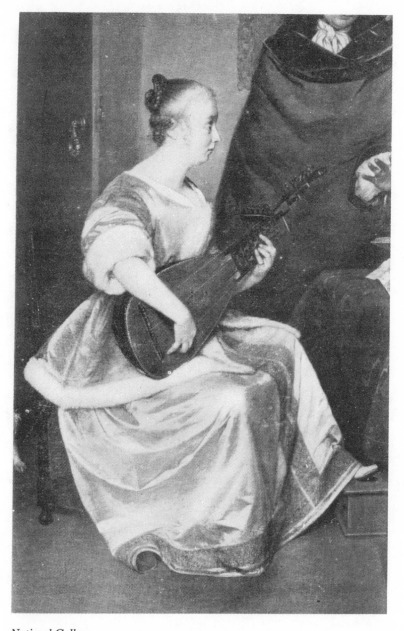

DETAIL OF PICTURE BY TERBURG

PLATE 15

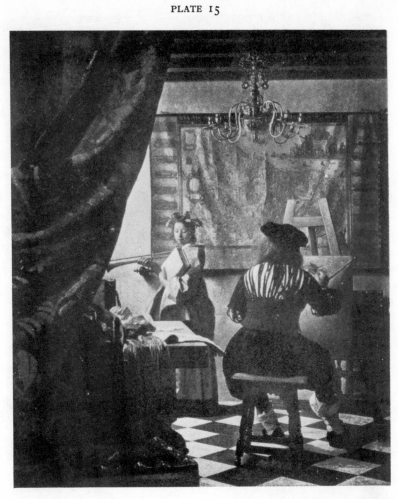

Vermeer of Delft

STUDIO INTERIOR

Photo : Hanfstaengl

of some slow-drying mediums. I have found slow-drying amber varnish produce something of this result. But the utmost skill and care would be necessary to see that it did not go too far, but only just far enough. But Vermeer's skill in handling was amazing. Note in the " Lady standing at the Virginal " the quality of the little bows of ribbon that do up the blue over-bodice and come against the light wall background. Notice the skill and deftness with which these little bands of tone are painted, and how even they are in tone, how regularly the paint has flowed off the brush. This is a very difficult thing to do with oil paint, and such a small brush as would be necessary. A small brush holds very little paint and therefore soon empties itself, the usual result being that the tone is not the same at the finish of the stroke as at the commencement. As the brush empties the tone of the ground shows through and varies it. Or, if the brush is loaded so as to carry through the same tone, you are apt to get a heavily loaded quality at the commencement. But the even quality Vermeer has got is remarkable in an oil painting, and more like what can more easily be got in tempera painting, and I recommend these little touches to your notice the next time you are at the National Gallery, as an example of his marvellous skill in handling.

The picture reproduced (Plate 15) is another one that interests me. Here you have the same room, but he has dressed his wife up in an absurd fashion, with a wreath on her head and a trumpet in her hand. What does he mean by this ? Who knows ? I have an idea that he was poking fun in his democratic way

at the Flemish painters over the border, who at this time were painting in flamboyant manner such extravagant allegorical compositions and apotheoses. " Is it a victory you want ? This is the way it is done, you dress your model up with a wreath upon her head and give her a trumpet to hold, and there you are." The Dutch at this time had cut off from the rest of the world, with its kings, nobles and grandees, they had done with the Catholic Church with its pomp and state, and had set up a republican form of government, and a Protestant religion. The artists found themselves bereft of all the usual subject matter that had occupied the attention of painters, except portraiture. So they set about painting the ordinary everyday life of the people; their homes, the good things they ate and drank, their town councils, their taverns, and even their drunken brawls. Vermeer was the type of man that, under other circumstances, would have been painting religious altar-pieces. There is a spirit in such pictures as the Lady at the Virginal, an awe and reverence expressed in its perfect balance and static calm, that exalts it to the status of a truly religious picture. Which goes to show how independent an artist can be of subject matter, and how, if it is in him to paint such pictures, he will exalt whatever subject he undertakes. One might have a sneaking regret that the circumstances of the time were not such as to allow so perfect a painter, to combine representational matter more in harmony with the sublimity of his treatment. And there is no getting away from the fact that the associations connected with the things represented, do enter very largely into the impression

PLATE 16

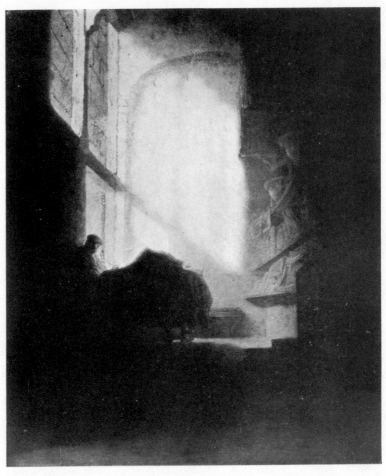

National Gallery *Rembrandt*

THE PHILOSOPHER
A wonderful example of a simple impressive tone plan

Photo : National Gallery

made by a picture on the many. But did not Vermeer do a greater work in showing us a heavenly view of common things ?

Rembrandt, in a more limited sense, used tone expressively. But his use is confined almost entirely to the dramatic effect of strongly contrasted light and dark masses, whereas it is in the middle notes of the scale that tone plays its most alluring harmonies. Strongly contrasted schemes of tone had been in use since the days of Leonardo da Vinci, but used chiefly to augment the expression of form; whereas Rembrandt used it as an expressive thing in itself, giving it æsthetic value. A typical Rembrandt effect is the little picture (that is so big) entitled " The Philosopher," in the National Gallery (Plate 16). The picture is little more than a dark mass, into which is cut a light one with a wonderful edge. But what an immense impression is created, an impression that is brought about, like all immense impressions, by very simple means. But while the light and dark masses of which the picture is composed are very simple, note the wonderful richness and variety in the edge where the two masses join.

In modern times Whistler is the painter who stands out pre-eminent as a master of tone values. The nineteenth century saw a great renaissance of this quality in painting, but Whistler is the painter who carried its expressive capabilities to a greater length than any other. He painted subjects where form and colour were so muted, that former painters had found nothing to catch hold of. Such subjects as twilight and night scenes had never been really

exploited until Whistler took them up. With his exquisite and subtle perception of delicate tone relations, he found new beauties that before had not been perceived; beauties that were dependent on tone values. Not that form and colour were entirely absent. Form is the only instrument in the visual orchestra that can play a solo and exist, as it does in drawings, without the support of the other two. Tone and colour must always have the support of some form, must be some shape. Tone can exist without colour, as in monochrome, but not without form. Colour, on the other hand, cannot exist visually without the support of both the others. A colour mass must always be some shape, and it must always occupy some relation in a scale from dark to light. This is why all the efforts to create an independent colour music by means of such devices as a colour organ have failed. Colour thrown upon a screen without any tone or form values is vapid in its effect.

Puvis de Chavannes is another modern who has used tone values extensively in his work. In his large decorative designs, a beautiful balanced scheme of large tone masses has been used to give a wonderful unity of impression, and vastness of effect (see Plate 1). No student should pass through Paris without going to see his large decoration in the lecture theatre of the Sorbonne. A decoration that must make the attendance at lectures a more ennobling experience than the dreary aspect of most of our lecture theatres is calculated to effect. And it is sad to realise that we in England at the same time had a man who could have covered the walls of our public buildings with equally ennobling work; and

who was burning to do it. But we allowed Watts to live and die without having a single commission of this nature. And when he, in company with Burne-Jones and Rossetti, offered to decorate the waiting-room of Euston station for nothing, the offer was refused by the short-sighted gentlemen of the board. How can a nation be artistic, when its artists are so suppressed?

This quality of tone values must be experienced to be understood. The few painters mentioned as instances of artists whose work excels in this quality, are only intended to help the student to grasp the idea of what is meant by tone values. The work of practically all painters has some amount of this quality, but in those mentioned it is given greater prominence. It is so intimately associated with colour, that many think they are admiring colour when they are admiring tone. What is often called muddy colour, is generally the result of bad tone relationships. I do not mean to say there is not such a thing as muddy colour, colour of a lifeless, poor quality as colour; but whatever mud you paint with, if your tone relationships are good the result is not what is usually called muddy colour. If you notice the palette of a painter while at work, who excels in tone, you will often find it a mass of muddy colour. But the painting, from the beauty and vitality of its tone values, may be beautiful and fresh-looking, and a great surprise after seeing the palette.

To sum up, this quality is one of the most difficult for the young student of painting to get acquainted with, as it requires an entirely different way of looking at visual phenomena from any he has been accustomed to. Everybody has some idea of the form and colour

of objects, but tone relations are an acquired perception. But it is of the utmost importance to the painter, and the study of it is at present very much neglected. It depends on an emphasis given to the tone relationships of the different masses of which a picture is composed. On these relationships from light to dark being considered as notes on a scale, with which æsthetically significant arrangements are made; in very much the same way that a musician makes a melody, by an arrangement of notes on a musical instrument.

CHAPTER VI

ELEMENTARY TONE EXERCISES

THERE are innumerable ways of painting, but in setting out to study the craft it is as well for a time to confine your attention to mastering one of them. For purposes of study there is nothing better than simple, direct, solid painting. Painting with transparent colour, with a mixture of solid and transparent, glazing, etc., are all things that must be tried later on ; but for some time confine yourself to direct, solid painting. Any part can be altered at any time ; whereas with many other methods, alteration or repainting often ruins the effect. It is the method that is best calculated to train the observation, and offers one a better point of departure for any other manner one might want to adopt. Before developing an individual style you must have acquired knowledge, and solid painting is the best for this training.

For preliminary exercises in painting, nothing is so good as a clean cast placed in a strong light and shade, such as you would get from a small window with an uninterrupted view of the sky. The larger the window the less concentrated will be the light, and the less strong the effect. Strongly-lit effects are the easiest to paint, but will be found quite difficult enough for the beginner. Casts without intricate detail, and fine in mass, such as those from the Parthenon sculptures, are the best. The horse's head in our illustration is

OIL PAINTING

a very good one to start on, and the small-size cast can be obtained for a small outlay. Set it against a background of brown paper.

In oil painting one expresses oneself in terms of mass, so that the first thing to learn in order to develop any fluency as a painter, is how to conceive what you set out to express in terms of mass on a flat surface. Nothing is done on a canvas that has not first been conceived in the mind; and as a canvas or whatever you paint upon is a flat surface, the first technical consideration you have to master, is how to see what you want to do in terms of two dimensions.

This is by no means easy, as a long habit of associating touch with sight, and the possession of two eyes giving slightly different pictures, has accustomed us to perceive things in the third dimension ; to see things, not as flat visual pictures as they exist on the retina of the eye, but as objects in space.

It is a help at first, to look at what you are going to paint through a rectangular hole cut in a card, across which straight lines have been drawn with cotton threaded through at equal distances, both ways, and drawn tightly. By shutting one eye and looking through this, the spaces occupied in one's field of vision by any object, or set of objects, can be observed on the flat surface of the trellised opening, and the shapes noted in relation to the unit of measurement the squares give. But these mechanical helps should not be relied upon too much, and should be dispensed with as soon as possible, as they interfere with freedom of expression. But just at first, such a device is of great use in helping one to reduce things to a flat appearance.

Observed in this way and not considering colour, it will be seen that all things may be considered as an arrangement of masses of different shapes and different qualities of edges (here a lost edge, and there an accented and sharp one, etc.); and that these masses that compose appearances considered in the flat, have varying shades of lightness and darkness. Between the darkest mass, and the lightest mass, there is a whole range of varying degrees; in some cases of a level tone, and in others gradating variously. The relation of these tone masses is a subject of great importance to the painter, and a matter capable of yielding great beauty of effect.

The first lay in should be as simple a map of these tone masses as you can reduce your subject to. If this simplified foundation is well laid, and properly set out, you have a foundation on which you can proceed to add the smaller details of tone that will complete the work. But until you have this foundation structure properly done, you are no more in a position to proceed, than is a builder who has not got his foundations properly laid. This is a stumbling-block for some time with young painters; their eye is attracted by the accents of the lights and the darks (the last touches that should be done), and they cannot resist putting them on before the middle tones on which they lie are finished. " And now what am I to do ? " they ask. There is nothing to do, but for them to retrace their steps to the earlier stage from which they rushed ahead, and proceed to paint ever thing in its proper order. They are like the traveller who sees across the ground the point at which he is aiming and leaves the

tedious road to make a direct dash for it, only to find himself soon thoroughly bogged. He has to retrace his steps to the point at which he left the road. This is an almost universal experience of young painters ; for in drawing you can often start with the dominant accents (the things that attract the eye first) and construct the other parts round them. But in painting one has to reserve these enjoyable touches to the last. And then again these final touches that look so clever are, as a matter of fact, much easier to do than the earlier construction, which mental indolence encourages one to slur over. But this must be faced, and no further stages attempted until the habit of seeing the simplified basic structure of tones on which the final touches are built has been acquired. Half closing the eyes is a great help in seeing the general simplified appearance of your subject. Many of the smaller superficial facts disappear when observed in this way, and oddly enough, some of the more essential structural features of the modelling are more apparent.

Let us assume you are setting out to paint a monochrome study of the horse's head (see illustration). Raw umber is a good colour to use. It is very like the general tone of a cast slightly yellowed by age, has an excellent body, and works well. It is also the best dryer on the palette, so that your work is dry the next day for going on with.

It would be as well to block out with charcoal the general shapes of the principal masses in the way that I have explained in my book on drawing. But this preliminary setting out of the spaces to be occupied by the work should not be carried very far, as the real

PLATE 17

MONOCHROME EXERCISE

No. 1
Blocking in the middle tones

No. 2
Adding details of lights and darks and completing the work

PLATE 18

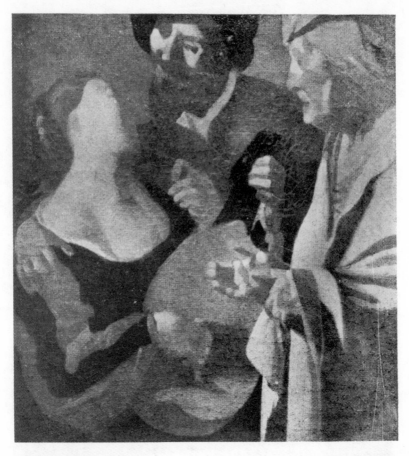

National Gallery *Vermeer of Delft*

DETAIL FROM PICTURE, GIRL SEATED AT VIRGINAL

Showing Vermeer's method of working from simple blocked out tone masses

drawing (form expression) is to be done in mass with the brush. In this exercise I want you to concentrate your attention upon tone masses. First settle what amount of your scale from dark to light you are going to use. Your highest light will be very near pure white, and in the case of the cast in the illustration, the base being pure black required the pure raw umber for its darkest part. But most casts have not a black base, in which case the shadow behind the horse's nose might be the darkest note, and this would require a little white added to the raw umber. Having settled your two extreme notes, put a dab of each on your canvas in the places occupied respectively by the highest light and darkest shadow. The relative positions of all the other tones can be judged in relation to these two extremes.

I ought here to make some apology for the illustrations. Accurate tone reproduction is one of the things quite outside the capacity of the photographic camera. And subtleties of tone relations are sadly missed and falsified, by the photographic process by which such illustrations are made. But they are the best that can be got, and may serve to illustrate these instructions.

First paint in the mass of your background. And great care should be taken to get it just the right degree of tone. Now a word as to the consistency of your paint. As supplied by the artists' colourman it is usually a little too stiff for free handling. It is a good plan, therefore, to mix up with the paint from the tube, using a palette knife, a little linseed or poppy oil with an equal part of turpentine spirit; so as to get both your white and raw umber to a consistency

that will cover easily and solidly, without leaving brush marks. It is as well to have on your palette in addition to this thinner white, some taken direct out of the tube, for occasions when a thicker consistency is necessary. But the first lay in should be as thin as the paint will cover solidly. Anything more than this will make it difficult to get the tones you will afterwards want to paint into it, to tell ; too much of the under tone will come up and destroy the value of the one you are painting on to it. Thick painting should always be reserved for the occasions later on, when you want to cut in a tone that will not mix with what is underneath. Paint the background as evenly as you can at first. It is true that useful variety can be got by painting it with a little movement in the tone. But at first do not trouble about this. You must learn how to control the paint that comes off your brush by painting a perfectly even tone at first. You will probably find that you get your brush too full of paint, and that it collects at the top near the handle in a very annoying manner. Notice how the house-painter only dips the tip of his brush in the paint and do likewise. Too much paint on the brush makes it difficult to control your touch. Paint up to the line of the commencement of the shadows and well up to the edge of the masses of the head. Avoid painting in parallel streaks, and in the case of a background, it is as well to let your brushwork be in every direction. Form emphasis can be given by the direction of a brush stroke, as by the lines of shading in a drawing; lines down the form emphasising toughness, across the form softness, and in every direction mystery and atmosphere.

ELEMENTARY TONE EXERCISES

After the background, paint the ground. This was slightly lighter than the background, a difference that hardly shows in our illustration.

Now paint the general tone of the shadow thrown by the head upon ground and background, and also the shadow on the left hand side thrown by an object not in the picture. You may find that there is some variety in the tone of these shadows ; but at first ignore this and paint the general average of tone that may be found by half closing your eyes. The varieties can be painted into this afterwards. Having laid these tones in a perfectly even manner, completely covering the canvas but not anywhere heavily loaded, turn your attention to the edges where the shadows come against the ground and background. These should be carefully studied and painted as completely as you can. In these early stages *keep your tones as simple and empty as possible, but not your edges*. These should be completed with all their variety and shape. Note particularly where they are lost, as on the right where the shadow comes against the nose, and where sharper, as in the upper edge of the shadow on the extreme left. Now lay in the base with a simple flat tone of pure raw umber, noting particularly the shape of its silhouette, and where lost and where accented, etc.

At this point your real difficulty commences, how to see the head in a simple statement of tones. What details to ignore and what to put in, is a very difficult thing to decide at first. Half closing the eyes will be an aid here. Leave out the details and reduce it to as large and simple statement as you can. In objects you can generally divide the tones into three, the lights,

the half tones, and the shadows ; but the half tones
are a part of the lights, the main division being between
the lights and shadows. There will of course be much
individual variety in each of these three divisions.
But ignoring this, paint the general middle tone of
lights, the half tones, and the shadows in perfectly
flat tones. And be very careful to note their tone rela-
tions, that you get them the right degree of lightness
or darkness. In judging the degree of darkness to
make the shadow down the front of the horse's head,
do not look at its relation with the light mass. The
glare of light on this will be apt to make you think it
is darker than it is. Judge its degree by comparison
with your darkest dark on the base. This is an im-
portant rule to observe. If you judge the darks from
the light end of the scale you will be apt to get your
shadows too dark, and to arrive at your limit of dark
paint much too soon. There is a force and brilliancy
in nature's lights that are apt to make most shadows
look black by contrast. Judge your tone relations
from the dark end of the scale. Note that I have
taken the shadow thrown by the head on the back-
ground round the nose, right up to the half tone.
That is right over the edge of the nose in shadow,
which edge we may entirely ignore in this early stage.
If you half close your eyes you will find that this
entirely disappears. It is not the edges of the object
but the edges of the tone masses that make up the
visual impression, that you are painting. Shadow
details such as this can be put in afterwards.

And now for the edges. Here is the most difficult
part of your task. At this early stage these should be

as carefully finished as you can make them. With large simple tones you have nothing in the way of the free swing of your brush down the edges. Their shape and quality, their lost-and-found-ness, should be very carefully studied. Work with as large a brush as possible. A flattish brush without very sharp corners and not too short is the best. With such a brush, of about $\frac{5}{8}$ of an inch wide, you have a fairly large brush for painting surfaces, if you use the wide side of it, and also a small brush, if you turn it edgewise and use the narrow side of it. And it is sometimes useful to commence a touch with the narrow side, to get into some corner, and then open out to a wider touch, as one may do by turning it over as one proceeds with the stroke.

After using charcoal or pencil you will find at first, that you want to hold the brush too low down near the metal holder. Hold it as far up the handle as you can manage; by this means you have a much more delicate control over it. Holding it low down you can only make a very short stroke with the movements of your fingers, and a rather stupid stiff touch it gives. But the same movements of the fingers when the brush is held high up, will give you a great sweep of the brush and a touch of much more lightness and delicacy.

Notice the edges of the light mass of the head against the background on the left. Here the background has been painted well up to the edge, and it is to be hoped without any ridges of paint. A loose edge, not painted down the contour but rather loosely across it, is the best sort of edge to leave where the background cuts an object; and never one of thick paint with

ridges. Any thick painting is better on the side of the object, not the background; if it is on the background side it would effectively prevent it from having any atmosphere or going behind. This edge of the light mass on the left is a prominent one all the way down, on account of the contrast of the light mass with the background being fairly sudden. But towards the top it is slightly darker, and so is not so pronounced as lower down. The variations of tone on all the edges should be carefully painted and finished as far as possible.

If this is done and your tones are the right shape, the details in the lights and shadows can be painted with facility. If the edge against the cheek-bone, for instance, is found not to be in the right place after all the detail of the mouth has been put in, it will be much more difficult to shift, than when no detail is there to get in the way of the free sweep of the brush. Or take the eyes ; if the little dark accent that gives the shape of the eye, had been put in early, as most students would want to do, how difficult it would have been to model the globular form of the mass of the eyes with this little dark accent to be dodged and worked round all the time. This is one of the very last touches to be put in, but it is one of the very first the average student wants to go for. If after such a little dark accent has been put in it is found that there is something wrong with the modelling of the mass of the eye, the best thing to do is to take it out with the palette knife, and return to the earlier stage that was not properly done. A certain amount of delicate correction can be done to the bigger modelling after the details are put in, but generally speaking, it pays

to boldly scrape out what is wrong and begin and build it up in orderly stages from the start. The little forms fit into the big forms. The big forms are not to be engineered round the little forms. You proceed very much in the same way as a stone carver would work if he were carving the head. He would first cut the big main masses in square planes and afterwards add the small planes and refinements.

If this stage has been properly completed, all is ready for putting in the smaller planes, that give the details of the modelling. This middle tone of the lights, half tones, and shadows that you have, is ready for you to paint the lighter and darker tones into, of which these details are made up. And this is much easier to do than the earlier stage you have already completed. In this early stage everything has to be the result of a careful analysis, that requires a good deal of mental effort for some time. But the final work is what is much more obvious, and is what you have been holding back from for some time. At every touch, check the tone you are using by a reference to the whole effect. If it jumps out of its place it is wrong. The details of modelling must all be subordinated to the large general impression, and carefully considered values will alone give this unity of effect.

A thing to be guarded against, is the tendency of the paint to come off your brush in a variegated, not a clear flat tone. There are times later on when this habit of paint may be made use of, when you are skilful enough to control it. But the first control you want to acquire, is that of getting the paint to come off your brush in an even tone. The quality of your canvas

will have something to do with this. It is difficult, on the slippery soapy surface so many canvases have, to avoid this, particularly in painting over an already painted ground. This is where the quality of " tooth " in a good canvas comes in useful; the paint is picked off the brush evenly instead of only occasionally, with a sliding quality in between. See that the paint is quite evenly mixed on your brush, and that there are no light or dark streaks in it not properly mixed. Just the right quantity of paint in the brush, is also a consideration that helps the even quality of your touch. Experience alone can give you this. Always use the largest brush that will do what you want; more variety of touch can be got with it than with a small brush.

I have dwelt at some length on this elementary exercise, as it really contains lessons that if properly learnt, will put the student well in advance along the road to become a painter. The principles here applied to a cast can be used on any subject. Everything can be reduced to an arrangement of large simple masses, into which are fitted smaller and smaller masses, until the complete result is arrived at. And the same principle of keeping the tones as flat as possible, and avoiding gradated modelling applies to the early stages of any painting ; putting all the chief work at this stage into the. edges. The disposition of these simple masses gives you all the main features of your design, and if their edges are carefully wrought you are well on the way with your modelling.

This manner of building up your effect on a carefully laid foundation of middle tones, is one that many

painters have used; and there is a striking example of this earlier stage of the work still to be seen in the picture hanging on the wall in Vermeer's " Girl sitting at the Virginal " in the National Gallery, that I have had reproduced separately (Plate 18).

Here you see a painting by Vermeer in its earlier stage. The focus not being on this part of the picture, it was not necessary to carry it further, and there it remains as a useful painting lesson.

All the other parts of the picture now completed were, at an earlier stage in the course of the work, in a similar state. Notice how he has designed it in simplified masses of tones, and how separate and distinct he has kept them, and how he has emphasised the character of the edges by keeping them as far as possible in square shapes.

I am citing Vermeer as an example as he was such a perfect craftsman, and it is craftsmanship that we are talking about; as it is all that can be taught. And because his manner is one that can embrace the whole of visual phenomena as we now know it; and because he is a master of the particular method of painting, I am recommending as a means of study. But much as I love him, it must not be assumed that I am placing him before all other painters. Very perfect craftsmanship is the ideal to set before the student of painting, but it is a thing one does not always associate with the very highest flights of genius. Perfect manners of expression often have to be sacrificed in the heat of very animated work. But although Vermeer does not touch the highest notes that can be reached by the art of painting, he is a very fine artist, and one that the young craftsman can study with great advantage.

After casts, objects of differing tones should be arranged, but it is as well for a bit to avoid objects with much colour.

The group (see illustration, Plates 19 and 20) of a wine bottle and two saucepans, one of aluminium, with a piece of drapery hanging at the side on a white paper ground and background, can be arranged by anybody. Here you proceed in exactly the same way to reduce the subject to as simple a number of tone planes as you can. The degrees of tone are a little more difficult to judge, as the objects vary in quality; some being shiny and some dull, some dark and some light. But these differences of texture and quality, must all be ignored and the whole group considered as one thing; as one arrangement of tone masses of varying shapes and degrees of light and darkness.

You will probably need a word of advice as to painting the shiny lights on the bottle and saucepan lid. Such glittering lights need to be painted very deftly; just lightly flicked on from a well-loaded brush of not too thin paint. It is generally rather difficult to get this quality, and at the same time make your touch the exact shape you need it to be. The quality of lightness of touch on which the sparkle so much depends, is of more importance than the exact shape. You can trim up the-shape afterwards, if you have made sure of getting it big enough with your deft touch, by cutting it off with the surrounding tone. This surrounding tone does not need such deft handling, and can be painted quietly, when more precision of shape can be got. But, generally speaking, it is always best to put your paint on as lightly and deftly as you can, touching

PLATE 19

MONOCHROME EXERCISE OF OBJECTS WITHOUT MUCH
COLOUR BUT OF DIFFERENT TEXTURE

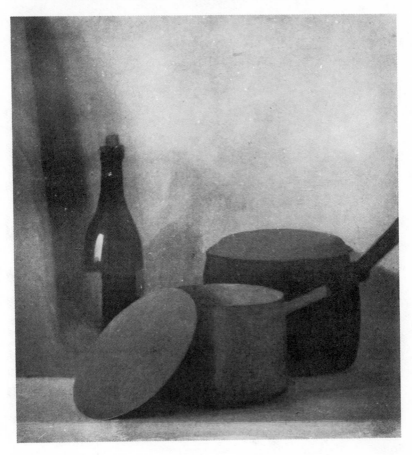

STAGE I
Simple blocking in of the masses in middle tones

PLATE 20

MONOCHROME EXERCISE OF OBJECTS WITHOUT MUCH
COLOUR BUT OF DIFFERENT TEXTURE

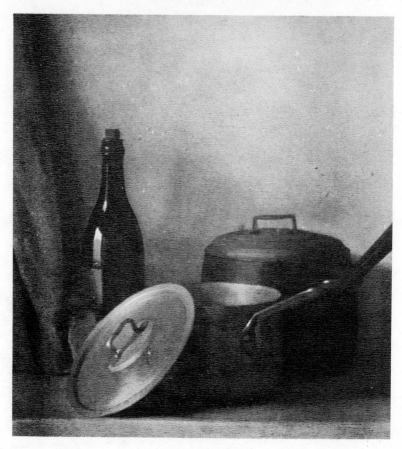

STAGE II
Lights and darks painted into middle tones, finishing the work

it as seldom as possible. Many students keep on patting away with their brush when they don't know what to do next, in the hope, I suppose, that something will turn up. It won't, but all the life and beauty in your paint will be destroyed. Do far less with your brush, and much more with your head at first. In these initial exercises you will not be able to let yourself go and trust your instincts. You are like a raw recruit handling a rifle for the first time on parade. It needs a deal of thinking about. Afterwards, at the word of command, the action becomes almost automatic. And so with handling your brush, and setting out your subject in simple masses ; at first this is a laborious process, requiring much thought at every stage, but after a time such elementary matters take very little of your mental attention, which is free to concentrate on higher things. But do not despise these early exercises, they are much more important than is usually thought. Much of the messy painting, and crude ugly handling one sees in these days, can be traced to the neglect of such simple monochrome exercises. Students are apt to rush into painting with a full palette of colours, and absolutely no preliminary experience in handling paint whatsoever ; with naturally the most appalling results. Don't be in a hurry to do complete work, be content to stick at the early stages of laying things in with simple broad masses, until you have mastered this important preliminary painting. Your drawing exercises which you will be carrying on simultaneously will be training your appreciation of the subtleties of detail. So be content for a time to concentrate on developing a perception of visual phenomena in terms of simple tone masses.

OIL PAINTING

By this time the student will be getting very tired of monochrome and the desire to attempt colour will be getting irresistible. If it is very violent and insistent, let yourself go in such an exercise as is described later in the chapter on Colour (practical). But to continue our progressive studies, a still-life group in colour should be attempted next. Continue to rely more on tone values than on positive colour for your chief interest. Work on the same plan of laying in simple planes of the general colour of the parts and afterwards break into them the varieties of colour and tone. Remember that the general tone already painted, into which these varieties are afterwards put, will modify their hue. So that they can be painted with purer colour than you will want.

There is nothing like still-life for studying different methods of painting, and trying experiments in different techniques. The form is much less exacting than in painting from the life, and the effect remains constant; which it does not when working from the life or making landscape studies direct from nature. You can therefore study your subject much more closely and thoroughly. A great deal of distinction and individuality can be got into the arrangement of your group, and the placing of it on the canvas; and this should always be done with great care. The method of solid painting into a first lay-in of middle tones, that we have been describing, is undoubtedly one that a great deal of beautiful work can be done with. But in the matter of colour it has distinct disadvantages. Particularly if the distinction given by a simple palette, chiefly of earth colours, is aimed at. When these

94

simple colours are used, their range is very much extended if a mixture of transparent and solid colours are used together. And if some method of this sort is not adopted, a much larger range of solid colours will have to be used to get the full colour effects. All colours used transparently, that is, so thinly that they show a light ground through them, are warmer and richer in colour than when white is mixed with them to lighten them. And if this quality of transparent colour is not used, and the effect has to be got by solid paint, additional bright colours will be needed to give this extended range in solid painting. But still-life groups and flowers, are the subjects one should adopt for trying all manner of experiments with these different qualities of painting.

Another method of painting with solid colour, that avoids the sullying effect of painting into a middle tone and preserves more purity in the colour, is what may be called the mosaic method. Looking upon your subject as a pattern of colour spots and masses, proceed to match them on your palette, putting them on dab by dab as directly as possible. The spottiness of the effect need not remain if the study is carried far enough, as other dabs can be put uniting the spots and bringing the work into a unity. In effects where the colours and values are very complicated, such as a group of some sort arranged in front of a window and seen against the light, such a method is more suitable than the middle tone one, we have been describing. These effects require the use of much broken colour (see later chapter on Colour, practical) and the method of painting directly dab by dab enables one

to make tones of very varied mixtures. One colour can be dabbed into another, and the process continued until the quality of colour and tone desired has been attained.

Another method that should be tried, is to paint the whole subject in the solidly-painted middle tone method, keeping it on the light side everywhere. This will necessitate more white in the different tones and consequently dull the colour effects. When this is dry, and before working into it, scumble the parts to be worked upon with transparent colour of some hue that will be useful to work into and leave here and there. Then work into this lightly with solid colour. A greatly enhanced colour effect is obtained in this way, the richer colour of the transparent scumble being left in places. And solid colour when painted lightly over a transparent colour is of a more lively quality than it would be alone.

But the different methods of putting on paint to produce different qualities are as numerous as the individual artists. Everyone stumbles upon some methods that suit his particular temperament. And the more advanced student should be encouraged to experiment with all manner of means. But this is getting to the point where our system of training the faculties of observation and expression stops, and leaves the student fully fledged enough to be left alone to forage for himself.

PLATE 21

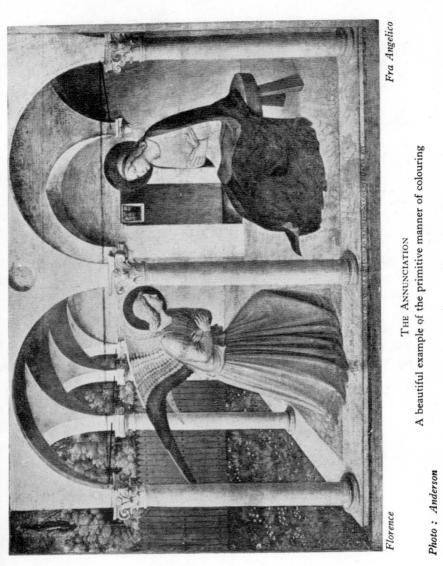

THE ANNUNCIATION

A beautiful example of the primitive manner of colouring

PLATE 22

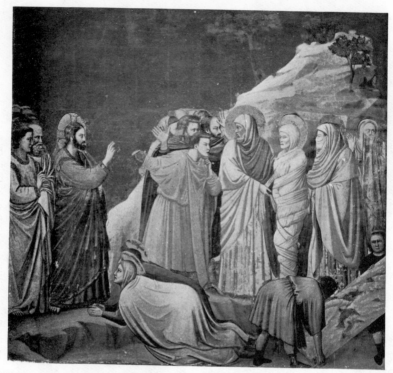

Padua

Giotto

THE RAISING OF LAZARUS

A beautiful example of the primitive manner of colouring

Photo : Alinari

CHAPTER VII

COLOUR

THE history of colouring in the art of painting has yet to be written, and only a tentative sketch can be attempted here. I would suggest that the subject may be roughly divided into three periods, which we may call the *Primitive*, the *Brown School*, and *Impressionist colouring*.

Primitive Colouring : Primitive colouring consists in simply filling in the boundaries of objects and background with their local colour and expressing the internal forms by the introduction of a little shading. And it is surprising what magnificent work has been done with this very simple formula. The colouring in Italian painting right on to Botticelli was in the Primitive manner. A typical example of primitive colouring is the work of Giotto, an example of which is reproduced on the opposite page. There is no serious attempt at light and shade, and objects cast little or no shadows. The purity of the colour masses, is unsullied by the disturbing elements, which the full realisation of the effect of light and shade, would introduce. An intense clarity of expression is possible with this simple formula, and the expressive power of the colour masses, as colour, is undisturbed. In religious paintings, where an atmosphere of other-worldliness is wanted, this simple scheme of colouring is unsurpassed. The fuller realisation of the solidity of objects, that more

97

sophisticated colouring gives, is apt to break the spell, and bring things down to earth. The colouring of the East, of China and Japan, of Persia and India, seldom allows itself to depart from this simple formula. Their preference for colour rather than form as a means of expression, leads them to eschew anything like light and shade that would spoil the purity of their colour masses, and introduce a disturbing sense of bulk. Colour has a music of its own that has its fullest opportunity when considerations of form are subordinated to it. Fra Angelico's " Annunciation " from San Marco, Florence, here reproduced (Plate 21), is another more advanced example of primitive colouring, although unfortunately we cannot reproduce the colour.

For decorative work, when the painting has to take its place as part of an architectural scheme, this primitive formula is still largely used, the flatness of treatment it gives making it conform to the architectural scheme, without the disturbing effect that painting in high relief would produce.

The Brown School : The next division of the subject I have called the Brown School. It commenced with the introduction of chiaroscuro, or light and shade. Beginning with Masaccio, it was more fully developed by Leonardo da Vinci. The discovery of light and shade and the fact that you could paint an object to look round and solid and to stand out, gave great satisfaction, and was almost universally taken up by painters. A few, like Botticelli, refused to have anything to do with it ; feeling instinctively that the particular æsthetic experience they wished to convey, and did convey in

their work, could not be helped but might be considerably interfered with, by the introduction of this new and somewhat disturbing instrument into their orchestra.

However much the introduction of light and shade and the full realisation of relief may have added to the force and vigour of expression possible in painting, there is no doubt that the difficulty of preserving a unity of effect was very much increased. In the Primitive work, where there were no contrasts of light and shade, the artist was free to indulge in contrasts of colour without unduly disturbing the general effect. But as soon as contrasts in light and shade were also introduced, certain restrictions had to be put upon the free use of colour, or the disturbing influence of so many contrasts, would spoil the harmony of the whole. There seems to be a limit to the amount of contrast the eye can stand. The Chinese and Japanese know something of this, and have a habit when they want to contrast two colours strongly (such as bright red and bright green), of making them both the same tone. That is to say, neither of the two colours being lighter or darker than the other. Where there is no contrast in tone it is astonishing what violent contrasts of colour can be indulged in without hurt.

From the introduction of chiaroscuro, the practice became almost universal, of keeping the colour scheme together with an underlying tone of more or less warm brown. In the eighteenth century this was held to be a rule, and Reynolds, in his discourses, frankly states it as a principle that all the shadows should be the same brown colour, so as to allow freedom for colour variety

in the lights. This common denominator running through all the picture, certainly made it easy to keep the colour scheme together.

There was another thing which led to the adoption of this universal colour for shadows. As I have already explained, the outline idea which is so universal in Primitive art, is not so much the result of the visual perception as the touch perception. It is an attempt to represent in visual form the idea of a boundary in space that the touch sense teaches us to associate with every object. Light and shade was conceived of as something, as it were, stuck on the surface of this outline-bounded form. It was not associated with colour but only with modelling conceived as different degrees of tone from light to dark. It was natural, therefore, when light and shade was added to the outline conception of visual appearances, that it should be added of a universal hue ; the idea of associating changes of light and shade with changes of colour not yet having occurred. And in the same way that colour, in Primitive work, was added after the outline was done, so now colour was added after the outline, and light and shade, had been considered. Visual phenomena were considered as a monochrome of outline, and light and shade, to which colour was applied ; as it were stuck on the surface of form. It was not until the science of the nineteenth century produced the impressionist point of view, of considering all visual phenomena for what they are as colour sensations striking the retina, that the brown school with its universal shadow colour was dethroned.

The great advances that were made in the search for visual truth along the lines of the Brown School,

brought the work of many of the masters very near to the full realisation of visual phenomena; at any rate in its more ordinary aspects. Masters like Velasquez and Vermeer of Delft have little to learn from any later schools about the restricted effects of light they painted.

But it was in the matter of tone, rather than the domain of colour, that they arrived at the full visual impression. And although Vermeer may be said to have freed himself from the thraldom of the Brown School in his delightful cool schemes, the colour is so much under the beautifying influence of tone values, that it can only be called a very tentative arrival at the full visual impression, as far as colour is concerned.

And although Velasquez arrived at the full visual impression as far as tone is concerned, and carried it to a more wonderful degree than any other painter, and although he introduced a new unifying element in design, by subordinating his edges to the impression of one wide, all-embracing visual focus, it was not the instrument of colour that he used so much as that of tone. By largely substituting black for brown, he brought the general colour effect of his pictures nearer the silvery effect of nature's colouring; but did not entirely free himself from the thraldom of a universal shadow colour; and nowhere did he launch out with much enterprise in the matter of colour. Velasquez was an impressionist as far as tone was concerned, because he observed things as a visual impression in terms of light. Instead of observing objects (in his latest manner), he concentrated his attention on their visual appearance; and to a large extent freed himself from the

obsession of the tactile sense that had for so long been the dominating consideration. In consequence of this, his pictures have a visual unity that puts them in a class apart from his contemporaries.

After saturating yourself with his pictures in the Prado, those in the other rooms look patchy and hard. For the effect of this all-embracing unity of visual observation, was to melt the edges to a large extent, and you look in vain for anything like a continuous sharp edge. An occasional sharp accent is all he allows himself. Notice the edge of the shoulder of the recumbent figure in his so-called " Venus" in the National Gallery (Plate 23). This is in strong light against a dark background ; but even here he has resisted the temptation to make a sharp edge, as it would have broken the continuity of the visual ensemble that is diffused over the whole picture. A sharp edge always holds the eye. Not that his edges are not quite firm and full of structural design ; but they are never realised as the sudden boundaries of felt forms, in the way they were in his earlier work ; but are observed in relation to a large all-embracing vision that considers object and background as one thing, one visual impression. Velasquez had a fine sense of form and modelling ; but I should prefer Rubens if I had to model in the round from the work of either, as he is hard on the surface of the form all along, whereas Velasquez's form is seen through a veil of atmosphere.

Do not let it be assumed that there is anything derogatory to a master, in the fact that his work was done with a restricted amount of visual knowledge ; that he has not used all the instruments of the visual

PLATE 23

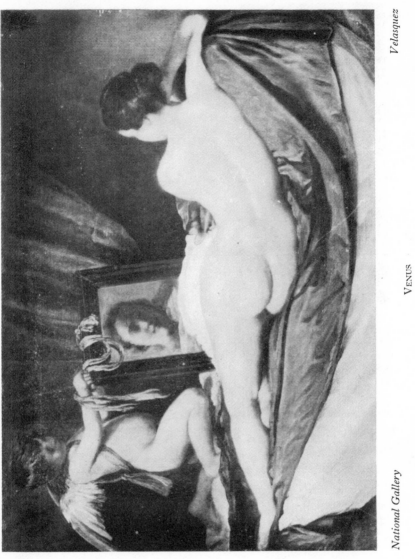

PLATE 24

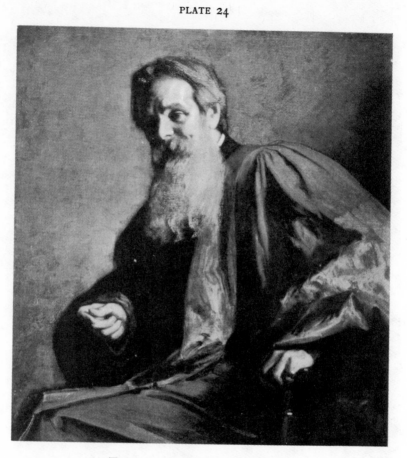

THE LATE W. HOLMAN-HUNT, O.M.

The draperies painted upon wet white

orchestra. This power of representing the appearance of objects has always been the popular quality in a work of art. But it is very much overrated. The music is more important than the instruments. And in the same way that you do not judge the quality of the work of a musician by the number of instruments he uses in the orchestra, so you do not judge the work of a painter by the amount of visual fact he makes use of in his pictures. And in the same way that the instruments now at the disposal of the musician are so complete, that the illusion of natural sounds can be given (as instance the sheep baa-ing in " Don Quixote," by Richard Strauss), so in painting, there is now little difficulty in rendering the illusion of natural phenomena. But this does not mean great art. On the contrary, such complexity of orchestration as is now possible, both in music and painting, is apt to be against the production of those qualities of simplicity and clarity, that we associate with all really great things. But this is a technical book, and therefore more concerned with the instruments of expression, where teaching is possible, than with the music they are capable of creating, where teaching is of little avail.

In the past the history of art has largely been concerned with noting the gradual addition of this visual knowledge to the primitive outline formula, which is usually the first instrument the early artist uses. The real matter of art, the rhythmic visual music that results, has been neglected in art criticism ; and it is no doubt a very illusive thing to write about, like all experiences.

OIL PAINTING

The interest in the full realisation of the roundness and solidity of form that took possession of Western painting after Leonardo da Vinci, naturally rather drove art indoors, as it is only there, or in a courtyard lit at the top, that you get the kind of light that gives these strong light and shade effects so much in fashion. But this did not mean that the artists neglected out-of-door subjects. However, determined to have the best of two worlds, they set out with an audacity one can now only envy, to place figures strongly lit, and modelled in a palpable indoor lighting, against outdoor backgrounds of every description. In the wide lighting that you usually get out-of-doors, these strong effects of light and shade are impossible; and it is amazing with what skill they justified such flagrant departure from visual truth.

From the sixteenth right through the seventeenth and eighteenth centuries this convention held; the common denominator of brown helping greatly to unite these landscape backgrounds with the interiorly-lit figures. And a magnificent instrument they made of this convention; the figures being presented in a full rich scheme of modelling with large simple lights and rich shadows that ennobled the meanest subjects.

Velasquez is well on the border line that divides the Brown School from the next development in visual discovery, the impressionist vision. He was very uncomfortable at introducing outdoor backgrounds with indoor lighting, and was evidently well aware of the incongruity. The figure subjects he used outdoor backgrounds with usually being painted with the light of a low studio window shining directly at the figure,

giving no shadows; and not, as with Reynolds and the eighteenth-century portrait painters in England, from a subject lit by a high side light, thus showing distinct and sharply-cut shadows from a studio window. And some of Velasquez's portraits look as if they were actually painted out-of-doors.

Impressionist Colour : With the Impressionist movement, the whole facts of vision were for the first time recognised. Most people flatter themselves with the mistaken idea that the possession of two healthy sound eyes, endows them with the power of sight. Animals possess sound healthy eyes, but it is doubtful if they see much ; smell seems to be the sense that gives more knowledge of outside phenomena than sight. I remember once testing the power of sight mice have, in a studio I had, for which they were very partial. Seeing one come in at the far end of the room, I stood quite still in the centre of the floor under the big window in full view. There were crumbs on the floor, as I had been using bread on a charcoal drawing. The little stranger came right in, picking up crumbs, and continued right up to where I was standing, even walking between my legs. It was not until I moved that he noticed me and scampered away. The only thing that mattered as far as his survival was concerned was movement, and that his eyes saw immediately. And humanity has developed the perceptions of the eye only so far as they ministered to their survival. And these perceptions are much more connected with touch, than with the symphony of prismatic colours that the light entering the eyes displays on the retina. The perception of this retina

picture as colour sensations, has come very late in the history of the race, and it is the foundation of what we call the impressionist movement. Nobody would survive for a day if he had not the power of associating sight with touch. This is why we put bars across the nursery door to keep the child crawling on the floor (who has not yet acquired this power) from falling downstairs. Its eyes have not yet learned to perceive the difference in appearance between the solid landing and the space that takes its place as the stairs commence. It would attempt to crawl on the one as readily as the other, and many of our early troubles are concerned with acquiring this knowledge in the hard school of experience. This perception of touch, of the solidity of things and their felt shape, soon becomes the all-absorbing concern of sight. Even colour is thought of as connected with the surface of objects. An object is examined at close range to see what colour it is, and ever after when that object is seen, no matter what aspect of light it may be in, or what distance it may be from the eye, it is thought to be that same colour.

We know that white light is compounded of all the colours of the rainbow, the rainbow being, of course, sunlight split up into its component parts. And that when white light strikes what we call a red object, the red pigment has the power of absorbing all the rays of colour in the light *except* the red, which it rejects, and thus allows it to come to the eye. So that red is the colour least associated with the surface of the red object; it is the colour it rejects, and for this very reason we see it as red. And, moreover, these rejected rays in passing through the atmosphere may,

and generally do, undergo modifications; so that by the time they reach the retina they may be very different from what they were when reflected from the surface of the object.

This dissociation of colour from objects, and the concentration of the attention upon the retina picture, has placed us in possession of an entirely new vision. It seemed no longer necessary to build up a picture by a laborious study of outlines of the solid forms, filled in with light and shade, local colour, aerial perspective, etc., the visual picture could be studied directly for what it is—variegated rays of the solar spectrum passing through a point behind the lens of the eye and caught by the retina. If pigment can be so manipulated upon a painted surface as to reflect back light to the eye of similar quantities, the illusion of appearance is produced. And this is very much what the extreme impressionists, of whom Claude Monet is the type, in reality did. Instead of a carefully drawn outline filled in with colours, the whole subject before the artist (and they always worked direct from nature) was considered as colour alone; drawing having only to do with the shapes of the colour masses. The colours of the rainbow, as being the colours that produce nature's effects, were chosen as their palette. The earth colours and blacks were eliminated. The immediate effect of this new way of approaching the representation of nature, was startling in the extreme to eyes accustomed to the older methods of colouring, of men like Ingres. Although two painters years before, and both Englishmen, had stumbled, in their independent search for visual truth, upon very much the same

formula. I refer to Constable, and Turner in his later work. There is a picture by Constable in the National Gallery, No. 1272, the " Cenotaph," that might almost be an early Claude Monet. There is the same broken colour used to give the scintillation of light on foliage and leaf-strewn ground. And in his last works Turner adopted prismatic colours put on as pure as possible to get effects of light. Not side by side and left to blend as they come to the eye, as has been the method adopted by many impressionists, but painted thinly one over the other. The interesting series of unfinished pictures recently unearthed and now hung at the Tate Gallery, by Turner, show his method. Most of them are just laid on with the purest colours. A sunrise will be pure lemon-yellow and white, a cow in the middle distance of one picture is pure cobalt blue. Over these early stages, when dry, he would work other pure colours thinly, so that they mixed one through another ; but the result approximates very much to the impressionist formula, except that with Turner, his magnificent sense of form never deserted him, and gives to his arrangements a lyric splendour that places them on a different plane.

The weak point, as it seems to me, in the impressionists' theory of colouring carried to its extreme, is that although it may be quite true that the phenomena of nature are perceived by different degrees of the rainbow colours contained in the light that strikes the retina, that is no reason for eliminating black and most of the earth colours. For surely the earth colour must reflect the prismatic colour obtained from the white light they receive, like any other pigment. Despite the

fact that they are somewhat composite in hue, and not recognisable as any single colour of the spectrum, like the brighter pigments may be, there is a dignity in earth colours that is apt to be sadly missed when they are eliminated from the palette. And there is some considerable danger of that nasty acid, fruit salad sort of colouring turning up, as in some of the worst impressionist pictures. And there is another point with regard to the elimination of black. Although it is perfectly true there is no black in the solar spectrum, visual phenomena are not entirely made up of light. There is the negation of light—darkness. There are places where the light does not fall, although there is probably no shadow so deep that some light is not reflected. But objects receive light in different degrees, and black as a pigment has a power of lowering the intensity of a colour without much changing its hue, such as no other pigment possesses. These omissions on the palette rob most of the impressionist pictures of much of the dignity associated with really fine colouring.

But the impressionist point of view has given a tremendous impetus to colouring. It has opened up a new field for the use of colour as lyric expression. Tied to the light and shade formula, it has had a long period of servitude. Much of the freedom enjoyed by the Primitive colourists has been regained Freed from the trammels of the Brown formula, colour can now extend from one end of the picture to the other. Leaving the stuffiness of the studio with all the sullying effect upon its hues of light and shade, colour can now come out into the wide light of the open air

with very little shading to interfere with its purity. Something in the nature of a return to the large primitive simplicity of colouring is now possible, with the added quality that the subtle refinements of perception we now have gives us, which the primitives had not. Particularly with regard to the edges, which are nearly always hard and of uniform quality in Primitive work. Whereas the impressionist point of view has opened up quite a new range of beauty in the varied treatment of edges. The possibilities opened up for the treatment of colour in pure flat masses, without any return to primitivism, by this open-air impressionist colouring have not yet been fully grasped; the movement having been more concerned with the realisation of the illusion of light and air, than the use of visual facts for the purpose of fine expressive pictorial design. And the particular broken colour and spotty treatment adopted was more useful in suggesting luminous atmosphere than fine design. Such treatment carried all over a picture, does not give any fine mass of colour a chance of giving you its full sustained note.

CHAPTER VIII

COLOUR, PRACTICAL

IN order to draw aside the veil that obscures one's perception of colour in nature, it is necessary to strip from the mind, for the time being, all other associations that appearances set up, and consider them solely as colour. Throwing the eye out of focus helps this; not by half closing the eyes as one did when observing tone relationships, but by dilating the pupils of the eye. By half closing them, colour is very much muted; but by throwing the eyes out of focus and observing a large field of vision by dilating the pupil, colour is intensified. Our early habit of associating the look of an object with its felt shape, has accustomed us, as it were, to label each object with the particular colour it would appear if its surface were examined when close. We say this is a yellow straw hat and has a pink feather. And whenever we catch sight of that hat, under whatever aspect of light it may be seen, we are immediately reminded of our close view of it, and the colour we have associated with its surface, and say I know that hat is yellow and its feather pink. The idea of observing the colour as we see it, say, in the warm glow of the setting sun with orange lights and blue shadows, never enters the mind of the average person; the subject of its colour having been settled once for all, when it was examined close to in an ordinary light. All such ideas must be dismissed from the mind, and you must approach

nature with no previous knowledge, and a perfectly open mind, keenly on the look out for colour sensations. This is not an easy matter at first, the habit of object-seeing, and label-reading, is very firmly set, and takes some shifting; and the perception of colour in nature demands a complete detachment from all other associations and ideas but the one of colour. It is difficult at first, to realise how full of colour shadows can be. We have a vague idea that it is only in light that the colours of objects can be seen, and that shadows must naturally add degrees of blackness. Coué yourself out of this idea and say : " What is the Colour ! Colour ! Colour ! " In quietly lit effects, colour can be seen more or less in a pattern of tinted masses. But even here you will find you cannot match the colour with your paints, as you could match the colour from a book of samples of washable distemper. Absolute dead level colouring is seldom seen in nature. There is movement, the play of several colours together; often to be perceived in the quietest effects. But when you turn to sunlight and try and observe the joyous song of colour that goes on, no distemper-matching methods of colouring will be of much use. As I write this, I am sitting before a window opening into a garden with the sun streaming in. It has been raining and all the leaves are wet and glittering, and the colour has that burnished, freshly varnished look that one only gets after rain. Now, the sun has gone in for a moment, and the colour is muted and grey by contrast. Again it is out, and a tremendous impression of colour is produced; although nowhere, except perhaps on the lawn, is there a place where one can fix on any definite

colour. The sun is almost directly in front of the window and streaming through everything glittering wet. But although there is only one place that you can definitely see as a colour mass, the whole effect unmistakably vibrates with scintillating colour. The old masters would have said it was unpaintable; no primitive, colour filling in outlines formula, would be of any use; and no brown school scheme could come anywhere near the sensation. It is to the impressionists, that we owe the secret of painting the delightful visual colour music, such an aspect produces. They were the first to strip the mind of all other associations, and observe the picture on the retina as colour alone. Seeing that colour is a property of light, and that the sun's rays contain all the colours of the rainbow, they realised that all the light that enters the eye reflected from the visible world, must be an arrangement of these solar spectrum colours. Once having got rid of the idea of colour as something associated with objects, and concentrating their attention upon the prismatically coloured light itself, a new view of phenomenon was opened up. The visual world was seen to be colour from end to end. Looked at in this way, our scintillating sunny window is no longer unpaintable. The impression is but the result of a certain arrangement of the colour rays, of which light is composed, striking the retina of the eye. The paints we use have the property of breaking up white light into different proportions of the colour rays of which it is composed, according to the nature (or colour, as we say) of the particular paint used. And we have a whole range of such paints, sufficient to reflect practically any variety

of the solar spectrum that can happen. And after all, seeing that the painter works with the very same light, to get his effect, that nature uses to get hers, the illusion side of painting is not so wonderful and mysterious as people usually think. There is mystery in art, but it is not here. The only difference is, that in the case of nature, the light is reflected from the objective world modified by passing through the atmosphere; whereas in the case of a painting, the light is reflected from the pigments of which it is composed. But in both cases it is the same colour rays that enter the retina and create the impression; rays got from identically the same light. So that if you only give a picture enough light, there is practically no aspect of nature, paint is incapable of reproducing.

A general brightening up of the palette was the result of this point of view. As light is composed of all the colours of the rainbow, and as all visible phenomena are the result of these colours, they said our palette shall be composed of such rainbow colours. There is no doubt that a wonderful new instrument had been added to the orchestra with which the painter composes. The painting of sunlight, and all the emotional stimulus this is capable of producing, was now an effect within the capacity of the painter to use. But at first the novelty and beauty of these paintings of light, was sufficiently interesting in itself, for nothing further to be asked of the painters than to play solos on their new instrument. The old instruments of form and design, that had yielded such wonderful things in the past, were neglected. And even the new instrument of vibrating light, was not used by the extreme

impressionist painters for anything but expressing the more superficial aspect of things. But the point of view was so new, and so fresh, that it was sufficient for the creation of some wonderful canvases; even if they did not strike a very deep note.

An entirely new method of painting was evolved from the new point of view. Outlines of objects had little or no meaning, all was one expanse of colour sensations; and the problem was to put paint on the canvas in such a way, that it would reflect back light of the same quality as nature.

Even to an ordinary eye it is, I think, obvious that when sunlight is seen in very strong quantities, its component prismatic colours can be observed. If you look at the sun itself, prismatic colours can be seen in the halo of light that radiates from it. Or, better still, look at its reflection on water, as it may be seen at any south coast watering place in the morning. You will observe a dancing mass of light upon the water, gradating from a white glare in the centre to more or less prismatic colours at the edges. Or look at the sun glittering on a wet leaf, and I think prismatic colours will be noticed by most people, if they are on the look out for them. This effect of prismatic colouring that most people only observe occasionally, in very brilliant lights, the sensitive eye of the impressionist painter, can observe in the glare of sunlight on ordinary objects. Indeed, without some such breaking up of light, such effects of glaring light cannot be painted with any degree of actuality. This breaking up of light into its prismatic colours by means of broken colour, which was adopted all over the picture, was

the remarkable technical change the impressionists introduced into the handling of paint. The paint was put on in small crisp dabs, one bright colour being broken against another, the colour rays from which blended as they came to the eye. This idea degenerated later into mechanically painted dots of pure colour; but in the work of the group of painters of which Claude Monet was the centre, there was nothing mechanical in the handling. An infinite variety of means were devised whereby the paint was brushed on to produce exactly the impression of light demanded. Some of Claude Monet's handling, giving the impression of moving water, is wonderful; as is also his method of suggesting the flutter of leaves in sunlit trees. His work should be studied by the student in order to see what can be done with paint in the representation of the vitality of light. I have been told by those who have seen Claude Monet at work, that he will begin on a clean white canvas and put down a dab of blue, where his principal blue note is. And then a dab of, say, yellow where his chief yellow note is, and so on; building up the colour arrangement from certain dominant notes, putting on more and more dabs until the whole canvas was more or less covered by the gradual filling up of the spaces between the dabs. By keeping his touches separate from each other, an extreme freshness of handling was got; and he avoided those muddy mixtures that come by two colours mixing with each other on the canvas, and producing a neutral colour that was not intended. At a second painting, when the first painting was dry, the spaces between the first dabs could be filled in

with other colours, and could be broken over the first work, without mixing and producing mud.

Every student should try this method of painting in order to learn what can be done by it in the painting of light.

A movement of colour in the tones, such as the impressionists developed to such an extent, is necessary in all vital colouring; and has always existed even from the days of the tempera painters. They painted one colour thinly over another repeatedly, thereby getting a play of two colours. Their flesh was usually painted in terra vert in the first instance, the pinks and ochres being thinly painted upon it afterwards. There is evidence that Vermeer of Delft used this method. In " The Lady at the Virginal " already referred to, the terra vert underpainting shows through in the head of the girl very strongly. The flesh tones that had been thinly painted over this, have been rubbed off, I imagine, in the process of cleaning the picture at some time.

Another method of getting movement is to paint solid colour into transparent; first scumbling the transparent colour all over, and then painting into it, leaving it to show through where necessary. This is a very beautiful way of getting colour movement. It is a method that was much in use all through the long period of the brown school, a transparent brown being the colour painted into; which brown could be left for the shadows. After the first rub-in, before repainting, say, a head, a warm brown would be scumbled thinly all over, and then cool tones to make the half-tones (probably terra vert and white or even blue and white)

painted into it. And into this cool half-tone colour, the reds and yellows of the lights, would be painted thickly or thinly according to whether they were wanted pure, or muted by some admixture with the cool half-tone colour already painted.

The effect of using thin transparent colours, and solid colours, in the same work, greatly enhances the range of your pigments. Every pigment is capable of yielding two distinct hues according to whether it is painted transparently or solidly mixed with white. Try on a clean canvas rubbing on a little Indian red, mixed with varnish, sufficiently thinly to show the white canvas through. You will get a rich crimson colour. Now take the same Indian red and mix a little white with it, and paint it solidly across the thin paint. It will be quite a different colour. Although not all colours will show this difference so markedly, all have this double range, even black. Try ivory black rubbed on thinly and it is a warm brown black. Now mix it with white and paint it solidly across and it will be almost blue in colour. *All colours are made warmer when painted over light grounds transparently*, and *all colours are made colder when mixed with white*. And the more white that is mixed with them, the colder they get. So that reds like Chinese vermilion, or even rose madder, with much white become almost purple. This is the occasion when a colour like Rose Doré is useful, it retains its redness with a much greater amount of white than any other red. The impressionist painters did not use this transparent quality of their paints much, and they have set a fashion for painting solidly all over. But for sheer

beauty of colour, nothing can touch transparent colour. The trouble is it is extremely difficult to use, and requires much deftness in handling ; qualities not much in fashion at the moment. No half tones in flesh are so beautiful as those painted thinly with solid paint over transparent shadows. But they have to be done very deftly and left. Any fumbling would mess up the whole effect.

In taking up one's work for a second painting, on those occasions when we did not quite bring it off in the first, when it is in such an unsatisfactory state to work into, it is often useful to scumble pure colour over, making it all wrong in an interesting way ; instead of nearly right in an uninteresting way as it was left. Some colour that may be interesting to leave on the edges, and will at any rate be useful to give movement and colour variety to the tones we paint into it. It is always as well to do something that will make you have to take up the piece you are going to work upon, all over ; otherwise the temptation to tinker at it, instead of painting, is often too great. Except putting in an accent here and there, you cannot retouch a piece of work that aimed at being finished in the last painting, without having to throw it back again to an earlier stage. Completing any part of a picture is like taking a bad motor-car over a stiff hill. If it fails to manage it, and stops when *nearly* up to the top, it is no good trying to start it again from the point at which it has stopped. You must take it down the hill and have another run up, to get the necessary impetus to go over the top. And it is just the same in painting, your work should be finished hot ; you cannot coldly come and start in

with the finishing touches. At least that is my experience.

Another method of getting colour interest into the tones that compose your work, is to paint one colour into another on the canvas, instead of mixing them together on the palette; breaking one into the other loosely so that the two colours, if looked at with a magnifying glass, would be seen to exist separately; or even be seen separately with the naked eye at a close view. It is necessary to take fresh colour on the brush after each touch, as the brush naturally picks up the colour already on the canvas. This should be wiped off by flicking the brush on your paint rag after each touch. It is a method much exploited by painters who use the solid-all-over manner of painting, but do not care for the violently broken tones of the impressionists. It is usual in this method to lay in the work with solid mixtures made on the palette, and afterwards break into it pure pigment where added force of colour and movement is wanted. In painting into any wet paint, one must always remember that what is already on the canvas will mix with what you are painting into it ; unless the touch is a very thickly painted one, and put on cleanly and left. So that in making one's mixture on the palette this has always to be borne in mind, and the mixture made accordingly. But in these circumstances it is generally better, if freshness and purity of colour are wanted, to paint a pure colour into what is already there, and modify it if necessary by painting another pure colour over it.

Another method of getting the colour movement in one's tones, that is so marked a feature of nature's

colouring, is to take several pure colours in one's brush at the same time, and put them on vigorously. This gives a touch containing variegated colours, which has been used skilfully by many landscape painters of the naturalistic school ; and is one that Rembrandt sometimes used in his latest phase, particularly in some of the portraits of himself. But it is a method that demands too much dexterity to be recommended, and is better left alone for some time. There are, however, many occasions in landscape painting when nature's broken colour effects ask for some such handling.

Extreme purity of colour and richness of effect is obtained by the method of the Pre-Raphaelites. After very carefully drawing their work and entirely completing the design, they thinly covered the piece it was intended to paint with pure white mixed with a little oil copal varnish; just a film which showed the pencil outline through. This was allowed to get slightly tacky, and on it they painted their colour lightly, often with soft sable brushes. Very great dexterity is necessary or the white will be worked up into your colour and destroy its purity. Of course where an admixture of white was wanted, this underpainting of white would be worked up and used instead of adding white on the palette. The effect of this white shining through the colours was to give them great brilliance; an effect something like the colour in a stained-glass window was obtained. The difference between this method of painting and ordinary transparent painting on a dry white ground, is that a much fatter, richer effect was obtained. On a

dry ground transparent painting is apt to look rather thin and poor; whereas the wet white on which the transparent colour was put, gave it the richer look of solid painting. I do not know where the Pre-Raphaelite painters got the idea of this method, but there is, I think, some evidence that Titian used some such method. I remember the late Elihu Vedder telling me in Rome, that he came across an old Italian book giving Titian's methods. He said it was his practice to paint the whole picture in red and black (probably Venetian red) and completely finish the design. After this was very thoroughly dry, he would go over it with a stubbly brush and a little white, using the brush as a stenciller does, stabbing it all over and covering the picture with a thin film of white. On this he painted his colours. Titian's work certainly has this semi-transparent look that such an underpainting might be expected to give. The film was of course so thin that everything could be seen through it. I remember seeing an unfinished picture attributed to Titian in Florence (I think it was), which had been put in with black and red, and where one part was completely finished in full colour; the method evidently being to finish completely piece by piece on this black and red underpainting.

Holman Hunt explained to me the Pre-Raphaelite method when I was painting his portrait, and I thought I would try it on the D.C.L. robes in which he was sitting. I was not painting on the smooth canvas used by the Pre-Raphaelites, but on one with a very sharp tooth. It had been rubbed over with glass-paper before priming to give it this extra tooth I personally

like. This enabled me to paint the whole silhouette of the robes with white, mixed with a little oil copal, of some body, as there was less danger of picking it up when putting on the colour, as in the case of a smoother canvas ; the paint being protected in the interstices of the canvas. On this I found I could paint freely with long-haired hog brushes. In the case of the sheen on the silk facings I picked up this white to lighten and cool the red tones used. But in the case of the dark shadow on the left, very little white was allowed to mix with the colour. The effect of this underpainting of white, was to give a rich translucent effect that was very useful in the darks. And this effect has not gone off with age (the portrait was painted in 1909). Darks painted in the usual way have a tendency to go dull and heavy with time, but this method of painting on wet white certainly does away with the tendency. It is a method to try, as there are times when a picture is getting overworked and stale, when a patch painted in this way, will often revivify the work.

Pure glazing is very much out of fashion in these days, and we seem to have lost the knack of it. The old masters used it abundantly, sometimes too abundantly, as the darkened effect of their work often shows. But very beautiful qualities are to be got in this way. It is essentially a finishing method, and I think perhaps the secret of glazing is that nothing should afterwards be done upon it. There is a bloom about a good glaze that has a very unifying effect upon the work; coupled as it is with the unifying effect of the thin colour it takes over all the picture, or the parts which are glazed. But the quality of a

glaze does not go with that of any solid painting afterwards painted upon it, and is only successful as a final toning of the whole or some of the parts.

Another use of a glaze is to intensify a colour mass. If you glaze a colour over itself, it gives a greater fulness of colour effect than a solidly painted darker tone of the colour would do. It is naturally the thinner and more transparent colours that are most suitable for glazing. But a solid colour like vermilion can at times be used. When the effect is not exactly a true glaze ; the heavy opaque particles of the pigment settle in the interstices of the brushwork of the painting, making a sort of powdering of minute particles of colour. I have found such a treatment improve a somewhat too raw Mediterranean blue sea by slightly warming it. In such cases it is better to use a good deal of volatile medium like turpentine spirit or petroleum with your oil or varnish, which distributes the colour in a thin wash and then largely evaporates. In all glazing remember the darkening effect of all oils and varnishes ; so that whatever oils or varnishes are used should always be diluted with as much turpentine or petroleum as possible. Some oil or varnish, or a mixture of both, is needed to bind the thin film of colour in a glaze ; but the smallest amount that will do this is all that is wanted.

Colour masses can be considerably modified by the treatment of their edges. A colour can be intensified by an edge of the same colour of a darker shade; particularly when the original tone is very light and much mixed with white. But the colour of the surrounding edge must be of a more intense hue. All pigments are not at their most intense as put up in

tubes. Such colours as French blue, viridian, burnt sienna, etc., are more vivid in hue with some white mixed with them. The effect of different coloured edges should be tried with different colours, to see what interesting modifications can be got in this way. This is a faculty of colour the impressionists have much used, putting bright colours round the edges of light masses, and in the shadows surrounding them, that add greatly to the intensity of their colour impression. The little jewels of blue that show through a dark tree, that are so light and yet so blue, can be intensified in this way. I have even seen a blue edge artfully inserted round the edge of hotly painted flesh, so artfully as not to be noticed as colour, but greatly improving the freshness of impression. But the subject of the colour playing around edges is too subtle for one to write about, and I can only recommend the student to study any pictures that are attractive in this respect.

The different manners of applying paint to canvas that I have been trying to enumerate should be illustrated. But the reader will have to do his own illustrations as these things are too subtle for process blocks ; and for those who have not had much experience I give the following instructions.

Get a canvas with a good tooth, size 24 ins. by 20 ins. One that is not a brilliant white is best for judging colours on. One of those dirty-white canvases sold as white will do admirably. Divide it with pencil lines into four-inch squares, by marking off five divisions on the shorter side and six on the longer and drawing lines between them. Taking the five squares

along the top line for red, mix up vermilion and rose madder; which will give you a fairly pure red, pure vermilion being too orange and rose madder too blue. Paint the first two squares from the left and the last (the fifth) with this red mixed with white to about the tone of the red on a penny postage stamp. Leave a space of half an inch all round your square so that the different patches of colour do not mix. Paint them quite solidly and as exactly alike as possible ; don't leave any brushwork showing that will vary the colour. Put aside this mixture of vermilion, rose madder without white, as you will want the exact colour again.

For the next line let us take purple. Mix up some rose madder and cobalt blue and white so as to make a purple, neither too red nor too blue. Paint the last two squares on the line solidly with this mixed with white to the same tone as the red on the top line; putting aside some of the mixture without white as before.

On the next line do the same with the cobalt blue, painting the first two and last squares with the solid colour mixed with white to the same tone as the red and purple.

On the next line, with a mixture of middle chrome or middle cadmium and cobalt blue, paint the last two squares solidly with this green mixture with white. Put aside what has not been mixed with the white.

On the next line take middle chrome mixed with white and paint the first two solidly, but paint the last square with pure middle chrome without white. This will have to be a little lighter in value than the rest, as the chrome is too high in key to be painted so dark.

COLOUR, PRACTICAL

For the last line make an orange colour with middle chrome and vermilion, and paint the last two squares with this mixed with white, putting aside some of the mixture as before.

Returning to the top line again, paint a bright red edge round the first square of red. This should not be so very much darker than the original square, but much more intense in colour. Make it with vermilion and rose madder and a very little white, using rather more vermilion. This is to show you the effect that a stronger coloured edge has on a mass of colour. Do not make this edge too dark or it will not harmonise with the general mass and give the heightened effect of colour, but act by contrast and only make it look lighter.

Paint the two remaining squares on this top line with pure white, mixing with the paint, in the case of the first one, a little oil copal varnish. Leave this to get a little tacky, which it will do in half an hour or so; and then try painting some of the red mixture, you put aside, lightly over this wet white in the manner of the Pre-Raphaelite painters. For this purpose use a thin flat brush, and wipe your brush after each stroke. It will pick up some of the under white after each stroke, which would prevent your getting a clean touch of the pure colour, if you did not wipe it before taking up more. You will find that great dexterity is needed to lay a flat tint. It should be of the same tone as the solidly painted red, and for this purpose it will be necessary to pick up just a little of the white. But do not take up too much, or it will become

similar to the solidly painted squares of red and white mixed together. The remaining white square we must leave to dry hard, as we want it for a pure glaze of red.

On the next line paint the first two squares with pure white, the first with a little oil copal as before. When this first square is tacky, lightly paint over it some of the purple you had put aside, in the same manner as you did the red. In square number three paint rose madder and white of the same tone as the solidly painted purple. Over this, while still wet, paint cobalt blue and white, painting it lightly into it so that a purple is made with the blue and red still to some extent showing separately.

Round the edges of the end square paint a darker purple edge.

On squares three and four of the next line paint pure white as on the top line ; only that you will now use pure cobalt blue instead of the red to paint over the wet white.

On the next line proceed as you did in the case of the purples, except that you use middle chrome and cobalt instead of your purple.

On the next line of squares proceed as you did in the case of the red line, using middle chrome instead of the red.

On the bottom line proceed as you did in the case of the second and fourth lines, with middle chrome and vermilion painted thinly over the wet white, and solidly over each other (painting the red first).

We have now the white squares on each line and the end panels of lines one, three and five to deal with.

But these must be let dry thoroughly before we can proceed with them. When quite dry paint on the red at the top pure cobalt and white mixed to exactly the same tone as the red. Paint this in irregular little dabs, leaving the pure red showing between, so that the whole is covered in such a way that at a little distance, or with your eyes half closed, the red and blue mix and form a purple. For this there should be about as much red as blue showing. You will find a curious effect about this which I cannot explain. As you get back the blue will look much darker, telling as dark spots on the red, while close to they look the same value, or even a little lighter. Seen under artificial light the effect will be stronger still, as cobalt blue looks much darker in this light while the red looks rather lighter. Over the white that is now dry glaze with linseed oil and a little turpentine or petroleum some of the red mixture. This should be the same tone as the solidly painted red. It can be made lighter or darker according to the amount of medium it is put on with, as with water colour.

Now glaze the other white squares, purple, blue, green, yellow, and orange, in the same way; using in each case the same colours as mixed with white made your solid mixtures.

To finish up dab chrome yellow over the blue at the end of line three, and vermilion with white over the yellow at the end of line five, in the same way as you did the blue over the red at the end of the top line. On account of the difference in tone between this chrome and vermilion and the blue and yellow over which they are painted, it will be necessary to

NOTE ON "PORTRAIT OF A YOUNG GIRL" BY VERMEER OF DELFT

This is a beautiful example of Vermeer's perfect manner. Notice the simplification of the modelling and the way he has concentrated the focal attention on the eyes, particularly the one on the right-hand, side. How out of focus the nose and mouth are. Also, notice the same simplification and subordination of smaller forms to the sweep of the larger ones, in the contours, as well as the interior modelling. Look how he has made much of the sharp accents, and square harsher forms, in the drapery on the head, as a contrast to the soft modelling of the face. And the wonderful edge of the head and figure against the background ; everywhere firm in its run, but nowhere harsh (as it might so easily have been), but everywhere varying and suffused with delicious qualities.

PLATE 25

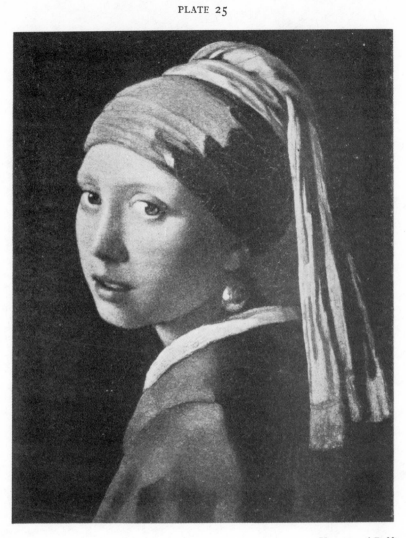

Vermeer of Delft

PORTRAIT OF A YOUNG GIRL

Photo : Bruckmann

paint them less solidly. Dab them on so that the under colour shows through a little; otherwise they will not blend into the green and orange you want, but will look too glaringly spotty.

If you have gone carefully through with this very tedious process, you will have a diagram that should help you to realise the different qualities that can be got out of the same colours differently put on the canvas. But it is important for a correct comparison that the different rows of colour squares should be the same tone. If this is so, you will notice that the solidly painted square without darker coloured edge, is the least coloury of them all; and that the glazed square is the most vivid in colour. But there is a certain thin glassy quality about it, that rules it out except for very exceptional occasions. The Pre-Raphaelite method of thin painting over white, combines something of the glow of colour of a glaze with the more substantial body of solid paint, and has more to be said for it as a method to be adopted all over a painting. But it has limitations that will not appeal to many modern painters. It considerably curtails your freedom, as everything has to be thought out to the last detail before commencing to paint, and every individual bit has to be finished at one painting, or of course scraped out and done again on another wet white ground. Therefore until the picture is finished, there is always an irritating space of bare white canvas to prevent one's seeing the true effect of what one is painting. But as a method to occasionally use, to get out of that heavy state a much worked-on picture is apt to get into, it is a useful one to know

about. For sheer vitality, nothing beats the separate colour mixtures at the ends of lines one, three and five. This is the method exploited by the impressionists. They did not, of course, paint one colour over another that had been let dry, as we have done here, but got the same effect by mixtures of separate colours. They commenced with separate dabs at first not touching each other. Afterwards, when these were dry, others were placed between them and the whole canvas eventually filled up. It was not done so mechanically as all this sounds. But the principle was to keep the colours separate, as far as possible, as the brilliancy of the mixtures depends on this. And to avoid those muddy mixtures that come when one touch of paint comes in contact and mixes with another of a different tone already on the canvas—mixtures that are the bane of the colourist as they are so difficult to control. There is a dazzling quality about colours put on in this separatist method that is indispensable in getting the effect of brilliant sunlight. And whether or not you use it with the whole-heartedness of the extreme impressionists, it is a quality of paint it is as well to have experimented with.

The objections to this method are, that it is so destructive of the finesse of form expression, and also to the quiet beauty of very subtle tone values, sacrificing everything to the beauty of an " ensemble " of atmospheric colour values.

Related to this method, and more amenable to form and tone expression, is that of painting one colour over another and mixing them on the canvas (centre square of lines two, four and six). While not so violent

and forceful as the separatist method, it adds considerably to the force and vitality of a colour mixture. It very much extends the colour range of solid painting and is very largely used by modern painters.

Let us compare the two solidly painted squares on each line, that with a stronger coloured edge and that without. It will be seen that the coloured edge strengthens the force of colour without disturbing the quiet serenity of the evenly painted surface. For all subjects where beauty of tone values is the heightened effect aimed at, the steady even tone of the solidly painted mass, takes a lot of beating. A canvas with a well-marked grain is generally used by painters who build up their effect with simple solid masses. This gives the movement in the tone that is lacking in the method. This is the way of putting on paint that will give you the largest number of tones gradated from black to white, each showing distinctly. So that by this method, the smallest degrees of tone relationships become apparent.

Adding a coloured edge to a mass, while not disturbing its purity of tone, does add colour vitality that is always apt to be lacking without it. And it is nature's way of adding colour force. Look at the sun when it is low enough in the sky to be looked at, as at sunrise or sunset, and you will see that the force of its colour is considerably enhanced by a strongly coloured orange edge ; sometimes a perfect halo of radiating orange and red. And what is seen here rather violently, may be noticed in quieter coloured masses where there is any force of colour.

These are a few of the many different ways paint may be applied to canvas. And one has emphasised

the means of getting brilliancy as this is the difficult matter with oil paint. It is easy enough to get quieter mixtures, not to say muddiness ; the difficulty is how to get out of this state, and how to avoid it. So that it is necessary to have some knowledge of the ways by which colour vitality can be preserved or restored to a picture. A fresh and brilliantly painted passage in a picture that has been dull and " leathery," will often freshen up the whole canvas. Painting a colour in the second painting over itself, as so often occurs in repainting, makes for a dull effect. Colours seem to dry very dull and lifeless when painted on a ground of similar colour. They look their most brilliant painted on a contrast to themselves—on a contrast of tone as well as a contrast of colour. White looks most brilliant painted on a black ground, and black most brilliant painted on a white ground. Blue looks most brilliant painted on red or orange, red on blue or green, etc. But this can seldom be arranged for.

It is a good thing, however, when a part has to be repainted, to rub a thin film of white over it. Not necessarily to be painted into while wet, although this may be done, but to let dry ; this gives you a ground to paint upon of some difference. One's colour, particularly the darks, will come much fresher on such a preparation.

As exercises in colour to begin with, nothing is better than bright-coloured flowers. The larger sorts are the best, as one can work more freely from them. Arrange a good solid bunch in a pot. I say a good solid bunch as in this exercise you don't want to be bothered by intricacies of form, but to be left free to

revel in colour, and in such an arrangement the individual forms will not be very marked. Arrange it with some care as to the beauty of the colour scheme, and set it against a background that will give it its full colour value. Try different backgrounds, including a black or a white. You will notice that it looks very different according to the particular colour and tone of the background. For a real good black that will throw up the colour of the flowers, nothing beats black velvet. To make it as easy as possible for a commencement, you want something striking in effect rather than something subtle. Don't set out with the idea of painting something that the gardener will admire, and all your friends think looks so " natural and stands out." You are not yet capable of such flights, even if you want to be. Try and get in touch with some colour values, some heightened effect of your stimulated perception of colour. It is a lyric in colour notes you want to paint. In the same way that you concentrated upon the perception of form and form values in your drawings, and upon tone and tone values in your monochrome studies, concentrate now upon colour and colour values. Don't be frightened if you make an awful mess; you can often learn more by doing so, than never launching out but keeping to safe unambitious efforts. Let yourself go, colour does not respond so readily to the plodding methods of study as form or even tone. It is more purely ecstatic.

One is handicapped by one's inability to illustrate this part of the subject, but we must do the best we can without.

OIL PAINTING

If you have arranged your group well and your instinct for colour arrangement is good, you will find that there is some dominant note of colour in the scheme, which is frankly the chief colour accent; and that there are other colour accents grouped round it. But besides these accented parts there is a supporting mass of colour much more difficult to decide upon. Mysterious muddles without any definite hues one can fix upon, and yet full of the feeling of colour for all that. These are the most difficult passages to manage, and the test of your colour sensibility. In the days of the brown school, when any doubt was felt, brown was the colour that would have been put; and with the feeble colourists who followed the new mode of the impressionists, it would have been purple. But these are recipes that will not do; you ought to be able to find something better than this, if your perception of colour is awakening. Notice particularly the colour of your edges, as one mass comes against another, and particularly the edge where the group comes against the background. There is always some colour here other than that of the background or of the object.

Having got an idea of your subject as a vital colour unity, proceed to rub it in loosely with the purest simple masses of colour it can be reduced to. In going for colour, always make sure of your purest notes when your canvas, brushes and palette are clean. And, moreover, you can easily paint the less brilliant colours into the brilliant ones; but you cannot paint the brilliant ones into the less brilliant, as they will get sullied by them. By rubbing it in, that is, covering your canvas

with the smallest amount of colour that it will take, you will not be so much bothered by its working up into what you put on afterwards, as you would have been had it been thickly painted. So that it will not matter if some of your smaller brilliant accents of colour are ignored at first, and have afterwards to be painted over it. Now proceed with some of the modifying colours, painting lightly and swiftly into this raw rub-in. When going for colour, your handling has to be very light and swift, and labouring your touches should be avoided. Paint is much more brilliant swiftly handled, than when put on in a hesitating manner. The fewer strokes of the brush you do your work with the fresher the painting. Don't bother at first about your more neutral colours, and as far as possible make your neutrals by one clear colour over another. I remember Pettit saying, " Don't bother about the greys, the greys will come." At any rate the clearer colours are the first things to go for if colour is your motive. Look out particularly for colour in your shadows. And when looking for the colour of a shadow, don't look *at* it, throw your eye over the whole colour scheme and notice what colour hangs round the particular shadow you are painting. If you peer into a shadow and focus on that particular part only, you will likely enough see very little colour. But if regarded as part of the vivid colour impression of the whole subject, the shadows will be seen to be affected by the glowing lights (which halate colour over them) and found to be full of colour that is unsuspected when they are individually peered into. Colour seems to disappear as you earnestly focus on each individual part in search

of it. It only sings when regarded as part of the whole vibrating scheme. That earnest person of honest narrow vision who comes along and says, " I don't see that colour," should have one's sympathy, as looked for with his coldly accurate eye, all the glory of colour disappears and has no existence. But Turner was quite justified in saying " Don't you wish you could ! " for colour is one of the most rapturous truths that can be revealed to man. Colour must be felt before it can be seen.

This feeling of colour will have no opportunity of development during your form and tone studies ; and if these studies are carried far before any opportunity is given for opening up this perception, it may never develop at all. That is why I suggest as a relaxation from the more exacting work of drawing, and tone study, some such exercise as this ; in which you throw off all restraint and let out any feeling for colour you can stimulate. The knowledge of colour that may be gained in this way will be useful, when combined with the more sobering influences of form and tone in your completed work. But something drastic must be done to start this new centre of perception, before the mind is too far set by line and tone work.

CHAPTER IX

PAINTING FROM THE LIFE

AS a preliminary to painting from the life, painting from an antique figure is a useful study. Here you have a model that does not change, with the big forms clearly defined, and of a uniform colour throughout. Drawing and painting from the antique is now much out of fashion, because in the past it has been the custom to keep students too long working laboriously from them. But much of the preliminary messiness, that it is usual for students to flounder into in commencing painting from the life, could be got over more expeditiously, if they had essayed the simpler practice of painting from the antique before going into the life room.

In painting from the live model in monochrome, proceed in exactly the same way as in painting from the cast and from still-life. The movements of the model and the more exacting drawing will make it more difficult, so that it is as well not to attempt this until your drawing studies have progressed But in the first instance, concentrate on getting the tone values good. This is the thing that is different from anything you have had to contend with in line drawing. And until you have acquired an aptitude for easily seeing tones, it is not much use troubling too much about the shape of them.

At first keep your work as large and simple in treatment as possible. You must learn to put in the main

masses in a workmanlike manner, before you trouble about details.

The varieties of colour in the flesh, hair, etc., in figure-work present greater difficulties in the way of tone, than a cast from the antique of one colour throughout. You will have two conditions governing your tone relationships instead of one. In painting from casts, the different degrees of light and dark are governed solely by the modelling. Those planes in the form that are directly opposite the source of light will be the lightest, and those which turn most away from the light and receive the least amount of reflected light, will be the darkest. And every variety of tone will indicate a variety of the form surfaces. But in a variously coloured subject such as a figure or head from the life, another consideration besides the one of modelling will govern the lightness or darkness of your tones, and that is changes in the local colour. The hair will probably be of a darker colour than the flesh, and the flesh itself will vary in colour. And all these variations of colour, as well as the variations of planes with relation to the light, will have their influence in deciding what tone in the scale from black to white, each part shall have. Light and shade and local colour must be considered as one, in these monochrome studies.

Reflected lights in the shadows are what give the luminous quality to them, without which they are heavy and opaque. And as the direction of the greatest amount of reflected light is usually the exact opposite of the direction of the light, the most reflected light will tend to be in those parts of the shadows that are

turned most away from the lights. So that you often find the darkest part of a shadow on its edge, nearest to where the light, or rather the half-tone department of the light, commences. Beginners often have a tendency to make their shadows gradate darker as they get farther from the lights ; with the result that a smoky, murky look comes into their work. This is because the only case in nature where you get this effect is in smoke ; which is not governed by the same laws of light and shade as solid objects : the darkness of the shadow parts being governed by the density of the smoke.

Painting from the life in two colours.—I have selected a head as a demonstration, because this is an exercise in which one can learn all one wants about the system of painting here advocated as a means of learning the craft. The difference between painting a head and painting a figure or anything else, is not in the method of painting but in the drawing (form expression).

Before commencing to paint in full colour from the life, I advise students to commence with two colours only—a warm and a cold colour. Blue-black for the cold, with possibly a very little cobalt blue with it, and Venetian red or light red for the warm. Or in the case of an Italian model with an olive complexion, burnt sienna instead of Venetian red. A great deal that is of vast importance with regard to colour, can be more directly learnt by this means than by stumbling straight into a full palette. And this position of the warm and of the cool colours in flesh painting, is one of the most important considerations in colouring ; as it is on the opposition of the warm and cold colours, that

the vitality of colouring very largely depends. Painting with red for your warm and black for your cold, and a mixture of both for your neutral tones, a surprising amount of colour vitality can be obtained, by the right placing of the warm and cold colours. And as very little effect can be obtained if this opposition is not attended to, one is forced by using this very limited means to concentrate the attention on this one new consideration. Having, it is to be assumed, already mastered the difficulties of tone, you have now the opportunity of overcoming singly this new and most important difficulty in the province of Colour. In training oneself, the thing to aim at is taking the difficulties one at a time, and concentrating the whole attention upon them. Muddling along with a full palette, and the whole difficulties of painting presented at once, which is the common method (or lack of method), is asking for trouble.

And there is another thing one learns by this method, and that is clean handling. Most students working with a full palette get into a very messy way of handling their paint. Finding that with dirty brushes and a dirty palette they cannot get the clean tone of red they require with, say, Venetian red, they fly to vermilion or, worse still, crimson alizarine or rose madder; when all the time Venetian red would have done if cleanly handled—and been the finer colour. Working with red and black, a scrupulous cleanliness of handling is made absolutely essential if one is to get any range out of such limited means. Another thing it teaches, is what a large amount of colour effect can be obtained by very simple means. Fine colouring usually results

from a simple palette the range of which has been fully used. You are forced, by starting with two colours, to find out the utmost that can be obtained with them. And even if ultimately a very full palette is used, the knowledge gained of what an amount of effect can be got out of a few colours is of permanent value. When you have learnt by experience what can be done with a few simple earth colours, you are more likely to use with greater effect the wider range. Whereas permanent habits of feeble pretty colouring, are likely to result from commencing with a palette set with too many colours.

In flesh, seen under an ordinary indoor aspect, the half-tones are usually the coolest colours, the warm being in the shadows and to a less degree in the lights. It is these cool half-tones that give the fleshy quality, and which differentiate flesh from painted wood. But generally speaking the colouring of flesh is nowhere very raw, but everywhere slightly muted.

After mastering to some extent the placing of the warm and cold colours, and the effect that can be obtained by this opposition, you can add a yellow—say yellow ochre. And with a red, a yellow, and a black a full realisation of the colour of most flesh can be obtained.

Later on, when more force and brilliancy of colour can safely be attempted, this simple range can be greatly extended. But it is advisable in your training for some time, to confine yourself to a very few colours, leaving the use of a fuller palette for the freer work in composition and sketches on your own account, that all the time this drilling of your faculties has been

going on, should never have been neglected. Don't deny yourself anything you may desire in the free work you should always be carrying on ; but in the drilling of your faculties be very severe with yourself.

On Painting a Head.—The accompanying reproductions are from photographs taken of the painting of a head in different stages of the work, done as an illustration of a method that, I think, can be recommended as a sound one for the student to practise.

Whatever individual method is eventually adopted, it is always wise to start working on some definite system. Few things are so difficult and complicated to paint as a head, and the method here described can be applied to the painting of anything.

Before commencing your work, carefully select the colours you will need, and be careful to choose the fewest that will serve your purpose. Do not set the same palette whatever the subject you are going to paint. Some of the colours may not be needed ; but if you have them set, you may be tempted to use more colours than are necessary, and this will disturb the breadth of your colouring. The fewer colours used, the more harmonious and large in effect your colouring will be. Always aim at doing your work with the fewest possible colours.

For flesh painting you need a red, a yellow, and a neutraliser, something to mute the force of the red and yellow and give you the more neutral tones. Hair and possibly eyes may want some special colour or colours, if they are of a particularly marked hue. In the subject selected for this exercise, the hair being

PLATE 26

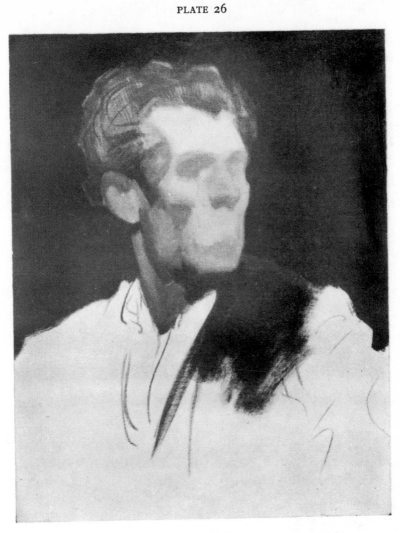

STAGE I
Different Stages in the Painting of a Head

PLATE 27

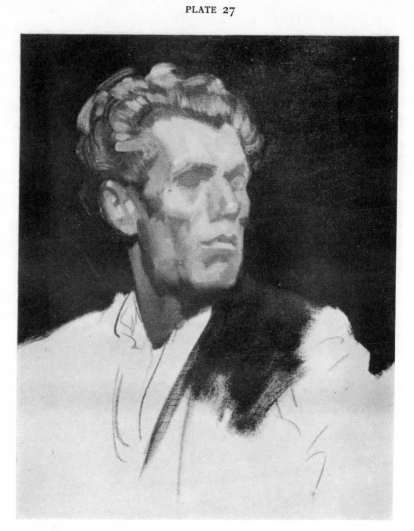

STAGE II
Different Stages in the Painting of a Head

iron-grey and the eyes brown, no special colour was needed. I find it a good practice not to take the colours as they are supplied by the artists' colourmen, but to mix a red, a yellow, and a neutraliser more suited to the particular subject I am painting. In this case the red was made with a mixture of burnt sienna and Indian red ; which gave the quality of red running through the slightly olive complexion of the Italian model. Yellow ochre as supplied by the colourman was all right. In very fresh complexions, such as one gets in a girl's head, yellow ochre is often too bricky in colour. But if some pale cadmium is mixed with it a yellow more suited to the quality of colour needed is got. With a little white a yellow similar to the Naples yellow—so largely used by the eighteenth-century portrait painters—can be thus obtained. There are a variety of colours that can be used for making the neutral tints : according to the quality of the complexion. Brilliant skins often need blue ; and sometimes terra vert, or even viridian, are used. But in this case I adopted the scheme that I think Velasquez often used. At least this was the conclusion I came to when studying his work in the Prado ; and that was to make the neutral tones with two blacks—a warm and a cold one. The warm black the Spaniards use, " negro hueso," is our bone brown. But it is a bad dryer and I find ivory black, with a very little burnt sienna, makes a very similar colour of better drying capacity, if a good transparent variety of burnt sienna be selected. Blue-black does for the cold black ; but here I find the addition of a little cobalt blue increases its usefulness. These were all the colours needed for this head,

except a little pure Indian red in the mouth, the corner of the eye, and the ear.

For a medium to thin the colours I used a mixture of equal parts poppy oil and slow-drying petroleum. But turpentine and linseed oil would do equally well if you want a quicker dryer.

The paint as supplied in tubes is a little stiffer than is always comfortable to paint with, and it is as well to thin the white by mixing up some of your medium with it. By this means a more uniform thickness of paint is preserved throughout the work, than would be possible were you to thin the paint by continually dipping your brush in your dipper. It is so difficult to be sure of only taking up just the right quantity of medium on the brush; and varying thicknesses of paint uncontrolled give a poor quality. It is as well also to set out a small quantity of the thicker white from the tube, for use on those occasions when a crisp touch is wanted that will not mix with what is underneath, such as the high lights on the forehead, cheekbone and nose, etc.

In the following description, when I say red I mean the mixture of Indian red and burnt sienna we have made.

First rub-in your background thinly with the warm black, using some amount of medium to thin the colour. Do not leave a hard edge where it comes against the head, particularly against the hair, where it should be very loose. The sort of edge that shows against the unpainted shoulder on the left is what you need. This black, rubbed on thinly, will be a warmer tone than you will eventually need, but it can be cooled after the

head is finished by painting the cold black mixed witl
a little white into it. The play of this cold over warm
will give the interest and movement necessary; and
particularly necessary in the case of a background
which is out of focus.

Now rub-in the general tone of the hair. There is
one thing it is as well to make a note of in painting
hair. Whereas in flesh colouring the half-tones are
as a rule cool, the warmer colours being in the shadows
and in a less degree in the lights, in the case of hair
I think it will generally be found that the half-tones
are the warmest and most coloury tones. So that the
first rub-in wants to give you this warmer half-tone
colour, into which the lights and shadows can after-
wards be crisply painted, leaving this first tone between
them. The model having iron-grey hair, this middle
tone was of a greenish-brown hue. Yellow ochre and
the cold black rubbed on thinly gave this. In the first
instance I took this right over the hair except just
over the ear, where a darker tone made with the same
two colours, was used. The whole of this hair was
afterwards finished entirely with these two colours,
yellow ochre and cold black, with, of course, white.
Some of the tufts of hair against the background had
a warmer edge; and this was got by picking up some
of the warm black of the background, when deftly
painting these touches. But this is anticipating our
future stages.

After rubbing-in the hair, paint the forehead. This
should be laid in at first in a general middle tone nearer
the lights than the darkest half-tones; and was made
of our red and white with a slight touch of cold black

hue a little. Paint this against the hair with
l edge.

......ering blocking-in the planes of the lower
part of the face, always remember the change of plane
between the front, and side, of the face. Roughly
speaking, the front planes consist of the forehead, the
plane of the cheek-bones, the surround of the mouth,
and the chin. A line dividing the front from the side
of the face runs down the ridge at the sides of the
frontal bone, round the outside of the eye socket, and
then circuits the cheek-bone and curves round the
mouth to about the middle of the jaw bone. This
change of plane is often forgotten, as it may happen
that they are very similarly lit and that there is not
much change of tone noticeable. But the subtle
indications of this change of plane must be carefully
looked for, as it is a very important part of the con-
struction of a head. Now paint this front of the face
with a slightly darker tone of the same mixture of red,
white and a touch of black. Below the nose, however,
the colour changed, due to shaving, and was of a much
colder hue. In this lower part I used much more cold
black. The sides of the face are next put on with a tone
somewhat darker than the others, made of warm black
and yellow ochre and white. This was carried right
through to the neck, the darker tone of the jaw shadow
(made with our red and warm black) being painted
over it.

The eye socket was now put in with yellow ochre
and warm black and white. At first all over of the tone
of the outer edge; and then afterwards with a darker
tone of the same mixture, with much more yellow ochre

for the more shadowed parts. Lighter tones were now painted in the corner of the eye and in the centre of the cheek-bones. These were made of our red and white without any black. The black in the tone already painted, into which this light tone would mix, is enough to mute its rawness. A lighter tone of cold black, white, and a very little red, was now painted about the space to be occupied by the mouth.

A darker tone under the cheek-bone and the zigomatic arch (I presume you know your skeleton) can now be put in, made with our red and white under the cheek-bone, and yellow ochre and warm black towards the ear.

But we are forgetting the nose. This, as is often the case, was of a warmer tone than the surrounding cheeks and was put in at first all over with red, white and a touch of warm black. The dark half-tone at the tip of the nose, and its shadow on the upper lip, were colder in colour. And this was next put in with cold black, white and a very little red. The half-tone at the wing of the nostril that joins this tone, was much warmer, as is also usually the case, and was put in with red, yellow ochre, white, and a very little black.

The ear always has an undercurrent of warm colour through it, and this should be made sure of in the first instance. The ear and the bridge of the nose are the only two contradictions to the general rule of cool half-tones in flesh. I painted the ear with yellow ochre, red, and white, with a darker tone at the top made of the same two colours.

At this point a photograph was taken (Plate 26). This stage might have been better finished, but the

head was painted on a short December day, and I wanted to get it done in one painting, and so was in a great hurry. But in the case of a short portrait sitting nothing more than this stage need be attempted in the first painting. And if it is right as far as it goes, it will suggest the finished work and be a useful foundation to continue on. In finishing such a stage, do not attempt any more complications in your tones. Keep them flat and simple at first. But put all your finishing work into refining the edges everywhere. That light edge of the face against the background on the right might have been more carefully wrought at this stage, as also the edge against the hair. In fact, all the edges might have been more carefully finished. All such edges can only be done well when the tones on both sides are still wet. And they are easier to do when there is no detail in the tones to interfere with the free swinging of your brush along them. Such conditions only occur at this stage ; and if your work dries and they are not completed you have to go over the whole process again. But in this case, as I was finishing in the one painting, I knew it would keep wet, and so was not under the same necessity of finishing them so carefully at first. Or perhaps I was a bit impatient that morning.

In case anybody reading this does not know what rubbing it in means, look at the edge of the smudge of coat on the right, which shows the effect of this manner of putting on paint. It is done with the side of the brush and is the best way of putting on the thinnest film of solid paint that will cover the canvas. The advantage of this manner of first putting it on is that

you are enabled easily to make another touch over it, without the new tone picking up much of the under-paint ; as would be the case if it were more thickly painted. Always paint with the least amount of paint that will get the effect you want. Reserve thick paint for those occasions when you want to make a crisp touch quite separate from what it is painted into.

In the next stage, a few lights have been put in the hair. This needs very deft handling, a touch too much spoils it. I like very big brushes for painting hair, and did this mostly with a fairly large and long-haired, round brush with a blunt end. Yellow ochre and cold black and white were the only colours used.

I then put the highest light on the forehead. This should always be done as soon as possible to give you a key to work to. When you have your highest light and your deepest dark tone (as we have in the back-ground) you can judge the whole scale of tones in relation to these two extremes.

Some more work was now done round the eye sockets. Notice particularly the position of the corner of the eye, usually a prominent light spot connected with the light on the cheek. This is practically the only fixed point in the eyes. All the other parts, the brows and lids, are liable to move during conversation (and you should always talk to your sitters if you want them to keep alive). Put all your work on the edges of the eye sockets at this stage. Then carry the modelling of the nose a bit further. And in observing the nose, do not, as most beginners are inclined to, observe only the ridge of the nose down the front and the nostrils branching from it ; ignoring altogether the

consideration of the space between the nostrils and the corner of the eye. This is where the plane of the side of the nose meets the plane of the front of the face, and is a most important part of the nose's modelling. Always observe the area of the nose in relation to the four points, corner of the eye, springing of the bridge, outer corner of nostril, and tip of nose. Note carefully the position of these points in relation to the head, and in relation to each other. In this model, although the nose was a bit rubicund, the farther edge against the cheek was of a cold colour. This was put in with a cold black and white on top of the first lay-in of warmer colour.

Now the mouth was lightly indicated with pure Indian red and a little white, the under lip being painted with more white, as it was a little lighter in tone than its surroundings. The darker tone under the under lip was painted with yellow ochre and warm black. The lights on the chin, and at the corners of the mouth, were done with red and white painted into the colder tone already there. The lighter tones on the ear were painted with Indian red, white and a trace of cold black. Then another photograph was taken (Plate 27).

At this stage, work was largely concentrated round the eye sockets and the brow. Always paint the eye sockets before the pupils of the eyes. Remember that the eye is a cavity, through which is pushed the globe of the eye, on which the eyelids are placed. The eyelids therefore partake of the spherical form, as do also the " whites " of the eyes.

In painting the eyebrows, notice that the colour on the edges is usually colder than in the centre

PLATE 28

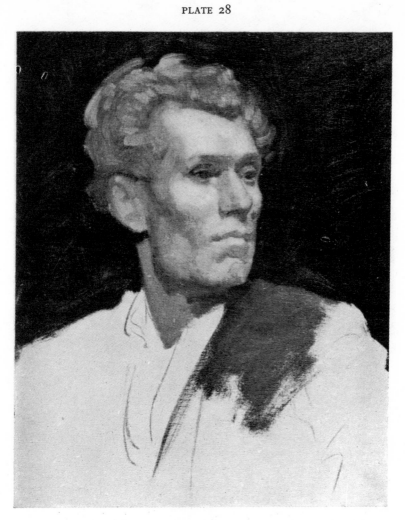

STAGE III
Different Stages in the Painting of a Head

PLATE 29

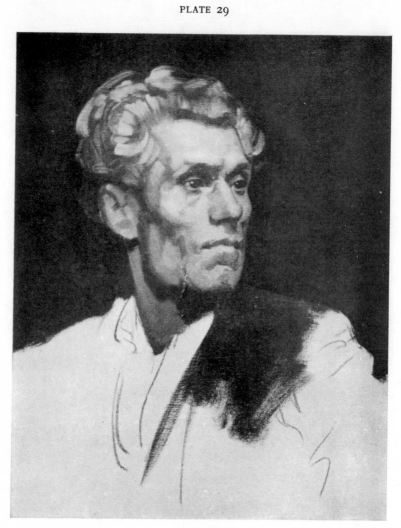

STAGE IV
Different Stages in the Painting of a Head

parts. And this edge colour should be painted first. The warmer and darker accents in the centre can be placed later. In this case the colder surround was painted with blue-black and yellow ochre and white, and the darker centre with warm black, yellow ochre and a little white. The darker tones in the shadow passages of the eyes, at the top of eyelids and corners of eyes, were painted with warm black, red, and a very little yellow ochre. The corner of the eye is a subtle piece of modelling, and colour. There is usually some very warm colour hanging round the inner side of this light (the side nearest the eye) where the corner of the eye is usually very clear and red in colour. This was painted with a crisp touch of pure Indian red and white. But on the other side, towards the nose, there was a cold edge which was put in with cold black and white painted into the colour already there.

Do not neglect the under eyelid, as is so often done. I know of no part of a head that so easily shows the hand of the master as the painting of the under eyelid. And it is this that makes me think the fine portrait of Philip in the Dulwich Gallery, is not the original of Velasquez, but a copy. The under eyelids are so poorly constructed that to my thinking they show the hand of Manzo, or some other of Velasquez's followers. However loosely Velasquez painted, the construction was always well understood.

In painting under eyelids see that they tuck in at the outer corner of the eye, following the spherical surface of the eyeball that disappears at this point. Note the soft line of the under edge of the band of tone marking the under eyelid, that goes from the outer

to the inner corner of the eye. This is where the surface of the eyeball (on which the eyelid is placed) meets the surface of the cheek, and a sharp change of direction occurs. There is often a lot of loose flesh here which obscures the clearness of this transition. But be on the look out for any suggestion of this important structural feature.

Some more work was now done to the nose. In painting noses do not be in a hurry to put in the details of the nostrils ; and beware of making too much of the light that often runs from the cheek into the side of the nose. These smaller forms monopolise the attention, and obscure the bigger structural facts of modelling that should be put in first, and to which the others should be subordinate. The big structural fact of the nose is that it is made up of two planes converging at the top and wider apart at the base, rising from the plane of the cheeks and united by the ridge of the nose. This ridge is cut off at the tip of the nose by a little plane that usually shows a crisp high light, at their point of juncture. The plane of the side of the nose is generally marked by a change of tone from that of the cheek. And if you look at the subject with your eyes half closed, you will usually find a much more marked line from the wing of the nostril to the corner of the eye where these two planes meet, than is visible with them open. The odd thing about half closing your eyes to study your subject is, that while most of the smaller modelling disappears, the larger modelling stands more clearly defined in this muted vision of the subject. All the beginners I have seen make too much of the surface plane that runs from

the cheek up the side of the nose, between the nostril and the corner of the eye. So be on the look out, not to let this unduly obscure the larger fact of the plane of the side of the nose meeting the plane of the cheek.

The shadow under the wing of the nostril, was now put in with a very warm tone made with red, white and a very little yellow ochre. The nostril itself merging into the shadow under the tip of the nose, was painted with red and a little yellow ochre. I had already painted the cold half-tone of the tip of the nose and taken this cold tone right over to form the cold edge of the shadow on the upper lip, so that the pure red and yellow ochre I painted into it, was muted somewhat by what was already there. This is a very important point to note as you proceed with your work. Unless painted very crisply with thick paint, every touch you put on will be modified by the colour and tone of what is already there. And you must let this enter into your calculation, when mixing up the tones on the palette. Having laid in your work with the muted middle tones, you will be able to use much purer colour in the later stages, as they will be quieted by mixing with the middle tones already there.

More work was done round the mouth. The edge of the under lip, as it came against the shadow of the upper lip, was very red. And here I allowed myself the luxury of a touch of vermilion and white along the edge. This mouth was not a very rosy one. But very often, particularly in girls' heads, there is a very pure red in the lips (in these days only sometimes natural). It is as well to make sure of this at first. You can easily modify it when necessary ; but very pure colouring

is not so easily got on top of more neutral colouring, as neutral colouring is on purer colour. You will remember I put in the mouth in the first instance with pure Indian red and white. This needs a little modifying in places with blue-black and Indian red. The shadows at the corners of the mouth, and along the division between lower and upper lips was done with our red and a very little white. Always look out for the three fulnesses in the modelling of the lips. The three cherries, as they have been called—one in the centre of the upper lip, cut off by the end of the depression from the base of the nose to the centre of the upper lip, and the other two in the lower lip on either side of a central line. Here another photograph was taken (Plate 28).

The individual touches in these later stages do not show so clearly in the photographs as I could wish, and in the final reproduction are softened out of recognition. More refined work was done in the modelling of the brow and the cheek-bones, and the eyes were put in. In painting the pupils of the eyes, you will notice as a rule that they are made up of a dark centre, and a dark edge, with a lighter colour between. And that this lighter colour, is usually lighter on the side away from the light. That is the opposite side to that on which the shiny high light reflecting the window is. It is as well to paint the whole pupil in the colour of the outer edge at first ; and afterwards put in the lighter colour between this edge and the dark centre. The dark centre can be darkened if need be afterwards. You get a much better quality of edge to the pupil if it is put in with a fairly large brush swinging round, than

PLATE 30

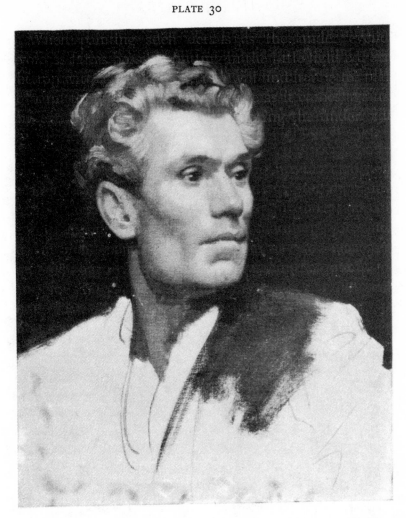

THE COMPLETED HEAD
Different Stages in the Painting of a Head

PLATE 31

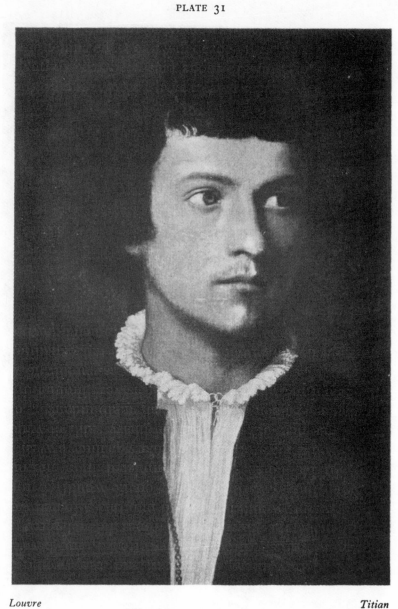

THE MAN WITH THE GLOVE
(part of picture)
Illustrating concentrating the main focus on one eye

if the general colour of the eye is put in first and the dark edge put in separately afterwards, as a line all round it ; which it seems to be a natural instinct of pupils to do.

In the finishing stages, always remember that finish is not necessarily the addition of details, but of refinements. A catalogue of carefully painted details of the parts, each observed with a separate high focus, will not express the impression of a whole head. Keep in mind all through the work the original impression of what you wanted to express ; which you should have taken in before commencing the work. Everything in the finishing stages should be done in tune with this visual chord—this oneness of impression, which is the first thing which should strike the spectator. This can be refined as the work proceeds : unduly jarring edges can be suppressed and dominant accents can be accentuated ; but nothing should be done that brings out any part of the impression in front of this unity of the whole.

Accent is a very important thing in the finishing stages. If you observe your subject as a whole, you will find that all the parts do not attract the attention equally. Certain things will strike one more than others. Parts of certain edges will be sharper, while others will be more lost. This quality of accent is analogous to phrasing in the singing of a song. If a song is sung correctly as written, with an equal attention to each note, it is a dull, lifeless affair. It is sung in phrases, with a stress on certain parts, in very much the same way that in speaking one stresses certain words and runs over others.

A good example of the sublimity of expression that is got by a fine scheme of accents is to be seen in

Titian's portrait of " The Man with the Glove " in the Louvre (Plate 31). Notice the way the attention is focussed on the eye on the left (looking towards the picture), and how the other features are seen out of focus, so as not to compete with it. The nose and mouth are quite nebulous by comparison. Another point where he has allowed himself accent, in the dark edge of the hair above this left eye. A vast unity and sub-limity of impression is given to the head by this simple unity of focus ; an intense restfulness which is sup-ported by the noble calm of the expression in the head. The largeness of expression is further accentuated by the crispness of the treatment of the little folds in the shirt, in contrast to the simple modelling of the face ; which, however, does not show well in the reproduction.

In refining the modelling, and getting rid, if necessary, of hard edges made in the earlier stages, do not soften one tone into another by brushing them together. If the earlier tones had been laid with sufficient deftness, nothing of the kind would have been necessary. But perfection of handling is not one's constant experience, and something has usually to be done to mend im-perfections. Brushing two tones together, besides devitalising the paint, as all subsequent touching is apt to do, also produces a tone that you don't want. Two tones come together too suddenly because another tone is needed between them to unite them. And it is very unlikely that the right hue of this tone can be got by mixing the two together. The new tone should be carefully made and deftly placed between them. I say deftly, as it cannot be too often insisted upon that the canvas should be touched by the brush as seldom

PLATE 32

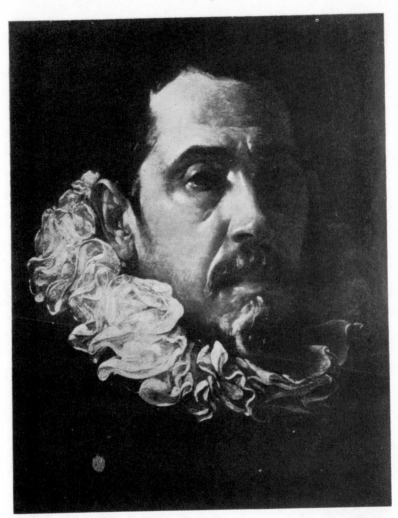

Prado *Velasquez*
EARLY PORTRAIT PAINTED BEFORE HE WENT TO MADRID
(detail of picture)

Photo : Anderson

PLATE 33

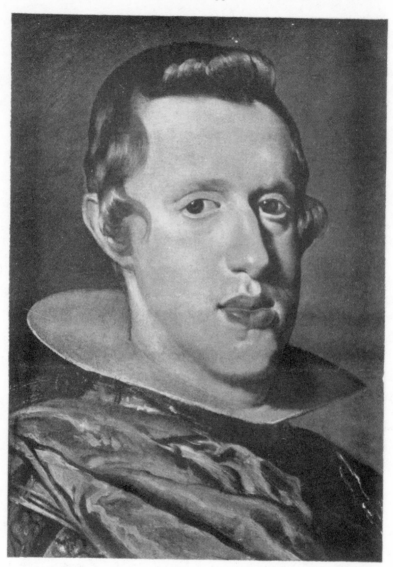

Prado

Velasquez

PHILIP IV WHEN YOUNG
(detail of picture)

Photo : Anderson

as possible in oil painting. The more often paint is touched, the less vital the impression.

The only way softening can be successfully indulged in, is when the colours are put on separately side by side in a more or less pure state, and afterwards once for all swept together by a softening process. The effect of lowered vitality in the colouring that softening gives, being allowed for by painting with stronger colours than will be ultimately needed. I think Rubens worked in this manner. He appears to have put in his work in the first instance with a transparent brown for the shadows and cool lights painted with white. When this was dry he appears to have scumbled a transparent brown tone over the whole, which was largely left for the shadows ; and then to have painted the half-tones of his flesh into this scumble in blue and the lights vermilion and a yellow (possibly yellow ochre), putting the colours on pure from the palette, mixed with white. The warm scumble already there would modify them somewhat, and they would be afterwards brushed together or softened, and between them make the creamy flesh tones he delighted in. Then accents would be painted into this softened work and the thing was done ; and off he would go for a ride on his horse, having completed in a morning what would have taken an ordinary painter a week to do. This method needs extraordinary skill, of which, of course, Rubens had more than an abundance ; and the colouring to be obtained by it is very limited in its range. It is a method that belongs essentially to the brown school ; but it is a very swift and expeditious manner of painting. I would recommend anybody

who thinks we work harder than our forefathers in this so-called energetic age, to take note of the vast amount of canvas this painter covered; and then remember that he found time to be a man of affairs and an ambassador of his country as well.

Pacheco writes that on his nine months' visit to Spain as an ambassador he painted the following pictures:— Half-length portraits of the King, the Queen, and the Infanta. Equestrian portrait of the King with figures— a very large canvas. Another half-length of the Infanta and several replicas of it. Five or six portraits for private people. He also painted full-sized copies of all the Titian pictures in the Prado, six of them, as well as two original religious compositions and three other portraits. It takes one's breath away. In our own National Gallery we have two large canvases by him, of War and Peace, thrown off while he was here as an ambassador; to illustrate his peaceful mission.

But to return to our method of painting a head that will allow of a much greater variety of colour schemes, than the simpler formula of the brown school. Do not forget that if you are painting a darker tone over a lighter, the tendency will be for the edge, where the paint is thin enough to show the undertone through it, to be warmer. And that when you are painting a lighter tone over a darker, the tendency will be the other way and for the edge to be colder. This is a very important thing to bear in mind, and governs the consideration of how your tones should overlap each other. Half-tones in flesh are generally cool, and consequently they should be painted with the lighter side overlapping the dark. Such things as the nostril, as it

comes against the cheek, usually have a warm edge
and are best painted dark over light. The edge where
the hair comes against the face is another important
edge that is often alternately warm and cold. It is
usually cold at the side of the frontal bone, where the
growth of the hair merges into the flesh, and warm
where a mass of hair overhangs ; such as one sometimes
gets on the brow. When the cold edge is wanted it can
be got by painting the flesh tones over the general
lay-in of the hair; and when a warm edge is wanted it
can be got by painting the darker hair tone over the
flesh. In some cases, however, such as red-haired
subjects, where the hair overhanging the flesh gives
a very warm colour indeed, it is necessary to paint a
solid warmer colour on this edge. But with ordinary
subjects it is generally sufficient to get the variety by
painting one tone over the other. The greater the
contrast of light over dark, the colder the edge, and,
vice versa, the greater the contrast of dark over light,
the warmer the edge. The enhanced effect that trans-
parent colour gives, can often be got in solid painting
by lightly painting dark over a wet light tone ; when
the light shows through and gives very much the same
effect as a thin glaze over a dry light ground. But this
effect needs very skilful handling, as a second touch
would be likely to work up the light into the tone and
dull its effect.

When painting such details as the under eyelid,
avoid as far as possible putting in the little light edge at
the top with a small touch. You will find it a better plan
to paint the tone of this upper edge as it comes against
the eye with a larger brush ; ignoring the under side

at first. And afterwards paint the under side with a darker tone; thus leaving the light edge, instead of painting it with a small touch. Generally speaking, remember that you can only attend to one edge of the touch that you are making. If you try and paint a touch that needs variety on both its edges, and you try and get the variety on both sides at the same time, you will fail to get either right. But if you attend to one side only you can usually make sure of this in one touch; and can afterwards get the other side right by painting the next tone against it.

The swing of the form in such edges as that of the face against the background on the right, where there is variety on the face side, and very little on the background side, is best got by clearing up the edge from the background side. When two edges come together with much variety on one side and little on the other, paint the variety side first, leaving the edge to be trimmed up when painting the simpler tone of the other side. You cannot vary the tones in a touch as you carry it along an edge, to any great extent. The emptying of your brush allows a certain amount of variety that can at times be usefully controlled, but the amount of variety that can be got by this means is very limited. Another way of simplifying the larger modelling of a form that is made up of a variety of colours (that must necessarily be put on separately) is to sweep them together with one stroke of a large, dry brush. But this can only successfully be done once, or the softening effect of it will deaden the colour too much

Nothing has been said about drawing (form expression), as this subject I have treated separately elsewhere.

But it cannot be too much insisted upon that at every touch form considerations will be met with, and nobody can hope to paint anything who cannot draw with facility, and that the distinction of your work rests more on this than on anything else.

This is perhaps the place to say something about focus. In looking at nature, it is only a small part of the field of vision that is in any sort of hard focus ; the longer part is seen out of focus. This is a fact of vision that is of great use in giving unity to the impression of a picture, and concentrating the attention. A picture painted to a hard focus all over, as in Primitive work, and the work of the form-loving Florentines, has to rely for its unity of effect upon design entirely. But when to a fine design is added the additional unifying effect of a single focus, you get a very much enhanced unity. In Primitive work, and in much Renaissance painting, every part is in strong focus ; the flowing lines of the design binding the picture together and making the unity. The Venetians were among the first to get rid of this hardness, fusing their edges, and getting a much richer effect. Titian used this quality of a single focus in his portraits, as we have already seen. And it helps to give an intense unity to the impression. A number of different parts attracting the eye may add vivacity, but it is disturbing ; and nothing gives so ennobling a vision of the subject as a calm, large, simple view, in which everything is in tune to one steady focus.

Velasquez used this quality of focus in vision to give unity to the impression in his later works, particularly in such pictures as " Les Meninas." But he

nowhere gives you the high focus that Titian has concentrated upon the eye in the " Young Man with a Glove," at the Louvre ; but used a much more generalised one. The principal focus is upon the Infanta in Velasquez's picture, but it is not a strong, hard focus. Except in his early work, Velasquez never used a hard focus : the edges are always seen as part of a larger impression which he never allows to be held up by a point of hard focus.

The unity, that painting to a large visual impression of single focus gives, was very much exploited in the naturalistic movement in the nineteenth century. A unity of impression could be got without much design, if this new *tout ensemble* vision were adopted. And this use of focus very much aided the neglect that design fell into at this period. When any difficulties of design presented themselves, they were softened down out of focus, instead of being faced. Used in this way focus is an enfeebling quality. But used in conjunction with good design, it is of great service in giving a largeness to the impression.

A Note on Velasquez

It is instructive to notice the different stages of Velasquèz's development. The early portrait (Plate 32) is an interesting example of his 'prentice manner, painted before he went to Madrid. You will observe his preoccupation with lost and found edges. The little sharp accents contrasting with lost edges. Notice the edge of the hair against the face, and the variety he has forced out of this. Notice the little tuft of beard on the chin and see how he has reduced the appearance

of real hair to a light tone set in a dark surround ; and the infinite variety of play on the edges he has found. He has not yet arrived at the largeness of perception, which could subordinate the accents on such edges as that going from the wing of the nostril to the outside of the mouth, to an all-embracing focus of the whole head. But their over-insistence shows his preoccupation with this quality, and is interesting as showing things, that the subtlety of his later work makes more difficult to discover. Notice how he has searched out and laboured the edges of the ruff, so different from the freedom and ease of his later work ; but interesting to the student in showing how conscientiously he learned his job. His frank acceptance from the start of the so-called realistic standpoint, is shown by the uncompromising way he has searched out all the character in the head.

Plate 33 is a study for the full-length portrait of the young King, which was the first thing he painted on his arrival at Madrid. It was a great opportunity for the young painter, and he was determined not to make a mess of the original canvas ; so made a careful study of the head. This evidently remained in an unfinished state until years after, as he put in the armour and drapery of the body to make it look more presentable, at a very much later period. He is still preoccupied with the contours of his tone masses but not in so small a manner as before. The larger masses are more felt, and the contours are considered more as their boundaries than as things in themselves. But it is all very tight and consciously searched out.

Tone values seem to have been a quality that Velasquez innately felt from the start. There is no work of his

extant that shows any fumbling for this quality. All his work is remarkable for its distinction of tone. The form of his tone masses is what occupies his attention, and is the thing he sweated at. In his later work, the play on his edges is so rich that it would be difficult to understand the care and attention he gave to their definite form, had we not these earlier works to refer to. His handling in these earlier works is solid all over, of an equal consistency of thin paint. After visiting Italy he used thin colour contrasted with more impasto in his lights on some occasions, but he never painted in the thick manner of many of his modern imitators. In his latest manner, the painting is remarkably thin all over, the dark background of such pictures as " Las Meninas " being merely an umbery stain thinly covering the canvas.

Note the hard tight treatment of the eyes and the collar and compare them with our next plate.

The head of Pope Innocent X (Plate 34) is a magnificent painting lesson. Velasquez painted it at Rome, when he was in Italy on a mission for King Philip IV. He had been travelling about the country seeing the works of the Italian painters for some months, during which time he had not touched a brush. The Pope was known to be a difficult subject to make a fine portrait, the Italian painters not having succeeded ; and so Velasquez was on his mettle. To get his hand in he painted a portrait of his half-caste servant, now in Lord Radnor's collection. A fine study for the Pope's head is also in existence, in which he learnt his subject. The colour is richer than was his wont, showing the influence of the Italian manner of the time. Notice the

PLATE 34

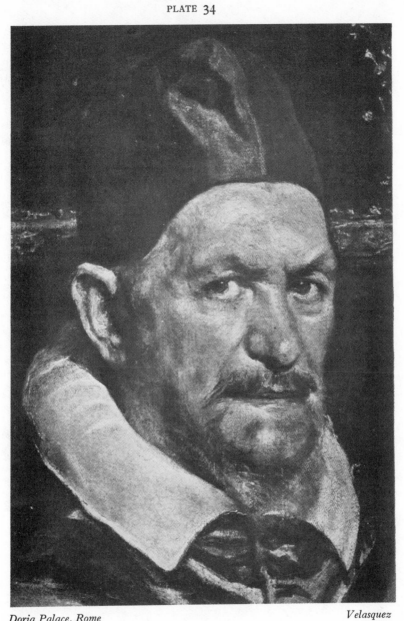

Doria Palace, Rome *Velasquez*

HEAD OF POPE INNOCENT X
(detail of picture)

Photo : Alinari

PLATE 35

Prado *Velasquez*

THE BUFFOON
(detail of picture)

Photo : Anderson

same preoccupation with the edges of tone masses, but how much more subtle and rich their quality. Instead of the sharp hardness of his first manner and the tight contours of his later development, what an infinite variety of qualities he has managed on the edges. Take the tying-in line of the cap running down the farther side of the face. While the firmness and run of this line is everywhere sustained, what play and variety there is at every point. Notice the difference between this contour and that of the ear, where a more brilliant type of edge is managed without anywhere a cutting hard quality. Look also at the edge of the collar, and think how hard and ugly this might have been in the hands of another. Notice the near eye as an evidence of how he was preoccupied with the visual impression, not with any objective fact outside himself. As objective fact, the iris of the eye is a perfectly even circular shape ; but look closely at this eye and you will see an edge more like that of a broken dark glass bottle. And yet when taken as a part of the whole impression of the portrait, at the distance at which this can be seen, how right it is. This was one of the last accents put in when he was vitalising the impression and pulling it together as we say. That is, leaving the work accented in harmony to one vivid impression. In such an impression, the eye was one of the staccato notes, and needed a different manner of putting on the paint than, say, the inner corner of the eye where the quality is soft. But while the quality of paint needed was of a more vivid order than the surrounding flesh, he did not need a hard continuous edge, as that would have attracted too much attention to this individual part,

while an ordinary lost edge would have been of too sleepy a quality. And I commend to your notice the device Velasquez has adopted on the spur of the moment, to obtain the lively effect he wanted. Seen from the proper distance, the firm shape of the eye is all there, but with an edge softening in effect from the right-hand top corner. But take a magnifying glass and look at the reproduction and see how he has got this and preserved the different and more juicy quality of colour needed for the eye. How he has concentrated on this eye—it is more teased than any other part of the work. All those little touches round the outer corner of it, where so much movement and expression is always to be found. For so large an impression the touches in this head (which show up so well in this reproduction) are remarkably small. It appears to have been painted largely with round brushes, with long extra stiff hog hairs. Velasquez appears to me to have used every conceivable device to get what he wanted, and many different shaped brushes. Some of the touches in the glittering robe appear to have been done with short-haired flat brushes. Such a touch as can be seen at the very bottom of our reproduction to the right-hand side near the centre opening of the robe, looks as if it were done with such a brush. But the particular speciality of Velasquez's brushes in his latest manner was long-haired ones, with the hairs extra stiff to counter-act the lessened spring that the length of hair would have. Such touches as the beard, and the little glittering lights on the chair just showing in the top right-hand corner of our reproduction, seem to be flicked on with the tip of a long-haired, rather small, blunt round brush.

This head wants to be studied in conjunction with those of his earlier manner if one is not to miss the underlying firmness in the structure of the planes and edges. The variety on the edges is everywhere so rich and full, that one could easily miss their firmness.

In the portrait of the court buffoon (Plate 35), that Velasquez painted to please himself, the large focus of the vision, with its accompanying fused edges, is carried still farther. This was painted in his latest manner, when his time was much occupied with the affairs of the King's household, and opportunities for painting had to be snatched at. And the shortest road to the end aimed at had to be found. But was it ever found with more sureness of touch ? The old fellow lives before one with his merry little eye, amused at the antics of the excited painter. So simple is the modelling, that one could easily miss the knowledge of structure that underlies the easy swing of the brush work. How well the skull and bones are felt under the surface. Notice how large the focal impression is, and how he does not let it stray for a moment from the general effect of the whole. Even the eye, which is the central point of the attention, is not realised to a degree that attracts any individual attention. Nothing is painted that could not be seen at a glance concerned with the whole head at once ; the attention is not for an instant allowed to stray from this all-embracing unity of impression. It is, like all Velasquez's work, painted on the same scheme that we have been describing, of working from carefully wrought middle tones up to the accents of the lights and the darks, which are the last touches put on.

Look at the edges of the velvet hat, and think what a hard uniform edge might have been made of this, by one that observed only from part to part, and not as here from a large impression observing the music of the edges seen as a whole.

And now we come to one of the last and most beautiful things Velasquez ever did, the bust portrait of Philip IV of Spain in the National Gallery (Plate 36). This miracle of paint, that has been the despair of painters, can be comfortably studied at the National Gallery, and no reproduction can give any idea of its beautiful quality. But there are certain things that can be studied in a reproduction. You must remember how very many times Velasquez had painted his friend the King, and how well he knew his subject. There is no fumbling and he knows exactly what he wants to do before commencing. The first thing you can notice in the reproduction is how magnificently the head is planted on the collar, like a column on its base. This is not an accident, nor the happy selection of the right moment, as some modern snap-shot-minded painters might think. The vertical chord has been instinctively felt as the rhythmic motive of the lines of the head, and this idea has been carefully played up to. That vertical edge of the hair against the face on the left, that gives such awe to the impression, does not look to me like a happy accident. I think there is some tucking in here; and I can almost see Velasquez doing it with the handle of his paint brush, in order to get it to come just right. The same line is further carried on in the shadow of the curl below, on the jaw. On the other side of the face the same vertical lines are

PLATE 36

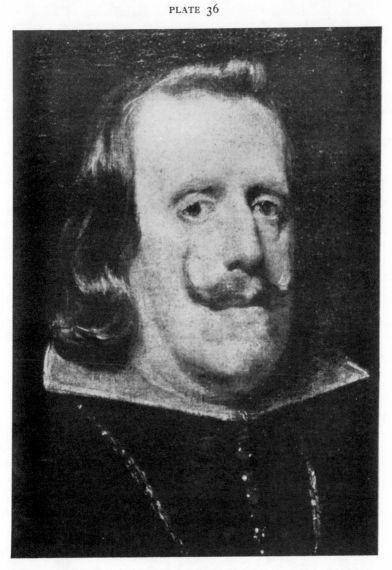

PHILIP IV OF SPAIN
(detail of picture)

[See corresponding text on pages iv and v]

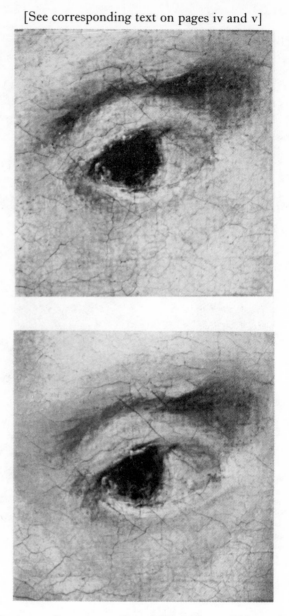

DETAIL OF PORTRAIT OF PHILIP IV OF SPAIN (*Velasquez*)
Above : Before cleaning
Below : After cleaning
(*National Gallery Photograph*)

emphasised in the boundary of the brow against the shadow, and down the cheek-bone to the moustache. There is also a vertical feeling, in an imaginary line from the outer side of the under eyelid on the right, down to the fulness under the eye. He would have liked another vertical line from the bridge of the nose down to the chin ; but this could not be quite managed without doing violence to the portrait. But the edge of the shadow here conforms to a straight line only slightly off the vertical, and quite in sympathy with the sublime vertical chord he was insisting on. It is on the dignity of these vertical lines, contrasting with the firm lines of the collar at the base, and the horizontals of the mouth, eyes and hair above the brow, that the splendid carriage of the head depends. Brought about as it is, so simply and naturally without any straining of natural truth.

The fine construction of this head, the splendid way the whole thing is put together, can easily be missed by those who only see the easy, loose handling and lack of hard definition everywhere.

But the thing which fascinates painters is the quality of the painting ; and, without having the audacity to say I can tell you how it is done, here are some suggestions on the subject. In the first sitting I imagine he rubbed-in the head with very simple colours, little more than his two blacks ; and concentrated his chief attention on placing the main masses of his light-on-dark scheme in the handsomest possible manner, and getting that basis of fine drawing on which the whole thing rests. All this being done in a fairly light key, and with very little paint everywhere except in the lights, which

while not loaded were solidly painted. In the next sitting this was scumbled with negro hueso (bone brown) and a yellow that Velasquez used. It is the yellow he has painted the lights on the gold chain with. It turns up in most of his pictures, and I made it when copying in the Prado with pale cadmium and a little yellow ochre. Into this scumble he painted the lights with a cool red, possibly madder ; a blue, possibly smalte, and the yellow above described. The distinguished red of the lips can, I think, be made with madder and the yellow. The particular pearly quality of the colouring, is just such as one gets painting with light touches, cool colours over a warmer scumble. You can find the scumble still showing on some of the edges and in the shadows. Working into warm scumbles is much out of fashion in these days of solid painting, and it is rather a recipe of the brown school. But, undoubtedly, very exquisite qualities can be obtained in this way. A colour painted in a second painting upon a similar colour underneath is poor-looking and dull. The advantage of scumbling all over your work before painting into it is that you make it all wrong and have to take the whole thing up again. But if you have allowed for it in the first painting, and more or less solidly finished your shadows in a light key, a scumble may well be left in these parts and solid lights dragged over the half-tones, giving a beautiful contrast with the transparent shadows. All such attempts at beautiful colouring should be left until the student is far advanced, as they need much more certain and deft painting, than he will be able to command for some time. But this head of Velasquez certainly exploits the beautiful

effects of thin, cool, solid lights painted into trans-
parent shadows. The danger of working into a warm
scumble is, that it puts your eye out, and you are likely
to get the tone of the scumble into the finished work.
To avoid this it is necessary to at once paint cool lights,
to correct the warm impression of the scumble, using
pure blue if necessary as the scumble will modify it
considerably and this should be allowed for.

But the chief distinction of this head remains, not
how it was done, but who did it. The eye that controlled
each touch and had in mind the effect aimed at, is the
thing you must try to acquire. The distinguished sense of
form, its large and simple treatment ; the beauty of the
light suffusing the cool flesh. Here an instructor in the
craft must leave the matter in the student's own hands.

A Note on Reynolds

Sir Joshua Reynolds developed a very rapid method
of painting portraits, no doubt partly due to the great
demand there was for his work. It is recorded that he
painted as many as 150 portraits in one year. This is
at the rate of one in every two days and a fraction,
working every day all the year round, Sundays in-
cluded. This he managed by painting the portrait in
monochrome, which would be completed in one or
two sittings in the case of a head-and-shoulder size,
and afterwards glazing it with colour and painting a
few solid accents into it, which would be done in one
sitting. It was a summary method and not always very
satisfactory to the sitter, as he had a room full of rejected
portraits in his house when he died. His system was that
you paid half the money down before the commence-

ment, and if you did not like the portrait you forfeited this amount, and need not have the portrait. He used black and white for this monochrome underpainting, sometimes with French blue with it ; the lights being almost pure white. He was very skilful in glazing this with transparent colours, but not very careful of the permanency of the colours or varnishes used ; and the result is that many of his works have suffered horribly by the darkening of the varnish and the fading of such fleeting colours as crimson lake, which he used. It is a quick way of finishing, as glazing refines the appearance of the handling ; but you are absolutely tied to a formula of colour, which cannot vary much with your different sitters. It is essentially a brown school method. But Reynolds' great distinction is rather in spite of, than because of, his method of painting. This distinction is in the largeness and splendour of his vision. The accompanying illustration shows his large, simple treatment of a subject. To reduce it to a simple statement of light and shadow, and eliminate as far as possible the weakening effect of half-tone, he lit his subject with a small window, commencing nine feet above the floor and four feet square only. This gave him a shaft of light that made everybody very brilliant and simple in appearance. For be it observed that the smaller the source of light the less half-tones you get. A person standing under a gas lamp at night is cut out in black and white with little or no half-tone. The demonstration head I painted for this book suffered from the fact that in order to get the most out of a dark December day, I opened not only all the side light but the skylight as well. I had

a better light to work in, and have the photographs taken by ; but the subject suffered by having too much half-tone for an impressive study.

Notice how well he has designed the masses of hair ; the square line against the forehead, and the square line from the ear backwards. Also how very simply he has treated the smaller surface modelling in the lights of the face. Nothing is so becoming as simplifying the modelling of a face. This is what powdering does ; it lowers the tone of the lights by taking away the shine, and raises the tone of the half-tones, by putting a powdering of white on the little hairs on the skin that catch the light in the half-tones ; and so brings the whole modelling to a more uniform tone. See how he has ignored those tiresome high lights that cut up the modelling. Even powdering does not always remove the one at the tip of the nose ; but the artist is not obliged to catalogue all these details, and Reynolds has only hinted at it here. This simplification, this seeing with a large vision makes anything look handsome; but it is not the mean form of flattery that alters the main facts in order to please the sitter. An artist is not only honest when he sees with the mean vision that catalogues all the little details, and misses the larger, nobler facts that are behind them.

The same simplification that he gives you in the modelling, he gives you in the contours. See the simple sweep of the line from the ear along the under side of the jaw, right round the chin. How well he has designed the folds of the fichu in harmony with the lines of the head and neck, making the whole light mass, face neck and fichu, into one scheme.

OIL PAINTING

A Note on Gainsborough

Plate 38 is a good example of Gainsborough's gracious manner. He worked with paint thinned with much turpentine, and sometimes a little linseed oil, on a fully-primed canvas toned to varying shades of a warm neutral tone. The Mrs. Graham as a servant (Plate 55) shows you his manner of commencing. The ·whole has been rubbed in with burnt umber cooled with terra vert, and a little red used in the face. At the next painting the head would be scumbled with a warm brown and painted into with terra vert and white. This, with the warm tone already there, would give him his cool half-tones, and into this reds and yellows would be painted for the lights, the whole of the modelling being worked up in this way. The darker accents of the features are then smartly painted in, with a small soft brush, in a sketchy loose manner, that nowhere give a very high focus; the attention being always kept engaged with the charm of the whole impression, and never allowed to be attracted to any one part unduly. The study of his daughters (Plate 39) in his earlier manner is interesting as it shows the deft way he rubbed in his work, in the unfinished hands and body. The heads show the hatching method of getting the modelling in his lights, that he no doubt used in the modelling of the Mrs. Norton, but the evidences of which he has afterwards concealed. There is in the Mrs. Norton, as is often the case with Gainsborough, a distinct break between the under modelling of the head (which is always very much simplified) and the final accents of the features. The

PLATE 37

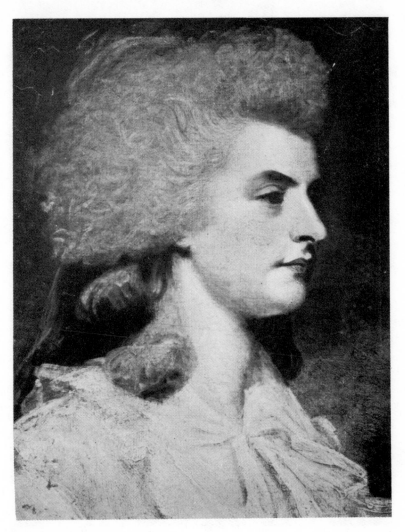

Wallace Collection

DETAIL OF PORTRAIT BY REYNOLDS

Photo : W. A. Mansell & Co.

PLATE 38

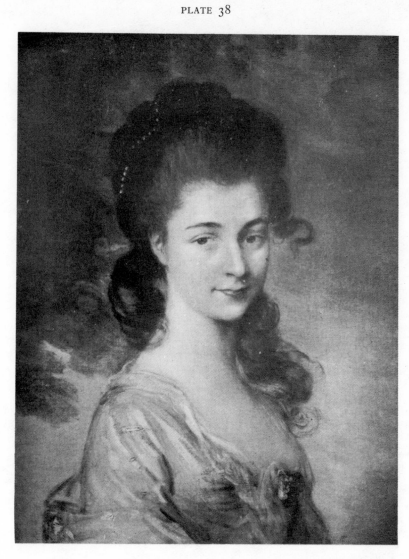

Gainsborough

MRS. LOWNDES-STONE NORTON
(detail of picture)

PLATE 39

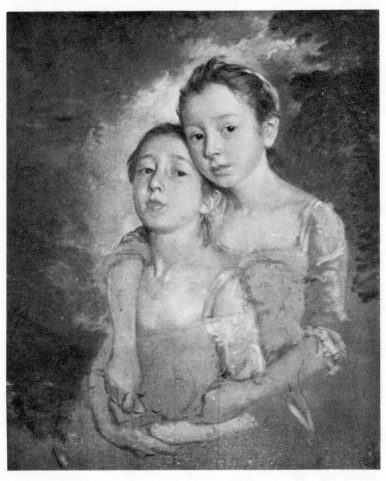

THE PAINTER'S DAUGHTERS
The unfinished state shows use he made of a toned background, and the
charm and variety of his handling

latter are put in at one go with the directness of a swift pencil drawing ; every touch in tune to a oneness of impression. This swift unity of impression, is one of the secrets of charm ; a thing that must always be caught on the wing. Gainsborough was one of the first to give us on canvas this feminine charm. The Venetians gave us women that are wonderful creatures ; the Florentines, mysterious sphinxes ; Velasquez appears to have been more interested in his dwarfs than women ; while Rubens and the Dutchmen give us buxom wenches. But it is not until Gainsborough that the real women we take to our hearts were born upon canvas. Vandyke was the nearest to it ; but there is still a barrier between us ; and the women of Reynolds, beautiful as they are, have not the intimate touch of Gainsborough's. His women flutter on the canvas with all the disturbing charm of real life. The light, feathery touch of his handling was developed, as being the best means of conveying this charm. The manner, as should always be the case, grew out of the matter. So that no laws can be laid down as to what manner one should paint in. The manners are as different as the men : every painter who counts stumbling upon one that suits his needs.

A Note on Franz Hals

Among the older masters nobody is more conspicuous for the fascinating quality of spontaneous handling than Franz Hals. Not even time has dulled its effect. Although it may be observed that his work, having been thinly painted with a simple palette of sound colours, has stood remarkably well, and changed very little. Plate 40 is a typical example of his handling ;

painted with soft brushes (not hog hair) in one painting, on a canvas slightly toned with raw umber. This thin scumble of raw umber greatly helps the quality of his cold blacks ; painted over it, in places so thinly that it shows through (see particularly the shadow side of ruff). His blacks are remarkable for their beauty; a result due to thin painting over a warm ground with soft brushes that did not leave a scratchy effect, as hog hair brushes would have done with such thin paint. The rather soft effect such brushes are apt to give, is counteracted by the crisp vigour of his handling ; and when he wants a crisper effect he hatches (as in the hair). Notice the square drawing of the edges which also helps to counteract the weakening effect of soft brushes. See how deftly he has painted the ruff ; a gradated middle tone from light to dark being first smoothly painted, into which he has flicked with wonderful dexterity the lights, and then a few darks. Altogether the work of a painter who thoroughly knew his job, and was not bothering himself to search much below the surface appearance of things. A contented bourgeois attitude of mind that nowhere strikes a deep note, but fascinates from the perfection of the means employed to accomplish the end aimed at.

A Note on Rembrandt

Rembrandt strikes a very different note to Franz Hals : one very far from the easy, superficial view of humanity that Hals was content to present so brilliantly. Portraits, particularly of old men and women, had never been painted before by such a penetrating vision, and with such sympathy for poor struggling humanity,

PLATE 40

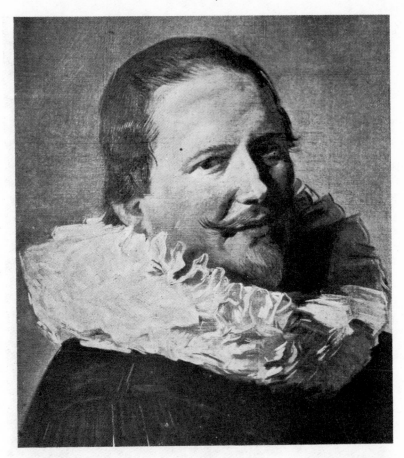

National Gallery　　　　　　　　　　　　　　　　*Franz Hals*

PAINTING OF A HEAD
(detail of picture)

Photo : W. A. Mansell & Co.

PLATE 41

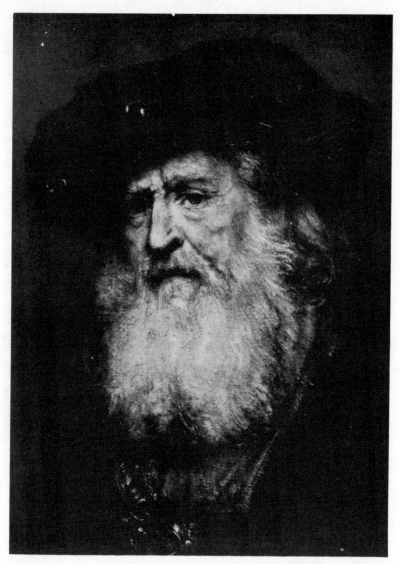

Dresden

Rembrandt

HEAD OF OLD MAN
(detail of picture)

Photo : Alinari

as Rembrandt gives us. Such profound notes cannot be struck off in a brilliant improvisation, but have to be groped for in a more fumbling manner. A very different technique becomes necessary, one that can be worked on over and over again if necessary. And instead of the clear noonday lighting of Hal's laughing burghers, we find in Rembrandt's portraits the mystery and glamour of a light penetrating unutterable gloom, and revealing the spirit of the sitter. It is said he commenced painting in an old mill ; and at any rate it was in some such dark place, lit by a small upper window, that he first learnt to love the scheme of lighting he afterwards adopted.

As to his technique ? What can one say of a man who painted in so many ways, and had such a wonderful command of the possibilities of paint, using solid and transparent colour in every conceivable way, and inventing new ways all the time? The face of the accompanying portrait appears to have been put in at first with a very broken quality of colour; with stiff untidy brushes that scratched the paint on very crisply, and left strong ridges everywhere. How many times it was worked on in this state, who can say ? But in the final painting there are a lot of very thin filmy half-tones, lightly dragged over a transparent glaze of warm brown when it was tacky; which glaze had evidently been rubbed over the whole face before commencing. This glaze over the dry crisp work of the earlier stages, turns up all round the edges of the face and beard; where, except for one or two crisp lights in the beard, it has been left. Thin, solid colour painted over a transparent glaze has a lovely pearly quality, exquisite

for half-tones if it can be dexterously brought off in the right place. In contrast with these films of paint there is also some very vigorous solid work in the lights in this last painting. But except for a sharp, solid accent on the bridge of the nose against the shadow, and the accents in the beard already referred to, this solid work is kept well away from the shadows; the filmy quality everywhere coming between.

This play of solid and thin paint on the vigorously handled under painting gives a lovely rich quality to the light mass. This quality is in itself a poem in paint and cannot be conveyed in words. Rembrandt was a great master of getting the utmost variety out of a few earth colours. By manipulating them in every conceivable way, both solidly and in a transparent manner, he obtained a great richness and variety of colour effect with a very few pigments. This helps to give his work that dignity and sublimity, the secret of which in colouring, seems alone to be possessed by the earth colours.

CHAPTER X

TONE AND COLOUR DESIGN

THERE are two things that excite one's interest in a picture, the objects represented, and the rhythmic arrangement of the form, tone, and colour. The first is the one that the lay mind is most consciously interested in, and is what in his mind constitutes the painter's magic. I say most consciously, because subconsciously he is often being carried away by the force of rhythmic expression, while thinking he is only being moved by representation. To see things " looking so natural " while all the time they know it is only a flat painted canvas, always inspires a certain amount of awe in the uninitiated. And while it is not here that the mystery of art exists, and while this quality has been too much exploited by popular artists in the past, representation is not a thing to be so entirely ignored and flouted as it is now the fashion in " advanced " circles to do. The expression of art must be capable of recognition ; it must not only satisfy the artist, but must communicate what he wishes to express to some beholder. Art may be expression, but if nothing has been communicated, nothing has been expressed in any effective way. A work of art is a bridge between the artist and the beholder ; it bridges the gulf that separates the spirit of the one from that of others. If the bridge cannot reach the other side it is not a bridge at all, however good the original intention of the builder may have been.

Representation is the universally recognised element in the language of the painter's expression, and one that cannot be ignored without the picture failing in its appeal. It is this matter of representation, and the power the painter has of exciting the many associations connected with different objects, that makes the contents of a picture so much richer than that of, say, a Persian carpet. They both have rhythmic expression ; but in the picture this is combined with the representation of objects, which opens up larger fields of æsthetic interest.

Naturalness of appearance is certainly not the standard by which painting should be judged, but it is the quality that makes a picture persuasive to the ordinary beholder; who is surely not a person to be so entirely ignored. A portrait that is not recognisable by anybody who knew the sitter, may be a fine work of art, but is certainly lacking as a portrait. While, on the other hand, the popular habit of judging a portrait entirely on its likeness is poor indeed, and justifies to some extent, the extreme attitude of those who would judge it entirely by its qualities of rhythmic expression. When the representation is carried to a sense of actuality that dominates the picture, getting in front of the true matter of painting, and smothering any æsthetic expression it may have, it is bad.

Rhythm, the other quality in painting that excites our interest, is where the real mystery and vitality of art exists. For it is by means of the rhythmic ordering of the different elements of a picture, form, tone, and colour, in harmony with an innate sense the artist has, that he lifts visual facts to the realm of those spiritual

experiences we call the æsthetic; and thus conveys his experience to others. For there is in form, tone, and colour arrangements an expressive power quite apart from anything represented; although combined with representation, with all its associations, it has a considerably added effectiveness. But in themselves alone, the elements of a picture have emotional significance. By far the larger part of the subject of rhythmic design comes under the consideration of form, which we are not now considering. But there are a few things that may be said on the subject under the head of tone and colour.

The expressive power of colour has been so much realised that a whole catalogue of meanings has been attached to different tints. And although we need not carry the idea to such a definite conclusion there is no doubt about the emotional significance of colour, any more than there is about the emotional significance of sound; and certainly not when the colours or sound are combined in the vital relationship that makes a work of art or a musical symphony.

Possibly this emotional expressiveness that is so mysteriously connected with form, tone, and colour has some connection by the association of ideas with our experience of visual things. It certainly seems as if natural appearances conform to the same laws of expression as govern form, tone, and colour unrelated to natural appearances. In painting, strongly contrasted tones excite, while closely related tones (those near together in the scale) soothe; and with colours, the hot colours excite and the cold soothe. And in nature it is in stormy effects that you get some of nature's

strongest contrasts, and on a quiet grey day when the tones are all quietly related that you get some of nature's most soothing effects. We say hot colours excite. Orange red is the colour of fire, of the flaming sunset after a storm, etc. That cold colours soothe. Blue is the colour of the vast infinity of the sky, and green the colour of the peaceful fields. Blue is also the colour of the sea, which is not always soothing in appearance. But it is bluer in its calmer effects than in its angry moods.

But I don't see how this reasoning will apply in the case of music. It is difficult to see how sound can owe any of its significant power to association with natural sounds.

Is it not rather that instead of this expressive power in form, tone, colour, and sound in certain rhythmic relationships being derived from material nature by association, it is derived from our inner immaterial nature, and is one of the evidences that our inner nature moves in another plane of existence to this. And that by the creation of works of art, we are continually seeking to transform the things of this existence into terms of this inner, more permanent realm. That art re-creates the material of nature, in terms of these inner, more absolute values. And that any relationship that may exist between this inner life and things seen, is due to the fact that the ultimate cause of both is the same. That we are a part of the same ultimate reality, that is expressing itself in and through all things.

But to come back to our craft. What the painter has to do is to see that the tone and colour design in his

picture is governed by considerations of its emotional fitness to the impression he wishes to convey; and not, as is so often the case, left entirely to considerations of truth to natural appearances, which may or may not give him the tone and colour scheme he needs.

As in the case of form, so in tone and colour design one is governed by the same two qualities of unity and variety.

TONE DESIGN

The most perfect example of tone unity is a simple, perfectly flat tone; unity without any variety. But this is an extreme, and like all extremes unsatisfactory. On the other side you have a chaos of variously contrasted masses of many different tones without any plan or order; variety without any unity. In the first case you had a deadness and in the second an excess of liveliness. In a well-designed tone scheme, a balance is set up between these two extremes; erring on the side of unity or variety according to whether quiet or excitement is your aim. But however exciting your tone contrasts, they should always be dominated by a well-marked tone plan giving them unity.

Unity of tone depends on a large, clearly realised scheme, the smaller masses being subordinated to the larger. The endless variety of nature needs co-ordinating into a unity of plan. One mass should generally predominate in scale; and equality of mass or shape should be avoided as it is dull and monotonous.

It was an old practice in designing, when pictorial design was considered as an arrangement of objects, always to contrast the light side of an object with a

dark, and the dark side with a light tone ; the objects being lit by a side light, and gradating from light to dark (Plate 42). And now that we are beginning to design in impressionist masses rather than with objects in space, the same principle is being applied to the patterning of the visual masses. A well-marked design is got by this means, but the effect is apt to be a bit worried unless the design of the shape of the masses is well considered—of a fine unity and breadth. This scheme is more applicable to decorative painting, where it is necessary to carry the attention more or less equally over the whole surface of the picture, rather than to concentrate it on a particular part. But it is not one that has much of the particular beauty we associated with tone values.

This forcing of dark against light and light against dark in the pattern of masses, throws up the form, but does not make for the breadth of tone scheme that is necessary for beautiful tone values.

Another scheme which makes for a broader effect, is to assemble the light masses together and to unite the dark masses also, so that the light and dark tones, instead of playing together throughout the picture, are divided and grouped separately. The difficulty here is to get the details in your masses to tell ; to get any definition in your light on light and dark on dark. Rembrandt used this scheme sometimes, particularly in his large etching compositions. But here the outline convention helped him and the difficulty of definition did not arise. Paul Veronese often used the same scheme in his pictures, putting a light sky or light architecture behind his light masses. But he got over the difficulty of definition by frankly putting a dark outline round

PLATE 42

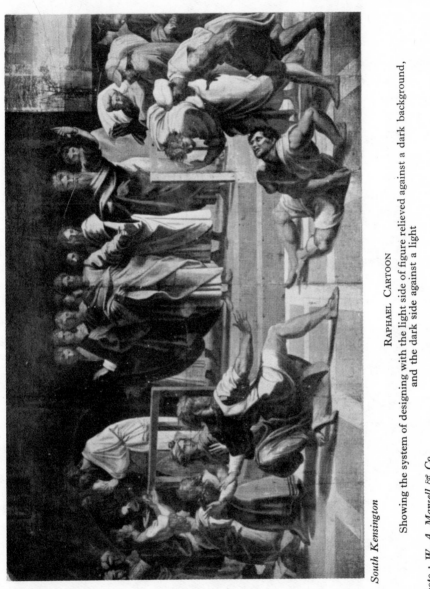

South Kensington

RAPHAEL CARTOON

Showing the system of designing with the light side of figure relieved against a dark background, and the dark side against a light

Photo : W . A. Mansell & Co.

PLATE 43

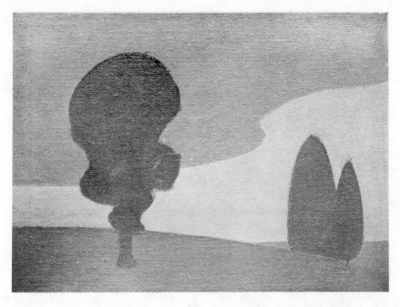

No. 1

Diagram illustrating restful expression of tones in middle range

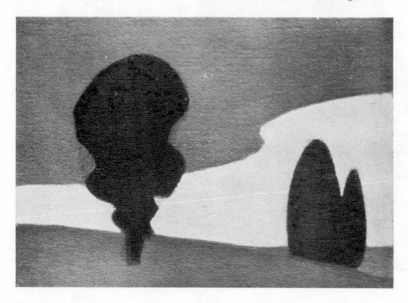

No. 2

Diagram illustrating dramatic effect of strongly contrasted tones

PLATE 44

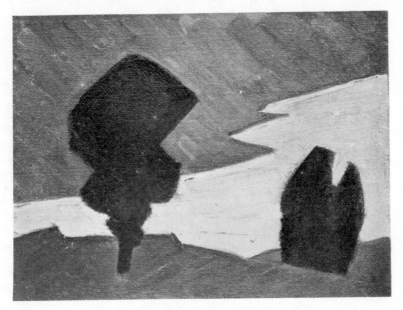

No. 3

Diagram illustrating dramatic effect of strongly contrasted tones made more dramatic by jarring edges

PLATE 45

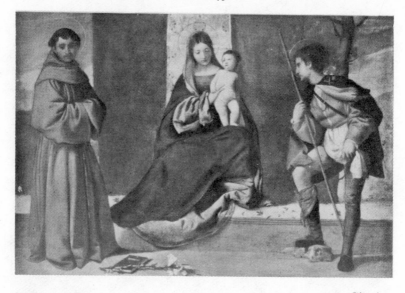

Prado *Giorgione*

HOLY FAMILY AND SAINTS

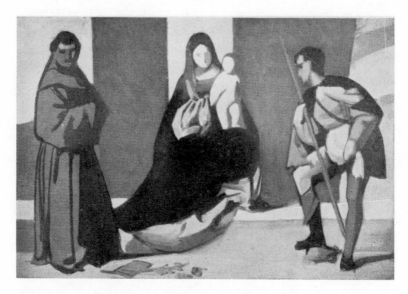

TONE PLAN OF GIORGIONE'S HOLY FAMILY

Photo : Anderson

his objects, subtly treated so that the device was not too obvious. Turner also was fond of this tone arrangement, particularly in his latest manner.

In a picture the predominant tone of which is dark, it is the light masses that will attract attention. And in a picture the predominant tone of which is light, it is the dark masses or spots that will catch the eye. This is why portrait painters so favour a dark background, as it so easily makes the light head the dominating interest in the picture.

Something should be said about gradated tones and flat tones. A picture designed on a scheme of gradated tones is more graceful than one designed on flat tones; but may easily degenerate into effeminacy and feebleness. It is as well to design as far as possible in flat tones; and let your gradations be the result of such tones melting into each other where necessary. As in form the finest modelling is built up of planes, and the character of a form is given best by the disposition of its planes, so in the larger form idea of pictorial design, it is best considered in the first instance in flat tones, which have more force of character; the gradations being given by lost edges. The larger the number of these lost edges the more gracious the expression, and the larger the number of hard edges the more forceful and less gracious the expression. In normal work there is a pretty balance between these two classes of edge set up ; lost-and-foundness playing in varying degrees along all the edges.

The smaller the range of tone used the quieter and more peaceful will be the effect. This smaller range of tone should always be chosen from the middle of

your scale, or the balance of tone will be uncomfortable. A picture with a limited range of tone all on the light side or all on the dark side is unsatisfactory. But such schemes can often be righted by a small accent. A dark spot, like Turner's black gondolas in his light Venetian subjects, such as No. 534, National Gallery, is quite enough to restore the balance. And one has seen many successful dark pictures with only one or two light accents.

When the full scale is used and the tones strongly contrasted you get the most dramatic effects. But when the full scale is used but the tones are not strongly contrasted but gradate quietly one into the other, you get an effect that is neither dramatic nor peaceful but simply a strong normal effect.

The diagrams on Plates 43, 44, may illustrate these remarks. No. 1 is the peaceful effect that you get when a middle range of tone is used. The lights are low in tone and the darks high. No. 2 shows the dramatic effect of a strongly contrasted full range. Only here the dramatic effect of the tones is out of harmony with the suave quality of the flowing contours. And also the even quality of the tones is quiet and restful. The reproduction has missed this evenness of tone. In No. 3 the contours have been altered to more dramatic jarring forms, and the tones have had the excitement of variety and movement introduced, to the intensifying of the dramatic impression.

The following are a few examples of the tone plan in some well-known pictures, to which is added a diagram of their line arrangements.

Giorgione's Madonna and Child with Two Saints: Prado, Madrid (Plate 45). This is an interesting example

of a primitive form of composition much in vogue at the time, into which Giorgione has introduced some of the wine of his freer manner. The Madonna's head is in the correct central position. The centre of her mouth, on which the focus of the head is fixed, is exactly midway between the two sides. But the drapery hung behind the head, in the regulation manner, is pushed a bit to the left. The Virgin's drapery is dragged violently in the same direction, attaching itself to the saintly monk on the left. From this point vigorous lines flow off to the right, ending in the lines in the sky and the elbow of St. Roche. In order still further to break the static symmetry of the composition, that evidently a little worried his unconventional mind, he has lost the edge of the dark drapery in the background on the right by wilfully darkening the sky at this point; thus carrying it away in the rush that sweeps to the right.

Giorgione's Fête Champêtre (Plate 46). Here Giorgione is free to indulge himself; and how wonderfully he has taken advantage of his opportunity. We who have seen so many pictures founded on this model, can hardly imagine the sensation such pictures as this must have created when first painted. Painting had been under the thraldom of the Church, and artists were getting more than a little tired of saints and Madonnas. And in this picture Giorgione has thrown off all reserve and let himself revel in the rich forms and colours he delighted in, without any of the restraints imposed by a Church commission. He has in this picture created a type of subject into which he could pour the rich music that was bubbling up within him, a type that

has had such a wide appeal with artists ever since.
His fondness for introducing musical instruments into
his pictures hints at his preoccupation with music, and
a conception of painting as visual music. But to come

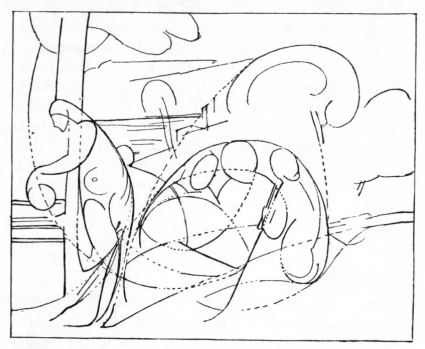

FÊTE CHAMPÊTRE *Giorgione*

to the cold business of tone analysis ; he has used a
fairly wide range of tone, but nowhere in very dramatic
contrasts ; except possibly in the female figure on the
right, where he has gone out of his way to get harshness
of effect, to balance the softnesses that abound, and
would cloy if not balanced by some hardness. But
generally the light masses play through the dark and
the dark through the light. Richly gradated tones are
contrasted with plain surfaces, and in the contours

PLATE 46

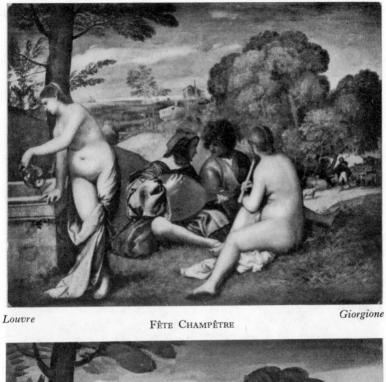

Louvre FÊTE CHAMPÊTRE *Giorgione*

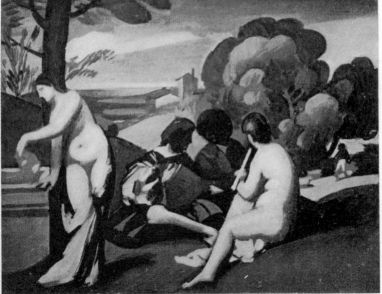

TONE PLAN OF FÊTE CHAMPÊTRE

Photo: Alinari

PLATE 47

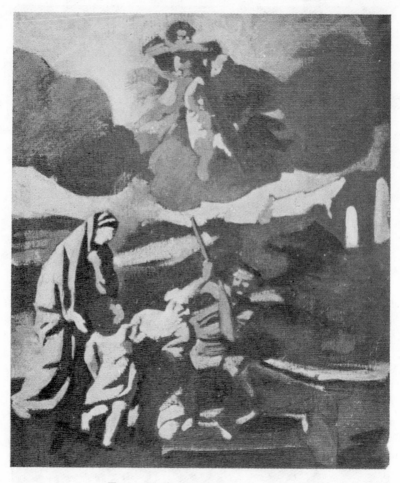

Tone scheme of Flight into Egypt

straight lines with curves. A lost-and-foundness plays
through all the edges. The soft forms of the flesh are
contrasted with the staccato accents of the draperies,
etc. I have tried to indicate the underlying tone plan
in the accompanying diagram; but in the reproduction
it looks much more like the finished picture than I

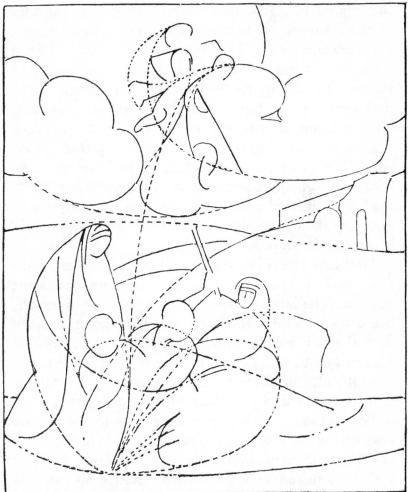

LINE RHYTHM OF FLIGHT INTO EGYPT

had intended, due to the block maker's incurable habit of putting in high lights.

Poussin—The Flight into Egypt : Dulwich Gallery (Plates 47, 48). This is a typical seventeenth-century composition, probably painted on a dark ground. The lightest and darkest masses come together at the feet of the Infant Christ in strong contrast. From here the lines of the composition flow and the accents, light against dark, gradate away. The main accent is echoed in a softer key by the cherubs against the cross at the top of the picture, and by the sudden dramatic accent of the dark arch against light on the right middle distance. This scheme of strongly contrasted light and dark masses at some important point in the picture, from which the lights and darks drift off in lessening contrast with echoing accents at certain points, is a much used conventional formula. It serves the purpose of directing the eye at once to the main subject and leads it through in an orderly way.

Paul Veronese (Plates 49, 50). This magnificent composition is a good example of Veronese's handsome manner. The large sweep of the long flowing lines, the breadth of the tone, the finely modelled forms, coupled with the rich colour, make this a supreme example of his sumptuous art. You will notice how he has got over the difficulty of contrasting his light masses with the light mass of the sky by the bold device of giving them a dark outline. This is particularly noticeable in the case of the back of the female figure. When a composition consists of several figures it is always a pleasing variety to introduce a back view. Notice also in this picture how the composition is conceived and designed

PLATE 48

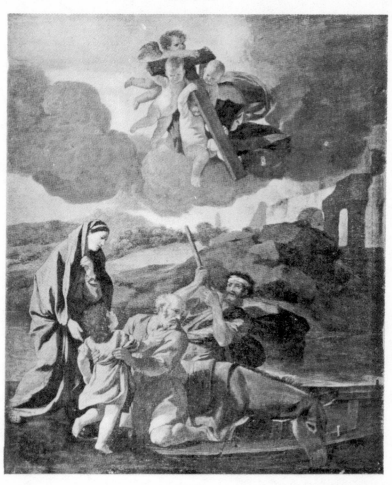

Dulwich Gallery *Poussin*

THE FLIGHT INTO EGYPT

PLATE 49

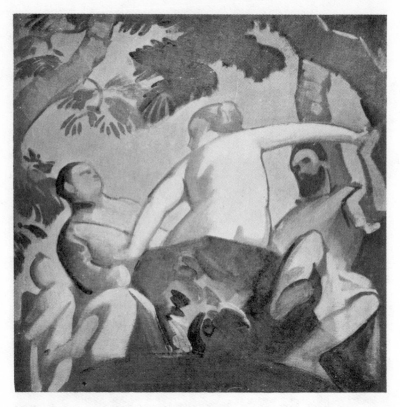

TONE PLAN OF PICTURE

PLATE 50

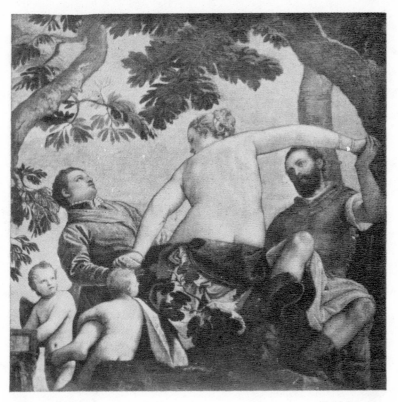

National Gallery

UNFAITHFULNESS

Paul Veronese

Photo : W. A. Mansell & Co.

PLATE 51

National Gallery *Corot*

LANDSCAPE WITH FIGURES

An example of the monochrome, full of colour values, scheme of colouring

Photo : W. A. Mansell & Co.

in three dimensions, not as a flat design only. How rhythmically the planes of the three principal figures are evolved round a common centre, and carry the

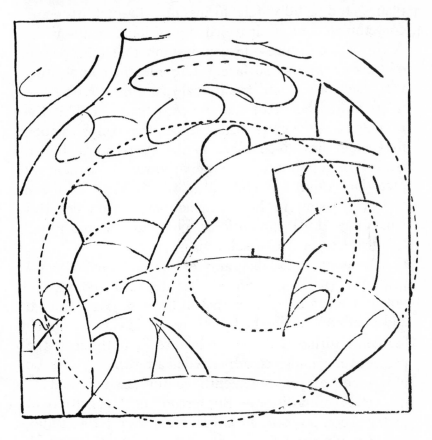

rich swinging movement of the lines into the third dimension. This third dimensional composition was a new thing, brought into composition with the introduction of perspective, and introduces a rich element in pictorial design. With it the movement of the composition is carried into the picture as well as about

the surface. And to the expressive vitality and rhythmic impulse given by a beautifully designed line pattern, it added a new sense of the movement of planes and solidly felt forms *into* the picture, and contemplated in their third dimensional relationship. A sort of sculpturesque composition that takes count of bulk as well as surface. This idea in composition that had never left traditional painting (Watts had it in a high degree) has recently come under the notice of the extremists, since the Impressionist movement has given place to the Post-Impressionist. And it is undoubtedly a very powerful element in pictorial design. Architecture, which Paul Veronese so loved using in his compositions, introduces this handsome third dimensional composition and gives a magnificent sense of solid mass.

In making these diagrams of the anatomy of compositions, it will be noticed that the result comes out not unlike some canvases that in these days are framed and exhibited as finished pictures. The earnest search for composition bed rock is an excellent thing at the present time, and was sadly needed after the naturalistic movement of the nineteenth century, which had so neglected composition. But a study in the anatomy of pictorial composition, however interesting in the studio, is not a thing to frame and exhibit as a complete work of art. The skeleton of a composition is very necessary, and a good skeleton a very valuable thing in a picture ; but it needs more than that before it is fit to leave the studio as a completed production. It is, however, a promising sign for the future, that some of our young painters prefer a skeleton with no picture, to a picture with no skeleton.

COLOUR DESIGN

Dividing the solar spectrum into two divisions at its lightest point (in the yellow), you have roughly the warm colours on the one side, and the cold colours on the other. Lemon yellow, green, greenish blue and full blue on the cold side, and the more orange yellow, orange, orange red and full red on the warm side. Purple that comes outside these is like the yellow in the middle, in that it can be either a warm or cold colour, according to whether it leans to the red or the blue side. It is on the play between these warm and cold colours that much of the variety that gives vitality to colouring depends.

Black is the negation of colour, and is not in the solar spectrum. But it is invaluable in painting for neutralising other colours and lowering their effect. It can err on the cold side towards blue and the warm side towards brown. These neutral tints, these warm or cold blacks, are very valuable, as the eye is easily surfeited with colour and enjoys the rest of neutral passages.

Something should be said, however tentatively, on the laws of Harmony and Contrast as they affect colour; although I must admit to having very hazy notions about them. By the law of harmony, if you introduce a red note, all the reds in the other parts of the picture are brought out. In the same way that a person with blue eyes, wearing a blue tie or hat, makes his or her eyes look bluer thereby. On the other hand, if the law of contrast is working, by putting a red note in your picture you make the surrounding colours look their greenest, and the person wearing a very strong blue tie or hat would make their eyes look less

blue. There is thus a contradiction between the laws of harmony and contrast, and the point one wants to know is, what are the occasions that are governed by the one and by the other. I think it will be found that it is only when the colour is very vivid, and of sufficiently large mass, that the law of contrast is effective. If the red introduced into the picture is very vivid and of sufficient quantity, it will kill all the quieter reds in the picture and everywhere accentuate and intensify the greens. And similarly with any other colours, if they are very vivid and violent they will tend to make their complementary colours tell in the picture, and to kill the quieter varieties of their own colour. I fancy this is due to fatigue of the nerves of the retina. The perception of a very strong colour, say red, tiring the faculty for perceiving that colour, so that there is no energy left for seeing the subtler red notes in the picture. The faculty for perceiving the reds being thus absorbed by the violent note, the blues and yellows are seen in the other tones of the picture, but the red is overlooked by the fatigued sense and a green tone predominates in consequence.

When the colour introduced is of a quieter order, those similar to it in the other parts of the picture sing up in sympathy. This is the more general effect of the introduction of a colour mass into a picture, as it is not often, except in poster work, that very violent colours are used ; and it is exceptional for the colour to be so violent as to produce the effect of strong contrast. Many a stuffy picture has been freshened by the introduction of a blue note, bringing out all the cool colours. And ladies know how fresh

and cool in colour their complexion is made by wearing a rich blue dress, or standing against a rich blue background. But it is difficult to lay down precise laws in regard to colour harmonies and contrasts. The student must observe and experiment for himself, but it is as well to be on the look out for these two somewhat contradictory effects of colour.

Harmony and Contrast are somewhat analogous to Unity and Variety; the two considerations that govern colouring, as they do all the other elements in pictorial design. And as in form and tone you want variety in unity, so in good colouring you want contrasts in harmony.

The most complete unity of colour is a monochrome. But such a unity being without any variety is lifeless as colour, dull and monotonous. The most extreme instance of variety in colour is a design of violently opposed masses of raw colour, with nowhere any attempt to introduce them and bring them into a unity. There is no lack of life here, but being utterly ungoverned the result is chaos. A balance has to be struck between these two opposing extremes, with a bias in the best work on the side of unity. When the bias is on the side of variety you get the picturesque colouring that is often very popular but which lacks the sublimity that unity alone can give.

The picture with the least variety and the most unity of colour, is what we may call the monochrome picture that is full of colour. Where there is an all-pervading unity of hue throughout the picture, which the varieties of colour introduced are not allowed to be strong enough to disturb. There is something

very sublime about this scheme, and many beautiful pictures have been painted in this manner. For while a picture in absolute monochrome is dull and lifeless in colour, one that has a prevailing unity of hue, but is full of colour varieties subtly introduced in the tones, is one of the most beautiful of schemes.

Moonlight subjects present this problem of the monochrome picture that is full of colour. There is an all-pervading unity with nowhere any pronounced colour, and yet colour seems to vibrate everywhere, and the colour values to be intense. London subjects on grey days present this problem of the monochrome picture rich with hidden colour. The mistake of so many painters of London is that they force the little varieties they can find, making pretty pictures, but missing the magnificent sobriety of London's serious colour note.

Corot's pictures in his later manner, show this beautiful monochrome scheme of colour; a good example of which is No. 2625 in the National Gallery (Plate 51). Here he has used a refined touch of warm colour on the head of the woman in the centre of the picture, which muted warmth is slightly echoed in the boat on the left and the tree trunks. But it is all very restrained and subtle.

Claude is another example of this restrained use of colour, keeping his pictures in a cool scheme full of qualities of colour, but nowhere of any striking hue. This scheme gives an intense restfulness and unity of expression.

This is the type of colour scheme where a note of strong colour is often effective. The postal authorities

seem to have had an instinct for this in painting
the letter-boxes which make such effective colour
notes in our sombre streets. Or perhaps it is a bit early
yet to attribute æsthetic intentions to a Government
official, and he merely meant them to be obvious.

In these large schemes of colour, the prevailing hue
must never be of a very pronounced colour, but always
in the more neutral range.

Another scheme related to this is a pattern of masses,
nowhere of any very pronounced colour and every-
where related to an all-pervading hue which underlies
and unites them into a whole. In this scheme a greater
freedom in the selection of the colours is possible as
the underlying hue can be relied on to unite them.
But the selection of too many varieties of colour masses
should be avoided. Colour is a precious thing, and
precious things are more enjoyed when they are scarce.
A lavish display is apt to be vulgar ; and to preserve
the value of your colour notes you need to use them
sparingly. The precious note is best reserved for the
principal object in the picture, as it will attract the eye.

Another more robust scheme of colour design, that
was largely used during the reign of the brown school,
was for the whole picture to be of a more or less rich
warm neutral hue, with two principal notes of con-
trasted warm and cold colours ; brought into harmony
by intermediate tones. Reynolds' " Holy Family,"
National Gallery, No. 78 (Plate 53), will serve as an
example of this scheme, which the student can observe
for himself in the Gallery on every hand. Here the
prevailing hue is a particularly cool brown, some-
what similar to what is found in Correggio's work ;

whose colour Reynolds admired so much. This particular cool warmth Reynolds thought was due to an underpainting of black and blue, which is how he has got it in this picture. The cold blue of the Virgin's skirt is the dominant colour note. This is echoed with considerable force in the sky, and to a lesser degree in the stone plinth in the background behind the Virgin's head. A warm note of less force is the red of Joseph's dress, which is echoed in the hue of the Virgin's tunic and the touch of red in the cheek. The colour balance of this picture is on the cool side; which is very refreshing in a gallery where old varnish has taken the place of so many of the original colour schemes.

This scheme of a strong note of warm colour, and a strong note of cold colour, brought into harmonious relationship by intermediate colours introducing them, you will find in the colouring in Leonardo's "Last Supper," an interesting early copy of which is in the Diploma Gallery at the Royal Academy. The two strong colour notes, red and blue, are brought together in the figure of Christ in strong contrast. The blue and red are very much the same tone, the contrast of colour being sufficiently violent without a contrast of tone. From these two notes, muted reds and blues drift through the picture to be united in the row of hangings on the wall, which are purple. This variety of colour scheme is analogous to the tone scheme in which there is a main accent, where the darkest and lightest tones are brought together in strong contrast, and then allowed to drift apart to be united by some middle tone passage.

TONE AND COLOUR DESIGN

Turner's " Ulysses deriding Polyphemus," in the National Gallery, No. 508, is a beautiful example of *tone* this principle in both colour and tone. The accent is *area* at the point of sunrise, where the dark mass of the water and rocks meets the lightest part of the sky. The strongest warm colours of the sky are at this point contrasted with the coldest blue of the water. From here the warm colour of the sky gradates away in more and more muted tones until it meets the blue note of the sea (which has also been losing itself) in the neutral tone of the sky on the top left hand corner of the picture. The warm colour is echoed in the cold colour by the warm mass of the ship. And the cold colour is echoed in the warm colour by the cold accents in the sky above the sunrise, and the whole brought into a perfect unity.

Beauty seems to delight in this bringing of opposites into unity, of diverse things into harmony.

In the same way that we saw that a large handsome tone scheme is obtained by massing your light masses together and your dark masses together, so in colour a fine arrangement is to mass your warm colours together and your cold colours also; letting this big scheme of variety take precedence over the smaller varieties in the parts. In his latest mood Turner used this scheme very largely; almost a little too obviously, suppressing the cold varieties in the warm parts and the warm varieties in the cold parts in a way that is often rather too apparent. Whenever any composition device becomes too obvious one's sympathy is alienated, and it fails to move us as it might if the device was not so noticeable. Turner's habit of painting the

incidents in a warm light mass, in pure red, and those in the cold mass, in pure blue (as in some of his more extravagant later colouring), while it considerably intensifies the warm and cold colour impression of the two contrasted masses, it a little irritates one by the obviousness of the device.

Scheme your colour arrangement with the same breadth as your form and tone. Begin with the broad idea and let the varieties be added to this large intention. The variety that strong contrasts give should always be used sparingly, and subordinated to a unity of colour idea. Uncontrolled violence of expression should be left to the poster designer, where frank shouting is the horrid aim. But violence is a quality to be used sparingly in a work of art. Notice how in Greek tragedy the violent action was never allowed to break the beauty of the whole play ; always taking place outside, to be recited only on the stage.

If the general tone of the colouring is harmonious, a small note of strong contrast introduced, as we have already noted, is often effective. But strong contrasts of colour unintroduced by secondary colours, you will have to be very careful about. In decorative painting such contrasts may sometimes be successfully employed, provided the masses are the same tone. That is, where there is no strong contrast of tone but only of colour.

By violent contrast one means two colours most unrelated to each other, such as yellow and purple, green and red, blue and orange. A greenish yellow and a bluish purple would begin to be related by the common denominator blue. But a yellow without

any blue and a pure purple are utterly unrelated. The stronger the contrast, the greater the excitement ; but a colour melodrama all exciting contrasts, is bad art.

While violent contrasts should only be used where the expression demands, and then with great care, except in small notes, contrasts of a less violent order may be employed all over the picture. The play between warm and cold colours in the more neutral passages may be kept up without upsetting the unity of the whole. In flesh painting, for instance, the pleasing contrast between cool half-tones and warm shadows and more or less warm lights need not disturb the unity of the flesh colouring. And it is the same in all other things, this play between warm and cold should be going on all the time ; although it will be more in evidence in picturesque colouring than in the simpler, nobler colour schemes of the greatest paintings. Students need to guard against the tendency to overdo the smaller varieties of colouring, while missing the bigger. It is much easier to notice the little varieties, and a mental effort to grasp the big. Many students cut up their life studies by overdoing the little changes of hue in the local colour of flesh, while missing the bigger schemes of cool half tone contrasts with warmer shadows and lights. Notice how simple and broad is the colouring of the fine portrait painters, and how they subordinate the little details of flesh colour to a larger scheme.

White masses always need very careful designing, as they catch the eye. One of the most difficult things in a modern man's portrait is the collar and shirt

NOTE ON " THE ALCANTARA, TOLEDO, BY MOONLIGHT "

This was painted on a monochrome basis of raw umber and white. Put in very crisply with a lot of broken quality in the paint. Not until this was completed, and had been left a month to thoroughly dry, was any colour introduced. The effect of scumbling colour over your work is greatly to reduce the accent ; hence the initial monochrome stage was painted in a very strong, over-accented manner. In this first stage all the drawing and design was worked out to the smallest detail. This was then scumbled with colour thinly, put on with copal medium and practically finished in one painting ; a little solid colour being painted into it where needed.

PLATE 52

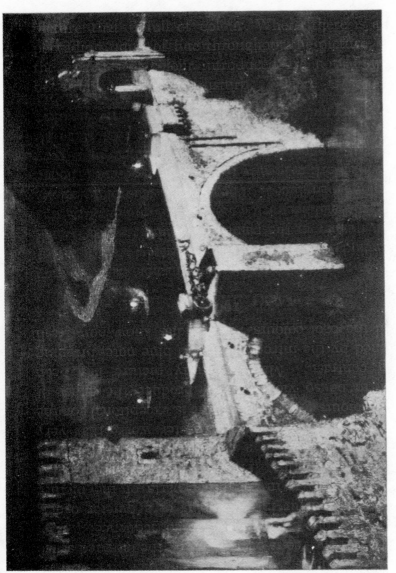

THE ALCANTARA, TOLEDO, BY MOONLIGHT

Painted upon a monochrome basis of raw umber and white

PLATE 53

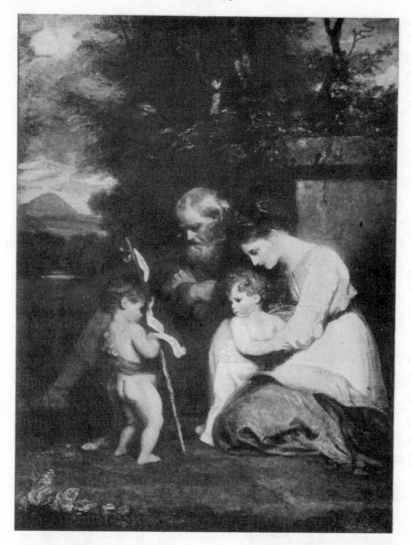

National Gallery *Reynolds*

HOLY FAMILY

A typical instance of brown school colouring, with a strong note of blue and
another of red, brought into harmony by the warm brown of the shadows
and supplementary colours

Photo : National Gallery

front. These are rather mean-shaped masses at the best of times, and their whiteness, of which we are so proud, is a great nuisance to the portrait painter. Watts got over the difficulty in Carlyle's portrait by making his linen frankly dirty ; which naturally raised the ire of the Sage of Chelsea. Millais, in his portrait of Gladstone in the National Gallery, has screwed it up, giving it a playful edge, instead of the severe one it had on coming from the laundry. These harsh edges and harsh white tones require some treatment if they are not to lower the dignity of the portrait. They should be painted out of focus, the focus being on the head. Felt in this way, and loosely painted, more quality can be found ; but it is a difficult task.

The most successful treatment of white is the white picture ; more or less light all over, with only subordinate notes of dark. Or a handsomely designed large mass of white contrasted with a dark mass. Both these schemes have produced many successful portrait compositions. In the case of the light scheme all over, the dark spots in the head are given great prominence ; and if a woman has beautiful dark eyes nothing gives them so much telling power. A figure dressed all in white arranged so as to make a fine silhouette shape of large mass against a dark background, is another successful way of using white. Or a group of figures arranged to make a large simple mass, as in Sargent's fine composition of the three Wyndham ladies. Good whites are full of lovely pearly colouring and need very carefully observing. Nothing is worse than a harsh chalky white without any colour ; but the chalky quality is often more the result of poor tone quality than colour.

Modern colour designing is still in the experimental stage. The unifying principle of an underlying warm neutral brown is hard to supplant. And in interior work, where there is so much shadow of a warm neutral colour, it will always hold some sway. But we are no longer content to take this interior scheme of colouring out-of-doors, as were the masters of the past. Manet in his early work, following Velasquez, by substituting black for brown, killed some of the stuffiness in colouring and brought it nearer nature's coolness. But it was the impressionists who followed Claude Monet who dealt the severest blow at the brown school, and took colouring right out of the studio into the pure light of the sun ; and made the great break with the colouring of the past, that modern art shows.

They substituted for the unifying, all-pervading warm neutral tone of the past, a "tout ensemble" of colour relationships taken direct from nature, and painted in the rainbow colours of nature's light.

With the new colour ideas thus revealed, we have to work out new formulas of pictorial colour design ; and on every hand one sees this going on. Painting direct from nature the matter is simple, as there is the visual impression to work on. But in designing your picture from within outwards, you have not this visual impression from nature to work from ; and a "tout ensemble" of colour relationships is a difficult thing to invent. Blue has been largely exploited as a substitute for brown as the underlying unifier ; and of course there was the dreadful puce period when raw purples abounded. But the same principles of colouring

PLATE 54

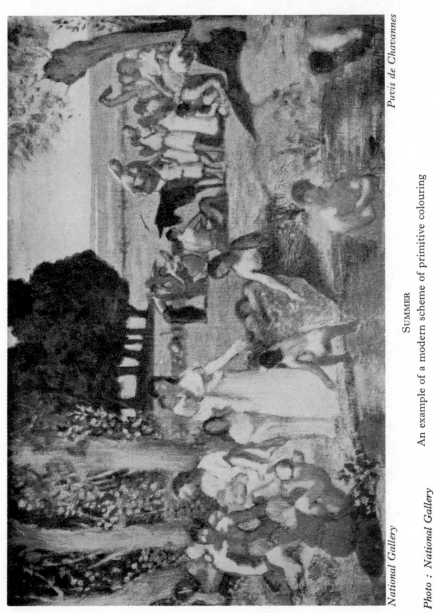

National Gallery

Puvis de Chavannes

SUMMER

An example of a modern scheme of primitive colouring

Photo : National Gallery

PLATE 55

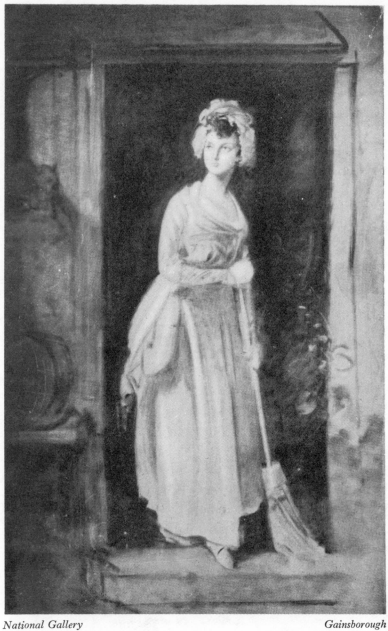

National Gallery *Gainsborough*

A COMMENCEMENT FOR A PORTRAIT OF MRS. GRAHAM

Rubbed in with burnt umber and terra vert, with a little red in the face

Photo : National Gallery

we have been trying to consider, will be found to apply in the fresher schemes of impressionist colouring that out-of-door observation has given us. There must be an underlying unity of scheme, whether a universal hue (as in the monochrome schemes), two strongly contrasted masses brought into harmony by easy stages, or many muted hues dancing together in harmony, or what not. It is in the increased interest and force of colour given to shadows, that the chief advance in colouring has been made. But this " tout ensemble " formula is very complicated and a highly sophisticated instrument to use. The genius of the age is seeking simpler conditions, being surfeited with complexity ; and is trying to dig out of the mass of visual knowledge we now possess a new primitive formula. Some of the more coloury work of Puvis de Chavanne points a way in this direction. The colour sketch for a decoration, No. 3422, National Gallery (Plate 54), is such a modern primitive colour scheme. It has the large simplicity of pattern we associate with the primitives, and yet is derived from the impressionists' vision of the whole of visual facts. By taking us out-of-doors into the wide light of the sky, the naturalistic movements of the nineteenth century have enabled us to design in large masses of colour undisturbed by light and shade, with something of the simple directness of the primitives.

And so the cycle of evolution from the early primitives through the Renaissance and the periods that followed, until the whole colour facts of visual nature were arrived at in the nineteenth century, is completed ; and we are beginning to return to a new primitivism

from which a new cycle of artistic development may be expected to evolve.

In order to develop an understanding of colour design in pictures, it is good to take a pocket-book with you to a picture gallery, and make sketches or diagrams of broad schemes of colour from the pictures. It is only in some such way that the student is led to understand the "anatomy" of colour combinations and arrangements. Colouring that appears so easy and natural in the finished picture, as if it was the result of no more effort than nature herself manifests, will often be found to be the result of a very carefully thought-out scheme of arrangement.

As an exercise in colour composition it might be as well to take a monotone reproduction of some good picture you like and make sketches of different colour schemes for it. The reproduction you are working from, will give you the form and tone; which will leave you free to concentrate all your attention upon the colour. As you cannot make a primitive colour scheme for anything but a picture designed in the primitive manner, and as I am not assuming you have selected such a picture for the experiment, suppose you start with a brown school scheme. Rub in a sketch of the whole subject in simple masses of a neutral brown. Then select a dominant mass for your chief note of warm colour and another for your dominant note of cold colour. And then proceed to introduce them by subordinate more neutral colours, bringing the whole into harmony, using the underlying neutral brown as a help to the unity of the whole. Many different schemes for the same picture will be possible with this formula.

Now try a scheme of massing the warm colours together, and the cold colours also.

The monochrome picture full of colour does not lend itself to a diagrammatic exercise, as its beauty so largely depends on the skilful handling of the painting; subtle varieties being introduced by painting one colour over another, by using colours transparently and solidly, and in every way getting the utmost variety in a restricted range. Then try a design with the scheme of a pattern of colour masses, nowhere of any very pronounced colour, but related by a unity of hue that underlies the whole.

And then try some more violent modern scheme with colour from one end to the other of the picture. In fact, experiment to your heart's content and try and learn something about pictorial colouring from experience. If the only experience with colour design is your own composition work, the matter will not receive the undivided attention it needs, as in these you will be fully occupied with the form and tone. But I think it is quite legitimate to annex the form and tone from another, so that you can concentrate entirely on the idea of colour.

A Note on Taste

What is merely a habit of mind is apt to be mistaken for taste in these democratic times, when the opinion of the average person is so much exalted. People get to like what they are familiar with, and to dislike anything that is different. The habits of the time, which may or may not have any relation with good taste, are what affect our likes and dislikes more than we always

realise. An easy proof of this is to be seen in the changing fashions of female attire. For reasons of their own, it suits the authorities who supply these things, that there should be constant changes in the fashions. And whenever a very violent change is made, the new fashion is generally received by the majority of people with howls. I can well remember the outcry that arose when it was decreed that ladies should go about with hobble skirts, and how many of my friends swore that nothing would induce them to submit to such a fashion. But in a short time, when the novelty had worn off, and they had become habituated to seeing them worn, the protest ceased, and they were all wearing them. These fashion authorities even have the audacity to demand changes in the shape of the female figure itself, and even here their decrees are meekly followed. All this goes to show how large a part habit has in the formation of the ordinary person's likes and dislikes. And this tyranny of fashion is not confined to clothes ; there are fashions in art criticism also, and this the artist needs to guard against if he would develop a sound taste. For true taste is a thing quite apart from the changing fashions of the hour, a thing of much greater permanence, that links up the artistic traditions of all times and peoples. How to develop good taste is therefore an important part of the curriculum of the art student.

There are two things that put one outside the influence of the petty changing fashions of one's own time, and develop a sound judgment in such matters : the study of nature, and the study of the best art of all times and peoples. One who has drunk deeply of

these two sources of inspiration, and become familiar with their excellencies, has freed himself from the thraldom of the fashion habits of his immediate time ; and is in a position to judge what is good and of permanent value in them, and what is only tolerated because one has become habituated to it. Such a one will not necessarily ignore the fashions of his time, but he will select for his work only those aspects that bring it into harmony with the principles that underlie all art and nature. The work of such a one is never old-fashioned in the miserable way old photographs are. His work may treat the same fashions of clothes ; but he will have discovered some vision of them, some arrangement of their form, tone and colour that brings them into line with the permanent qualities of good taste. The fact that people so soon become accustomed to anything in matters of taste and get to like it, holds out hope of what a better world we might have if real experts were allowed to control the formation of our habits, and were consulted by those in authority when anything demanding taste came up for discussion —in the same way as we now consult an engineer when anything concerning his job is discussed. But we have not yet got any further than the man in authority saying : " I know nothing about art but I know what I like." While we have a County Council that spends thousands a year teaching, among other things, beautiful printing in their art schools ; and yet when you come to have a number painted on your motor car you find that the ugliest and dullest printing known to any age or clime must alone be used according to County Council regulations, or you will be fined. Of

course, uniformity of type is necessary, but it need not be such a type. Our immediate forefathers used equally readable letters that were beautiful (see any old play-bill of the eighteenth century). Such things are done in sheer ignorance that there is such a thing as good taste of any permanent quality.

I do not think the mass of people prefer bad things in matters of taste, as is usually thought ; they would like good things quite as well if only they had the chance of becoming habituated to them. Their habit of so often choosing the bad is merely due to the fact that they are more familiar with it. Having had it rammed down their throats by tradesmen, who have for years insisted that they only liked vulgar things. They are no doubt indifferent and unconscious of the influence upon their lives that good taste in their surroundings would have. Taste is never likely to be a mass characteristic ; but the few might be allowed more opportunity of fulfilling their proper social function of controlling such matters.

How then, is one to develop what capacity for good taste one has ? In the first place a word as to the attitude of mind that alone holds out any promise of advance. The mind only opens to the reception of ideas and experiences that are beyond one's present capacity, in an attitude of reverence. It is only in this humble state of mind that the appreciation of what is above one has any hope of getting in. The hard, irreverent attitude that is not uncommon with impatient youth, one that will not admit anything that it does not immediately understand, shuts the door to any development.

TONE AND COLOUR DESIGN

I was accosted, when copying in a Continental gallery, by a globe-trotter, who said : " Young man, you are an artist ; will you kindly explain to me the beauties of that picture ? It is ' starred ' in Baedeker, so I suppose it is a good one but I can't see anything in it." This attitude of mind is hopeless, however earnest. In the commercial world things can be explained, but artistic things have to be experienced. And the picture itself is the only thing that can produce the experience. When this has failed, as it obviously had with my inquirer, you are as helpless as you would be if he had just partaken of a good dinner, which he had not appreciated; and had asked you to explain the quality of it, and refused to believe it was a good dinner because you could not do so.

The reverent attitude is not one that is popular in these days, for it is an admission of authority, and this is not always to the liking of go-ahead youth. But even if you want to flout the old masters and strike out on new lines, you are not in a position to dismiss them until you have comprehended them. And you are only in a position to see what is good in the new, by being in a position to compare it with the best that tradition has to show.

Go often to the National Gallery ; you will probably find it dull at first as I did, having a strong aversion to old brown varnish and much preferring the Society of British Artists round the corner (that was when Whistler was President). But gradually the splendour of vision of the fine painters of the past, will begin to dawn upon you. Don't give up your hatred of brown varnish—many old pictures were as fresh as nature's

colouring when first painted—but let the nobility of fine design and noble colouring have an opportunity of dawning upon you. As one excellence after another is revealed, the same quality will be perceived in nature ; and thus your vision will be enlarged and developed.

Taste is a difficult thing to write about, as it is in the realm of that part of our subject that cannot be treated. It is like the flavour of wine, you can write a poem about it, but you cannot write a treatise on it. But there is a form of bad taste that may be noticed. Let us call it the " one better " type. I mean that form of bad taste that always thinks to improve a good thing by going one better. We all know the heavy-handed cook who, because a little salt or pepper are good things in flavouring, thinks a little more will be better, and so on. One sees it also in badly dressed people. If big hats are being worn they have a bigger. If skirts are worn short they have them a bit shorter, if long, a bit longer, etc. The type of bad taste that is lacking in all restraint and always wants large quantities of anything it likes. In art we have had a lot of this type of bad taste in recent years—restraint is not the fashion. Colour being a good thing, they will have oceans of it ; square forms being fine, they will have nothing but square forms, etc. All unrestrained violence is bad, except in poster designs when anything is allowable, unfortunately. And it is naturally in poster designing that the popular note of violent expression is finding its most legitimate field of exercise ; many of which are wholly admirable if one admits the propriety of advertisements at all, with their necessarily aggressive assault upon one's attention. But in a work of art the

forces of expression are always restrained and balanced one against the other, like the flavourings in exquisite cooking. This " one better " school of bad taste is at present invading our theatrical productions. Scenic artists have at last realised that the attempt to create an actual illusion of nature on the stage is futile, as well as bad art ; except in the case of an actual room interior when practically the real thing can be put upon the stage. But fine stage scenery, like all fine art, admits the medium of expression, and does not attempt to smother it by the illusion of actuality. Fine scenery, therefore, should be of finely designed masses of form and colour, of a significance suited to the particular performance it is designed for. But in breaking away from the old realistic convention that was so tawdry, the " one better " school of bad taste has developed a manner at the other extreme. This scenery may be suitable for a background for the figures in a child's Noah's ark, but is not in sympathy with the actors and actresses who strut before it ; even when they are decked out in jazz costumes as bizarre as the scenery. And the scenery, instead of being the appropriate background it should be, has become aggressively tiresome ; dominating the picture and overpowering the poor actors, who after all have their share in the performance.

The crowded stage of modern democratic life largely tends to encourage this " one better " type of bad taste. The quieter methods of great art, make so little immediate appeal to the attention of the many, and are easily passed over. The young artist, big with the ambition to shine, is, alas ! almost forced to adopt violent methods of attracting attention.

But it is a short-lived notoriety ; one tires of extreme things more quickly than any other. And the tragedy of the latest extreme fashion is, that it is the first to become old-fashioned. The quieter work in better taste, is the only thing that lasts.

Please don't misunderstand me and take this to be an advocacy of the deadly, dull characterlessness which is the other extreme. All good artistic work is new ; but its newness is of the inevitable sort that naturally grows from sincerity ; not the forced newness for the sake of difference, which characterises so much of the peculiarity that in these days masquerades as originality.

CHAPTER XI

MATERIALS

Oil Paint

THIS is a much more difficult medium to handle than is generally thought, and very soon loses its vitality if not very deftly used. You may see this in any exhibition of amateur work, where it is not at all unusual to find many charming water-colour drawings, but where it is very rarely that the work in the oil medium is anything but dull, dead, and lacking in all vitality and charm. If any ordinary person plays about with water-colours on a piece of clean paper with plenty of water, quite charming messes will result. The medium lends itself to many delightful accidents. But give the same person oil paint to play with on a canvas, and a horrid, muddy mess may be expected. Oil paint does not lend itself so readily to charming accidental effects, and soon loses its freshness. But its range is much greater than that of any other medium, and it has many conveniences that have endeared it to painters for generations ; and that are likely to keep it in favour until the discoveries of modern chemistry produce for us the ideal medium.

The desire for primitive crude expression that is so fashionable at the moment, particularly on the Continent, may have something to be said for it in an over-sophisticated age ; but a more primitive medium of expression than oil paint should be chosen. Many of the crude canvases that crowd " advanced "

exhibitions by the acre, in which all the decencies of fine painting have been flouted, many of these carried out in a more primitive medium like, say mosaic, might have been much finer things. But somehow oil paint seems to be a clumsy medium in the hands of the primitive craftsman, one only to be successfully used by a very highly-skilled and sensitive artist ; or it soon degenerates into messiness.

The first essential of a successful painter in any medium is a love for the medium. It must be felt and enjoyed and delighted in as a fine means of expression. Buying our paints in the convenient form of tubes already prepared for work, we are not brought into such intimate sympathy with them, as in the days when painters bought the raw colours and ground them themselves. Every painter should provide himself with a set of powder colours, and a marble slab and muller for grinding them. So that he can understand the medium, and try experiments for himself with different oils and varnishes, to see if those provided by the artists' colourman are just such as to suit his particular requirements. I feel certain the old masters varied the nature of the pigments they used much more than is now the practice : sometimes using a slower drying oil to grind them with, and sometimes a quicker ; sometimes a thinner, and sometimes a more solid paint, as the occasion required. The better makers will always carry out any suggestions you make to them, and specially grind for you. But you have to find out what you want for yourself.

I am not sure that we have not something to learn from the house-painters. Many of them still mix their

own paints; and it is possible that some of the earlier traditions of the craft that the studio has lost, may have survived here. They still use the ancient palette with a handle for instance. I have often been struck by the beautiful, creamy consistency of the paint they use, that comes so nicely off the brush. Our habit of using stiff colours that stand up round the edge of our palettes, might well be varied at times by thinner paints in pots. I have made a palette for this purpose which is described in the note on palettes. Another of their practices is to keep the early coats " sharp," as they say. That is, mixed largely with turpentine which leaves a dull surface with a good " tooth " to take the final coat; this final coat being mixed with more oil or varnish.

We have not space to go into the subject of the chemistry of painting, which has been well treated in Professor Church's book on " The Chemistry of Painting," and Professor Laurie's on " Materials of the Painter's Craft." And also in that mine of information on the methods of the old masters, Eastlake's " Materials for a History of Oil Painting "—a book now out of print that ought to be reprinted, as it should be in every art student's hand. But something may be said about the materials of the craft from the point of view of one's own experience as a painter.

Oils and Mediums

I am convinced that nothing militates against the permanency of oil painting like the oils and mediums used. The subject of the permanency of the pigments has been well studied by chemists, and the painter

now has at his disposal a sufficiently large range of practically permanent colours for anything he may want. But as far as I can find out, the chemistry of the darkening of the oils and varnishes has not received so much attention.

Anybody who compares the tempera pictures of the early Italian school at the National Gallery with the later pictures painted in the oil medium, will see what I mean. If only we could see these later oil pictures in the freshness they had when they left the easels, instead of through a mist of rich brown that the darkening of the oils and varnishes has given them! But what a shock the worthy people who have come to associate their reverence for the " Old Masters " with this " rich glow " would get!

Personally, when visiting the National Gallery, it always takes my eye some time to accustom itself to seeing through this offensive stuffy brown; coming in from out-of-doors with one's eye full of the freshness of natural colouring.

The only safe rule in my experience as far as permanency goes, is to see to it that as little oil or varnish as possible enters into the composition of your painting.

There are two varieties of what are roughly called oils—the ordinary oils that solidify and the volatile oils that evaporate.

Linseed Oil is the ordinary oil chiefly used in grinding colours and as a medium for painting. It is usually sold after having been bleached by exposure to the sun. I am not sure whether some of its subsequent darkening in colour is not caused by its returning to its original state; it which case it might be better to

use it unbleached, and know where you were ; although
even the unbleached oil darkens somewhat. It is
certainly a fact that some of the darkening effect of
linseed oil is got rid of by exposing the discoloured
picture to the sun, which bleaches it again. In the
ordinary state it is a good dryer, and in the boiled state
(sold as pale drying oil) a very quick dryer. If too much
linseed oil is used, the surface of the paint wrinkles up
in time ; so that linseed oil should never be used ex-
cessively. If a very flowing medium is wanted the oil
should be diluted with turpentine or petroleum ; to
which some painters like to add a little oil copal varnish
also.

Poppy Oil is of a lighter colour than linseed oil, and
does not darken so much ; but I have found that
patches of both linseed and poppy oil, put on a canvas
over twenty years ago, have both darkened consider-
ably. The poppy oil not so much as the linseed ; and
some of the darkening may be due to dirt. It is not so
quick a dryer as linseed oil, and this is sometimes an
advantage when you want to carry on your work over
more than one day. Personally I prefer it to linseed oil.

Turpentine Spirit. This is a volatile oil, and should
entirely evaporate ; and care should be taken to see
that only a pure spirit is used. This can easily be tested
by putting a little of it on a piece of clean paper and
letting it evaporate. If it disappears and does not leave
any mark behind, it is a pure spirit. If a greasy stain,
however slight, is left behind, it is not. The difficulty
with turpentine is that when exposed to the air it
combines with oxygen and forms a resinous substance
which is highly injurious to a picture. So that the only

careful way to use it is to buy it freshly distilled from a wholesale chemist (a much cheaper and better way than the artists' colourman), and bottle it in little bottles full up to the top ; so that only the little you are using is exposed to the action of the air. Used in this way, it is a delightful medium for thinning paint and making it flow freely off the brush ; and as it all evaporates, your paint is left with the minimum of medium in it to darken by time.

Many painters say they have found pictures painted with turpentine darken. This may be because the turpentine was not a pure spirit ; but I am inclined to think there is another fact that may account for it. In time paint becomes more transparent and less solid than it was, with the result that what is underneath shows through, particularly in the thinner painting. As turpentine thins the paint, it very often happens that when it becomes more transparent with age, darker tones show through and darken the effect. I have noticed this to happen in some of Whistler's pictures, which I remember when first painted to have been much more brilliant, and which have undoubtedly darkened in many parts. He used turpentine freely, and was very fond of the charming effect of thinly-painted lights over darks ; and these are just the effects that would be likely to suffer from the paint becoming more transparent with time. Gainsborough used turpentine freely : so freely that, according to one of his models, he had continually to pour it off his palette on to the stove. But you will find little of the darkening effect that is complained of, in his work. But he was very particular about painting on a

very solidly primed light ground ; and in his best work, painted so thinly that the ground nearly always showed through. And if your paint gets more transparent with age and shows a *lighter* ground through, there is little harm done.

Petroleum Spirit. This is a pure spirit and has the advantage of remaining a pure spirit, and in recent years it has been taking the place of turpentine as a volatile medium. There are three varieties sold by Madderton & Co., quick, medium, and slow drying. This is an advantage, as some petroleums dry too quickly to be convenient for all kinds of work.

The disadvantage of the volatile oils is that if used freely your work dries with a dull surface. This does not much matter with work in a high key, where it is often an advantage ; but with dark tones it is a great inconvenience and necessitates oiling out between each painting. This oiling out is a thing to be avoided if possible, as it gives one a slippery surface to paint on and introduces more oil to darken the picture in the course of time. When oiling out is necessary, the thinnest possible film that will bring up the tone of the painting should be applied. I have found that the best method of doing this is to apply with a large brush, not very full, a mixture of equal parts of poppy oil, turpentine or petroleum, and water, shaken up together. The water helps it to bite on the surface and cover more easily, and if left for a short time the small quantity will evaporate with the turpentine, leaving the thinnest film of oil. Any surplus should be wiped off with the palm of the hand and only enough be left on to bring up the colour.

OIL PAINTING

Varnishes

Copal, mastic, or amber are the varnishes generally used. As ingredients in any mixture for thinning your paint, their disadvantage is that your work dries with a smooth, horny surface that is very nasty to paint on again. And the surface you leave is a very important consideration. Unless you are working for finishing in one painting, it is very important that you leave a surface on which it is possible to paint again with some quality. Whereas on a horny surface, the paint slides and is not readily picked off your brush, and little can be done with it.

Varnish used as a medium undoubtedly gives a brilliancy to one's colours, particularly the darker shades, and possesses qualities that certain classes of painting depend upon ; but it is best used in work that is finished in the one painting, or for the final painting only. There are two kinds of varnish, oil and spirit varnish. In the former the resin is dissolved in an ordinary oil, and in the latter in a volatile oil. Copal and amber oil varnishes only, should be used for painting mediums, and the spirit varnishes, picture copal and mastic, used for the final varnishing of your pictures.

Copal and *Amber* varnish are the two hardest and those most generally used as painting mediums. Picture copal is the quicker dryer, but will cause cracks if used as a painting medium, and should only be used for the final varnishing of a picture. Oil copal is not so liable to crack as picture copal, and is the one that should be used in any painting medium.

Copal medium contains oil copal varnish, linseed oil, and turpentine spirit or petroleum spirit, in equal

parts. The copal has a tendency to contract in drying which causes cracks, and linseed oil to increase its bulk when dry, forming a skin that wrinkles up on the surface, as has already been stated. The two mixed together counteract each other. The turpentine or petroleum thins the mixture ; and thus mixed with the oil and varnish, does not make the work dry dead. It also counteracts the tendency of the varnish to dry with too horny a surface. This is a useful medium when something fatter than a mixture of oil and turpentine is wanted. It can be used with more turpentine or petroleum as there is already some oil in the paints. The ordinary medium for painting is a mixture of equal parts of either linseed oil or poppy oil with turpentine spirit or petroleum spirit. My own preference is for a mixture of one part poppy oil to two parts slow or medium drying petroleum spirit. But one varies one's medium according to the effect desired, and all should be tried so that one may become familiar with their different capacities.

Amber varnish is preferred by some. It is very dark in colour, and one imagines could not go so much darker with age as copal, as it is already further on the road ; and it is a nice fat medium for certain kinds of work, and has been a great favourite with some painters in the past. The late Frank Holl, whose work has kept its freshness remarkably well, used it freely. It is a much slower dryer than either copal or mastic varnish, and is said to dry from below, upwards.

Mastic varnish is the one it is now customary to use for the final varnishing of a picture, because it contains no oil and is such a poor resin that when it

has turned darker, it can be taken off and another coat put on. By the simple action of friction with the finger it comes off in the form of a white powder. Holman Hunt used to say that in this process of getting off the varnish, it is highly probable that some of the thinner films of your picture might be rubbed off also. So that he always gave his pictures a coat of amber varnish (he used the very expensive variety manufactured by Messrs. Block of Belgium) to make sure of guarding his work from any rough handling the subsequent cleaning or varnishing might subject it to. His pictures are certainly in an amazingly good state of preservation.

The subject of varnishing pictures is a very vexed one, some artists refusing to varnish their work at all ; and it certainly does put a yellow film over the whole, destroying some of its freshness even at the start, and when the subsequent yellowing takes place, this is considerably increased.

One thing about mastic varnish that is very annoying is its habit of blooming. A milky cloud may appear, caused by damp, I presume. Great care has therefore to be taken in varnishing a picture with mastic varnish, that not a particle of moisture is on the picture or in the varnish. And for this purpose a dry day in summer should be chosen, and the picture, varnish and brush, all thoroughly dried before a fire. Of course, when the bloom is on the surface it can be polished off with a silk rag. But even when all the precautions above referred to have been taken, I have known pictures bloom underneath the varnish ; particularly on the parts where the paint was thinly put on. And I am inclined to think the damp gets in at the back of the

canvas, and that something ought to be done to make the back damp proof. Professor Church suggests collodion, and Professor Laurie formaline sprayed on the back of the canvas to make the size in the priming insoluble and therefore resist damp. This subject of preserving the backs of canvas from damp is certainly one to consider apart from the blooming of the varnish. I have even seen little white spots appear on a picture hung in a room left without a fire ; due to some fungus growth under the varnish, obviously caused by damp getting at the back of the canvas.

Colours

In using the word Colours in the popular inaccurate sense, I must ask pardon, but really " pigments " is too ugly a word for such delightful materials. There is an appallingly large number to select from in the enterprising modern artists' colourmaker's catalogue ; but only those that are practically permanent, and that I am in the habit of using, can be considered here. I say practically permanent as speaking with perfect accuracy probably only black, red oxides of iron, cobalt blue, and one or two others, could be said to be absolutely permanent ; and there may be doubts about some of these. But we have a sufficient number of colours that are practically permanent, and the modern artist, if he avoids the cheaper brands, need have nothing to fear on this score. The oils and mediums used, and repainting before the under coat is *thoroughly* dry, are much more usual causes of lack of permanency in modern painting. Changes in the raw pigments used, if care is taken in their selection, are not now a serious cause of lack of permanency.

It is usual to recommend a palette of selected pigments, or perhaps two—one for figure work and one for landscape. But I think the habit of setting a uniform full palette before commencing work is a mistake. *The fewest colours possible should always be used.* And they should be carefully selected to suit the individual subject. Nothing ensures harmony of colour so easily as a very limited palette. If you have only one blue, and one yellow, and one red, on your palette, how much greater the chance of a unity of colour harmony than when you have two blues, three yellows and reds, with a brown or two and a green as well. Carefully select the fewest colours you will need for the general colouring; selecting a different set for each subject, adding others as you may need them for rare occasions when contrast or extra variety are needed. The following list has no pretence at completeness, but is merely a catalogue of the colours I am more particularly acquainted with.

White :

Flake White, Zinc White. Great care should be taken in selecting a good white. Try the different makes on a white china palette, on the brilliant white of which some will look grey and some yellow; only the very best will look white. Flake white works more crisply than zinc white, and has a better body. It would be in every way satisfactory, were it not for its liability to blacken if exposed to sulphuretted hydrogen; a gas apt to be present in gas-lighted rooms. The final varnish might protect it from this danger, and now that electric light is becoming so universal the danger is not so great as it was.

Zinc white is a slower dryer than flake white, and for that reason useful when one wants to carry on the same painting on the following day. It does not work so crisply off the brush as flake white, having a more sticky consistency, nor has it the same body. It works better for thin painting, and is a beautiful brilliant white, and eventually dries very hard indeed. It should always be used when it is not intended to varnish a picture, as it is unaffected by sulphuretted hydrogen.

A new white, said to be permanent, that has recently been discovered, Titanium white, has a fine body and promises to be a useful addition to the palette now that they have succeeded in producing it in a perfectly pure state.

Earth Colours :

All the earth colours are good. They are as near absolutely permanent as anything can be. They have good body, with the exception of terra vert, and they have a nobility and dignity about them that the vegetable and mineral colours do not possess. Some care should be taken in selecting earth colours, as they vary considerably in different makes. Being natural coloured earths they vary in hue, and some artists' colourmen have the monopoly of a better variety than others ; having bought up the whole of a good find.

Yellow Ochre. A generally useful colour for figure work or landscape. For brilliant complexions I like it mixed with middle cadmium or chrome yellow, when

it makes a most useful yellow for flesh-painting, more like the Naples yellow of the eighteenth-century painters.

Transparent Golden Ochre. I use the darker transparent variety of this much varying colour. It is a fine, brilliant, glowing colour, very useful in landscape, and on the whole a nicer colour to use than raw sienna. It can be used instead of yellow ochre and raw sienna, possessing something of the brilliancy of the one and the transparency of the other.

Burnt Sienna. A fine colour of good body and staining power, but it needs watching as it is rather hot and raw. It is most useful when mixed with other colours. It is a colour I believe Velasquez used largely in his men's portraits, making it do duty for a yellow and a red, muted with a warm and a cold black.

Raw Umber. This is one of the finest dryers on the palette, and is therefore much used for monochrome painting, as it dries overnight and one can go on with a second painting in the morning. For the same reason it is a favourite for rubbing-in the general effect of the drawing and tone of a picture. It is the coolest brown we have on the palette. Some care is needed in using it for shadows, as it is apt to get rather muddy. Some painters use it for commencing a portrait in monochrome, when its quick drying is useful, enabling one to go on without leaving it a long time to dry.

Burnt Umber. A deep, rich brown of fine body, and a good dryer. It is rather hot, and I usually mix some terra vert with it, which makes it a more useful colour. I fancy this is what Gainsborough did, as he used a cool, rich brown that was not bitumen. The rubbed-in

commencement of a full-length portrait in the National Gallery (see Plate 55) appears to have been put in with burnt umber and terra vert.

Venetian Red, Light Red. Two fine, distinguished-looking colours of good body and great staining power, much used in figure painting and also for skies, and, in fact, for everything. The light red is a little more orange in hue than the Venetian red, but they are very similar.

Indian Red. Another fine red, but very difficult to use. It has a very great staining power, and if care is not taken it will get all over the palette. Used pure, its rich crimson quality (in the best varieties) is very useful in clearing up the muddiness of shadows. Some painters draw in their shadows in this colour and it makes a fine rich basis on which to paint other colours. Also it mixes conveniently with the surrounding tints and makes cool, purplish tones, useful in the half-tones. This is a remarkable characteristic of the colour: while pure or with black it is a rich almost transparent crimson, with white it is a cool, purplish colour. It is as well to mix up some of this colour with white on the palette, and take from this for all lighter tones, as its staining power is so great that one can easily take too much and spoil the whole mixture.

Terra Vert. A beautiful olive green of great permanency, but poor body and drying power. It is very useful for modifying the reds and yellows in flesh, and making half-tones. The early Italian tempera painters always modelled their heads in this colour first, and afterwards painted thinly over it with ochres; which gave them their half-tones into which lights

and shadows were hatched. Being very transparent it is useful for mixing with the hot browns to cool them. The eighteenth-century portrait painters used it a great deal for half-tones, notably Gainsborough.

These are all the earth colours we need consider, although there are others, like Cologne earth, which some people prefer to burnt umber, and they should all be tried. Always do as much as you can with the earth colours, particularly in the early stages of a picture.

The more brilliant colours have a fascination for the young students. Prone to messy handling and dirty brushes, they rush to the brighter pigments in the hope of getting themselves out of a mess; whereas with cleaner handling what is wanted could better be got by simple earth colours, the use of which gives one an excellent training in clean handling. The fine, dignified colouring of a Titian, or, among the moderns, a Watts, is greatly due to their extensive use of earth colours.

Before considering the brighter colours, something must be said about black.

Ivory Black, *Blue-black*. These are both safe colours, but poor dryers. In large shadow passages, such as the dark background of a portrait, if black is used, it is as well to mix up a little pale drying oil and oil copal varnish in equal parts with the paint set on the palette; as otherwise it is sometimes a long time drying and may never become hard, and may be liable to rub off when oiling out or varnishing. Ivory black is the richest black, and the one used for rich shadows. Blue-black is the best to use for greys, such as a white satin dress or the half-tones in a man's head. Some artists use it

for half-tones of flesh entirely. Velasquez seems to have used two blacks, a very warm one and a blue-black. When I was in Madrid copying Velasquez in the Prado, the Spanish artists were using a Negro Hueso, a brown-black similar to our Bone Brown, as well as a blue-black. And I found these two blacks very useful in getting the wide range of warm and cool greys and blacks he was so fond of. Bone brown is a poor dryer, but a beautiful colour. If used, some dryer should be mixed with it on the palette. Another colour I have found useful as a variant for blue-black is Davey's grey, put up by Winsor & Newton. It is a slate-colour black that yields cleaner greys than blue-black. It is made, I believe, from slate, and as permanent as the earths.

Cadmium Yellows and Chrome Yellows. A great controversy has raged over the respective permanence of these two varieties of yellow. They each have a range from a pale yellow to an orange, and both have a good body. The cadmiums are very much the more expensive, and I think that originally decided me in their favour. But I have in my possession a canvas on which the late Holman Hunt (who was the most conscientious artist of the nineteenth century) had painted all the cadmiums and all the chromes. And while the chromes have kept their colour, except for the darkening of the oil, the cadmiums have blackened; particularly the pale cadmium which is no longer yellow at all. He used chromes in preference to cadmium, and converted me to their use ; and it certainly makes a difference to the colour bill. The ordinary pale cadmiums are not reliable, but those made by a special process by Messrs.

(daffodil yellows) I have found stand well
years. The ordinary middle cadmium is the
only one that is absolutely permanent. Chromes
sometimes develop a greenish tint, but not always.
The cadmiums do not bind very well with oil, and care
must be taken in washing or oiling out a picture with
much of these yellows, as they sometimes wash off, if
not locked up under a coat of varnish. There is a large
range of hues in both cadmiums and chromes to select
from, ranging from a pale lemon yellow to a full orange.

Emerald Oxide of Chromium (Viridian). This is a very
beautiful permanent green, but very dangerous in the
hands of the inexperienced painter for grass and trees.
How many crimes has it not been responsible for on
the canvases of the young landscape painter. For skies
and for delicate blue shadows, such as on white walls
in sunlight, and for all delicate opalescent effects, it is
invaluable. But students commencing to paint English
landscape find an acid green in grass and trees quite
irresistible ; and with viridian you can make acid
greens to your heart's content. My advice to students
is to avoid using it for foliage and grass entirely at
first. Pale chrome or cadmium yellow, with terra vert
or blue-black, will give you a much nicer range of
greens. Leave the use of viridian for grass and trees
until the temptation to see too much green is not so
strong. Mixed with rose madder or mineral violet it
makes the loveliest pearly greys ; and with a dash of
cobalt blue it gives a useful range of colours for soft
blue skies, such as you get in the evening away from
the setting sun. A most useful colour, but much care
is needed in using it.

MATERIALS

Madder Reds. The fascinating range of madder reds are also colours that have been the ruin of many young aspiring colourists. Like viridian, rose madder seems to have a fatal attraction for the inexperienced. There are times when it is indispensable, but it should only be used when absolutely necessary. If Indian red, or Venetian red, or vermilion will do equally well, they are preferable, as they have more body and more dignity. There is something second-rate about rose madder, or perhaps I should say that it lends itself more readily than any other pigment to second-rate or fourth-rate colouring.

There is a range of similar reds made from coal tar, the alizarins. They have similar hues to the madders but much more body and staining power, and are said to be permanent. The alizarin Ruby madder is a fine colour for rich shadows where a madder red would be too thin to tell. The true madders are too thin except for the lighter tones, when they are supported by admixture with white. If used solidly, they are little more than a glaze, and should only be used thus over a light ground.

Rose doré is a very delicate madder red, useful when a pink of very high tone is wanted. Mixed with white it keeps its hue at a higher tone than any other red. Mixing white with any colour destroys the colour in proportion to the amount of white used. Mixed with much white to a very high key, few colours retain much of the brilliancy of their original hue at all. But rose doré, being little more than a transparent red stain, retains its colour at a lighter tone than other reds: a quality that makes it useful in very high-toned work and sunlight effects.

Brown madder has a better body than the other madders and is occasionally useful, but needs much care or a pucey tinge will get into everything.

Vermilion. This is a magnificent red of fine body. The Chinese vermilion, a darker and more crimson variety, is the most permanent. The ordinary vermilion, it is said, occasionally turns black. I believe there is a black variety of the same chemical composition into which, for no known reason, it may turn. But I cannot say that I have had any experience of this. A red poppy in a portrait I painted thirty years ago when a boy, has turned to a darker red, but not black. And I remember it was painted with vermilion and a little rose madder, and I fancy the oil would account for all the darkening ; and I think it is only when exposed for some time to direct sunlight that the darkening occurs. Tubes of vermilion should be kept upside down, as being a very heavy pigment it has a tendency to gravitate to the bottom of the tube leaving only the oil at the top.

Field's Orange Vermilion is made by a process that is supposed to obviate the tendency of the lighter vermilions to darken. It is certainly a very brilliant colour, and there are occasions when it is invaluable ; and I have used it for sunset effects and have never found it change. An indispensable colour for the rare occasions on which it is wanted.

Cobalt Blue. The most useful blue on the palette and a great favourite at all times. It is absolutely permanent, has a good body, works well, and is a beautiful colour.

French Ultramarine. A permanent artificial ultramarine of great power. The darker varieties are very

dark and rich, almost as dark as black. For dark shadows it is better than cobalt as it is not so opaque. It is not quite such a pure blue as cobalt, having a slight reddish tinge. But it has a fine body and is thoroughly to be recommended.

Cyanine Blue. A mixture of cobalt and Prussian blue. This is a useful blue for certain occasions. It has a greenish tinge, and is a beautiful colour. I use it in preference to Prussian blue, which is rather raw, on those occasions when such a blue is needed.

Cobalt Green. A beautiful opaque blue-green for occasional use and quite permanent.

Cerulean Blue. An opaque blue of a lighter tone than cobalt. Useful in high-tone work as it retains its blueness when mixed with white rather more than cobalt.

Mineral Violet. A rich dark purple recently introduced, and quite permanent. Useful in landscape for modifying other colours and for shadows.

Lemon Yellow. A pale brilliant yellow of very light tone. Useful in high-tone work.

Brushes

In doing school studies, that should not be done with any other idea than that of training the faculties, it is not necessary to use the more expensive brands of colours. It is when permanency is wanted, when one is painting pictures to last, that the utmost care must be taken as to the quality of one's paints and oils. But the cheaper makes of decorators' colours work practically the same as the finer brands, and as they are much less expensive, have obvious advantages to the impecunious art student. But in the case of

brushes it is different, even in school studies the best brushes should always be used. A cheap brush is useless from the start and has, luckily, a very short life as they wear very badly. The best brushes last much longer, and are a delight to use all the time.

Having provided yourself with the best brushes money can buy, see that you take great care of them. Soap and water cleans them most thoroughly and is the best way of cleaning them. But it is a most tedious process after a hard day's work, and the temptation to rinse them out in turpentine or paraffin is very great. There are several kinds of brush washers made for use with turpentine or paraffin ; and provided the brushes are occasionally given a thorough clean with soap and water they will keep fairly well cleaned in this way. Great care must be taken to get the paint out close to the metal holder. A block of dry paint here, such as one often sees in a badly kept brush, is fatal to its spring and usefulness as a tool. The finger nail should be used to get the paint out close to the handle. After washing in soap and water they should be thoroughly rinsed and dried, and then lovingly sucked to bring the hairs together; and afterwards thoroughly dried before the fire. The plate rack of a kitchen stove is a good place to leave them all night. When *thoroughly* dry they have plenty of spring in them, whereas the slightest dampness gives them a flabbiness.

Brushes are made in every conceivable shape and many should be tried to find something that suits your requirements. Roughly these shapes may be divided into flat and round.

MATERIALS

It is as well to remember that the surface on which one paints is flat, and a flat brush will accommodate itself to putting on paint with an even pressure better than a round brush, when the pressure from the greater mass of hairs on the centre is greater than at the edges. The thin, flat brush is the best for laying a perfectly even tone, but gives a nasty thin sharp edge that is poor. The ordinary pointed round brush is also unsatisfactory, except for small touches when the point only of the brush is used. If a broader touch is wanted the point of the brush is in the way. The extremes of pointed and flat brushes are occasionally useful, but are not so generally to be recommended as the less extreme shapes. For figure work and form expression generally, one wants a brush that will lay the paint in even, flat tones without thin sharp edges. Sharp edges are occasionally wanted, but they are the easiest things to obtain. What one wants generally, is a firm fused edge that will not need to be got rid of, as hard edges do. And for this purpose nothing is better than a full flat brush of longish hair, made so that the natural curl of the hair is inwards. Such brushes have not hard, sharp corners, but are slightly rounded inwards, and do not make such a sharp edge to the strokes. A round brush that gives a somewhat similar touch, is a long-haired one with a blunt rounded end, not a pointed end. Velasquez used brushes with extra long hairs, which give a greater variety of touches than the shorter-haired ones. But they need to be made of extra stiff hair or they are rather flabby in working. For students commencing I recommend the full, flat brush of longish hair and rounded corners. The fuller

and longer the hairs the more paint the brush will carry. It is annoying when you want to make a long stroke for your paint to give out when only half-way down. Thin brushes hold so little paint, that one cannot indulge in any free manner of painting with them. In recent years the fashion for using soft-haired brushes has returned. One has to work with thinner paint as they have not the spring and force necessary to carry through anything but thin flowing paint. Franz Hals and a great many of the Dutch painters evidently used soft-haired brushes, and it is as well to try them. Personally, I don't like them, but prefer very stiff hairs as they move the paint with more vigour ; and if the brushes are long-haired they have all the delicacy one wants, except for special occasions. You will need some soft-haired brushes of smaller size for occasional use, and also a long, small, soft-haired brush, called a rigger, for use when it is necessary to draw a line.

Always work with the biggest brush that will do what you want. If properly manipulated much more delicacy can be managed with a big brush than is usually thought, and it saves the necessity of making two touches when one would do ; and it is always an advantage to touch your canvas as little as possible. Remember, also, with a large flattish brush of the shape I have recommended for beginners, you have a smaller brush if you turn it sideways, so that the thickness, not the breadth, is what is presented to the canvas. A small touch may be commenced in this way and the brush turned during the stroke and opened out into a wider sweep ; which is sometimes useful.

Try any new shape you come across, so as to get just the brushes that will do what you want. But this you cannot know until you are more advanced. I keep a large variety of shapes and select the one I think most suitable for the particular thing I want to do.

The brush makers have an absurd habit of making the size of the handle fit the size of the brush, instead of the size of the hand that will have to hold it. Very small brushes need a very firm grip to control them as they are only used for very delicate work. And yet they are often given a handle no thicker than a match. Golfers have their club handles made all the same size to suit their hands, despite the fact that the club heads vary much in size and weight ; and in so doing they have gone one better than the artists' colourman who still persists in assuming that your hand varies with the size of the brush. Also, brushes are usually made to fall off the handle after several washings in hot water, and it used to be only German brushes that had an indented ring round the metal holder to prevent the possibility of this. In selecting brushes, avoid those where the maker has slightly stuck the hairs together to make them keep a good shape. Good brushes do not need this, as they are made by hand, and the hairs grouped so that any natural curl is inwards. A good brush will not spread its hairs out in all directions but keep a true shape even after long wear. Alas ! it is more difficult to get good brushes than it used to be, and I have noticed even in good makes that the hairs have not all their natural ends. The brushes appear to have been sharpened off to make them a good shape, after being roughly put together ; instead of the good

shape being the result of a careful placing of the individual hairs. This is a thing to look out for in selecting a good brush, as the natural end of the hairs is much more delicate than any other.

Painting Grounds

The ground on which you paint is of the very greatest importance ; not only with regard to the permanency of the work, but also because the quality of your painting so largely depends upon it.

For permanency there is nothing like a brilliant white canvas or panel. Oil paint in time becomes more transparent, and the ground will tend to show through, and if it is a light ground, this showing through will tend to counteract the natural darkening of the oils and the brilliance of the work will not suffer. But if your painting is done on a dark ground, any tendency to show through will only add to the darkening effect of time.

A brilliant white is not always a very sympathetic ground to paint on, but if you must use a toned ground, take a brilliant white canvas and tone it with a thin film of colour. A mixture of ivory black and raw umber makes a good neutral colour. Mix the paints together and put dabs of it with the palette knife at equal distances over the canvas. Then pour some turpentine spirit on the centre of the surface. Now with a substantial pad of clean rag, spread the turpentine into the dabs of colour until the whole is worked up together, and the entire canvas is covered more or less equally ; and so that no marks are left where the dabs were. As soon as this is done and before the turpentine has had time to dry, with another pad of clean rag go over the

surface evenly from side to side; commencing at the top and working downwards to the bottom with regular strokes, going completely across the canvas each time. And then repeat the process from top to bottom, working up and down from one end to the other. Continue this process until you have obtained an even tint all over the canvas. This gives you a tone that is not thick enough to prevent the white ground eventually keeping up the tone of the paint, and also of a more interesting quality than a dead colour; as the rag, in wiping the colour off, brings up the grain of the canvas in an interesting manner. The depth of tone required can, of course, be varied by the amount of colour put on in the first place, and the amount rubbed off. If a clean piece of rag is used after each rubbing, more colour will be taken off. Any colour, or mixture of colours, can be used for such toning.

The quality of surface you require will depend on the kind of painting you wish to do on it. A perfectly smooth surface is not often used nowadays, although beautiful work has been done on it in the past. It is essentially the surface for very thin painting and high finish when soft brushes are used. The paintings of the pre-Raphaelites were done on such canvases.

What one asks of an ordinary canvas, is a surface that will pick the paint off the brush evenly without any scratchiness. And that will hold the first touches painted sufficiently firmly, for other touches to be painted evenly across them, without picking up the under paint unduly. Such a canvas enables one to paint in clean touches that can be controlled, and that retain their purity of colour. The large majority of

canvases sold, particularly in this country, fall hope-
lessly short of this requirement. The canvas manu-
facturer seems to delight in a pretty, even soapy surface,
on which the paint slides about in a most uncontrollable
fashion. I don't quite know how this is got, as it
must be very difficult; no home-primed canvas has
this horrid quality. You can tell a good canvas by the
feel of it. Pass your fingers across it, and if they slide
silkily you may know it is no good. The good canvas
has a bite on it, a slightly gritty feel. It need not be
a coarse canvas to have this quality, the finest canvases
have it when properly prepared.

There is a great variety in the grain of canvases,
some are very coarse and some very fine. Certain
classes of work demand a coarser canvas than others.
Many modern painters who have gone for a purity of
tone in their work, where the colour masses are kept
as large and simple as possible, have liked coarse
canvas. A perfectly flat tone painted on a coarse canvas
is more interesting than when painted on a fine canvas.
The grain of the canvas breaks the surface up slightly
and gives it a little movement, whereas on a smooth
canvas it is dull and lifeless. In the latter case move-
ment has to be introduced by subtle variety of colour
painted into the tone. Whistler, who painted in large,
simple tones, often used a canvas with much grain.
The coarse-grained canvases demand a manner of
painting in which a full brush of very liquid paint is
used.

A beginner should commence with a medium-grained
canvas, and afterwards try others until he finds what
suits him.

Absorbent canvases suck the surplus oil from the paint, so that it dries with a dull surface. Pictures painted in this manner will retain their brilliancy, as there is no skin of oil on the surface to darken. For brilliant pictures, such as sunlight effects very high in key, such grounds are undoubtedly best. For interior subjects, or pictures with dark tones, they are unsatisfactory, as the darks when they dry dead are so much lighter and colder in colour, that one cannot see what one is doing, without continually oiling out. And this destroys the advantage of the absorbent ground by adding on the surface the oil that the absorbent canvas was used to suck up from the back. Painters who like the dry effect of an absorbent canvas are often loath to varnish their work when finished, as it destroys the dry surface. In this case it is absolutely necessary for the picture to be put under glass, as the dirt that would settle into the interstices would be impossible to dislodge without shifting the paint. Dirt is the great enemy of permanency in our modern cities. Thickly painted pictures are better on absorbent grounds, as the excess of oil that would ordinarily come to the surface and darken the picture, is absorbed by the ground.

Palettes. There is not a great deal that need be said about palettes, except that they want to be nicely balanced and have a large enough hole for the thumb to be comfortable in. In modern times palettes have been getting larger and larger, and it is difficult to understand how the old masters managed with the tiny palettes one sees in their self-portraits. The thing that needs impressing on the beginner is the necessity

of keeping the palette clean. I know some painters of distinction, particularly landscape painters, have painted with very dirty palettes; but any clear colour in their pictures was got despite their dirty palette, not because of it. One cannot be too careful at the start, in forming habits of cleanliness, as habits are easy to form and difficult to break. Most students clean the body of the palette with palette knife and rag fairly well, but leave the paint set out from the tubes along the upper edge. This in time dries, and other paint is set over it until a heavy load is formed that greatly adds to the weight. This can be avoided if after every day's work this unused paint is taken off with the knife and put along the lower edge, when the top can be cleaned off like the rest. This unused paint is then put back in its right position before commencing work next morning. After the rag has cleaned off all it can, a small piece of cotton wool is useful in finishing the job. A very slight smear of paint on the palette will prevent you getting a clean mixture, and spoil the purity of any light tones mixed upon it.

Another thing to be careful about is always to put the paints in exactly the same position on the palette. The hand becomes accustomed to going to certain places for certain colours ; which action, in the heat of the work, should be more or less automatic; and this cannot be so unless the colours are always in the same place. It does not so much matter what order they are set in, provided it is always the same. But some orders are better than others. In the first place your white, which is much the most often used, should be

in the most convenient place to get at, namely, in the middle. And the darker paints should be as far away from it as possible, in case of any accidental overlapping. Then there is just a possibility of so dark a blue as French blue being mistaken for black, so it is as well to keep them apart. This is the order in which I set my own palette. To the left of the white in the middle, I start with the earth colours, yellow ochre or transparent golden ochre, burnt sienna, Venetian red or Indian red, raw umber or burnt umber, then the blacks. On the other side, the chrome or cadmium yellows, then any greens, terra vert or viridian, any madders used, vermilion, then the blues.

In painting large work like, say, the background of a full-length portrait, I use a painting table or board, that I made with an imperial-sized drawing board, a sketch of which is here given. Along the top of the board I screwed a piece of wood, triangular in section, having a width at the top of four inches. Along this I nailed several sets of those square patty-pans, sold in groups of four, that are used in the kitchen for making little cakes. Round the edges of the board I put a little beading to prevent liquid paint flowing over the sides. And the whole was finally painted with grey Aspinall's enamel. At the upper part of the back I put two screws that stuck out about $1\frac{1}{2}$ inches. These enabled me to hang it over one of those drawing tables with a top that can be set at any angle, and move up and down, that are sold by all artists' colourmen for water-colour work and drawings. A tin for brushes, screwed on the side, completed what I find quite a useful painting table, such as is not at present on the market.

The patty-pans are useful for keeping mixtures of the tones that one is using. The paint in them can be kept wet by filling them with water. In painting large surfaces that one does not complete in one day, it is useful to have the same mixture to go on with next day, and even day after day.

MATERIALS

The following is a list of the colours set on the palette by a few of our distinguished modern painters, taken in alphabetical order.

D. Y. Cameron. Commencing on the right hand of the palette, near the thumb :
 White,
 Naples yellow,
 Cadmium,
 Yellow ochre,
 Vermilion,
 Rose madder,
 Venetian red,
 Cerulean blue,
 Cobalt,
 French ultramarine.
Used occasionally :
 Genuine ultramarine,
 Burnt sienna,
 Ivory black,
 Emerald oxide of chromium.

As a medium Mr. Cameron uses turpentine spirit and linseed oil very sparingly, and only at times. These are the only colours he uses ; and he finds that with blue and red he can get his deepest tones, and only on the rarest occasions does he require anything darker than French ultramarine. He says the less vehicle used the better, with which I entirely agree. He also adopts the safe plan of having a second canvas stretched behind the one on which he paints. This protects it from any mechanical damage in handling,

and also serves to prevent damp getting through at the back and destroying the priming of the canvas.

George Clausen :

Lemon chrome,
Chrome yellow,
Orange chrome,
Chinese vermilion.
Light red,
Yellow ochre,
Flake white,
Cobalt,
French ultramarine,
Emerald green,
Blue-black,
Burnt sienna.

Used occasionally :

Orange or Scarlet vermilion,
Rose madder,
Cobalt violet,
Transparent golden ochre,
Cologne earth ; and for delicate greys, Vine black or Ivory black.

Lately he has been using Smalt blue as the only blue in skies ; grinding the powder colour as he needs it with oil and a little copal varnish. He prefers to mix a brown tint rather than use a ready-made one ; and finds Cologne earth useful for greys when mixed with blue. For thinning the paint he only uses linseed oil and turpentine spirit, never any patent mediums or

varnish as he thinks they tend to dull the colours in time, as indeed they do.

He generally uses his colour fairly stiff, but in painting still-life and flowers, etc., he likes it thin and flowing, and mixes his white with oil and turpentine before commencing work. He gets his effects with solid colour rather than glazes, which he modestly says he does not understand. Round brushes are preferred by Mr. Clausen, and absorbent canvases. These are the only safe canvases for thick painting, as the large body of oil that would come to the surface if an ordinary canvas was used, would considerably darken the work in the course of time. Whereas with an absorbent canvas the excess of oil is sucked up by the canvas and very little is left on the surface to darken with time. Mr. Clausen is left-handed, so carries his palette with his right hand. For the ordinary left-hand palette the order of the colours should be reversed.

Sir William Orpen :

Ivory black,
Burnt sienna,
Raw umber,
Light red,
White,
Permanent yellow,
Yellow ochre,
Deep cadmium,
Vermilion,
Cerulean blue,
Cobalt,
Viridian.

Used occasionally :
Rose madder.
For thinning colours Sir William uses copal medium.

Glyn Philpot. Commencing on the right-hand side of the palette (near the thumb) he sets his colours in the following order (those in italics being for occasional use) :
Light red,
Indian red,
Vermilion,
White,
Yellow ochre,
Raw umber,
Burnt umber,
Ivory black,
Cerulean blue,
Cobalt,
Terra vert,
Burnt sienna.

Very occasionally, for glazes, he uses Rose madder, Transparent golden ochre and Vandyke brown, and sometimes for delicate greys, Ultramarine ash. As a medium and for glazes he uses oil copal varnish thinned with turpentine spirit.

Charles Ricketts. Commencing on the right :
White,
Blue-black,
Transparent brown,
Venetian red,
Indian red,

Terra d'Italie,
Terra vert,
Cerulean blue.

Mainly for glazes or for transparent effects and mixed with copal varnish, he uses :

Oxide of chromium,
Madder,
Cyanine blue,
Burnt sienna,
Cobalt (for local colour and for greys).

Mr. Ricketts uses a larger palette than formerly. Naples yellow he uses occasionally only for primrose draperies and it could be dispensed with. He considers burnt sienna always dangerous and feels sure it is different to the old masters' colour. Raw umber, he says, is worse, and he has discarded it for years. He does not use ultramarine or vermilion, as they are too strong in pitch for the yellow and greens he employs. He says the small scale of his work necessitates a narrow range of luminosity in his pigments.

Charles Shannon :

Flake white,
Naples yellow (imitation),
Terra d'Italie,
Alizarine,
Vermilion,
Indian red,
Madder,
Transparent brown,
Cerulean,

Cobalt,
Cyanine blue,
Viridian,
Terra vert,
Ivory black.

Used occasionally :
Raw sienna,
Yellow ochre,
Burnt sienna,
Ultramarine,
Cobalt green.

Medium :
Linseed oil and Copal varnish.

Charles Sims commences his pictures in egg tempera on a gesso priming, and carries the work to a high degree of completion in this medium. Mr. Sims has a very skilful method of getting over the difficulty of making gradations in so quick drying a medium as egg tempera, that obviates the old masters' method of hatching. With the side of a brush and a very small quantity of colour he lightly rubs on a cloud of thin paint ; so thinly that it dries almost immediately, the gradation being controlled by the amount of colour put on. If he is painting a dark over a light the more colour that is rubbed on the darker will be the tone ; and when he wants it to gradate into a light tone the slightest film only will be used. And when painting a light over a dark the thinner the film the darker the tone. It is a method something like using pastel, but needs extraordinary skill and delicacy of handling ; a quality Mr. Sims is pre-eminent in. Lovely pearly effects of

PLATE 56

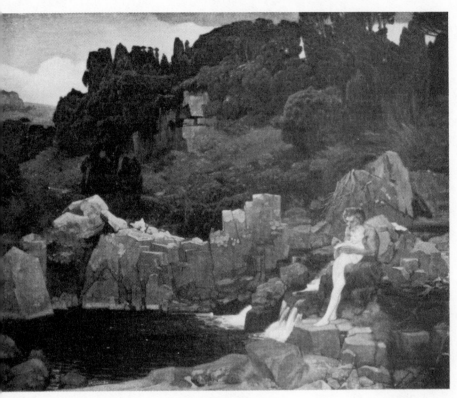

PAN'S GARDEN
Commenced in egg tempera and finished in oil paint on an absorbent ground

one colour thinly put over another can be obtained in this way ; such mixtures preserving a purity of colour greatly superior to that of a tone mixed on the palette.

He sets his colours (ground in water only) upon a piece of damp flannel to keep them moist, and mixes them as he goes along with the yolk of an egg kept in a china cup. He has lately taken to using the patent tempera white, put up in tubes by Messrs. Rowney. This white stands well and dries very hard, and does not flood in the same manner that white mixed with the plain yolk of egg does, when put on thickly. You can paint with strongly marked brush work with it, which will dry quite hard and crisp. The late Napier Hemey used to put in the impasto of his rolling seas with this make of tempera as an underpainting, and it has stood the test of time very well. I formerly used this make of tempera colours when made by the German firm of Brandt & Hasse (Rowney bought the patent when the German firm disappeared), and pictures painted with it twenty years ago have stood wonderfully well and not changed at all. I sometimes use it to put in a portrait head in monochrome, when it is required to paint on the next day. It enables you to get the head rubbed in and some body of paint put on in the lights that is useful as an underpainting, and if left before the fire is quite hard next morning. For tempera Mr. Sims uses the following colours :

Zinc white (Rowney's make in tubes).
Powder colours mixed afterwards with yolk of egg—
Aureolin,
Yellow ochre,
Light red,

Ruby madder,
French ultramarine,
Burnt umber,
Blue-black,
Viridian.
Used occasionally :
Indian red,
Prussian blue.

When the picture is carried as far as it can be with the tempera medium, it is oiled out with Madderton's copal medium ; which of course changes the dead surface of the tempera into the rich quality of an oil painting. The picture is then worked upon and finished in oil paint used with Robertson's medium, thinned with turpentine spirit. In order to prevent damp getting at the absorbent priming, Mr. Sims has his gesso priming put upon the back of an already primed canvas. So that the back of the canvas has a non-absorbent priming. The following is a list of oil colours used by Mr. Sims :

Flake white,
Pale cadmium,
Yellow ochre,
Light red,
Ruby madder,
French ultramarine,
Viridian,
Burnt sienna,
Blue-black.
For occasional use :
Scarlet vermilion,
Cerulean blue,

Terra vert,
Prussian blue,
Medium :
Roberson's medium and turpentine spirit.
P. Wilson Steer selects his palette from the following
colours :

Flake white ;
Reds—
Light red,
Chinese vermilion.
Indian red,
Rose madder ;
Browns—
Raw umber,
Burnt sienna,
Cappah brown,
Bone brown ;
Yellows—
Yellow ochre,
Brown ochre,
Strontian,
Lemon chrome,
Deep chrome ;
Greens—
Transparent oxide of chromium.
Terra vert ;
Blue-black ;
Blues—
Cobalt,
Cerulean,
French ultramarine,
Prussian blue.

OIL PAINTING

His favourite vehicle for painting is poppy oil with occasionally a small drop of amber varnish to help its drying quite hard; and sometimes thinned with turpentine spirit. He has never used the cadmiums and has found the chromes always reliable. Like all distinguished colourists, he uses as few colours as possible, and the full number given is only a list of those he selects from.

CHAPTER XII

PICTURE PAINTING

THE many different manners of painting pictures may be divided, broadly speaking, into two. There is the painting which depends for its effect on the personal charm of a free and vigorous handling; preserving the spontaneity of the sketch right through the finished picture, and relying much on the happy accidents of the moment. And at the opposite pole to this, there is the painting which is built up on a carefully considered plan, the result of numerous studies and much deliberation. The quality of which depends less on the allurements of spontaneous handling than on the expressiveness of the design, and qualities of paint deliberately prepared for. The majority of methods are not extreme, but combine the qualities of both in varying degrees. And there are few good paintings that do not preserve something of the freshness of the sketch in the handling, or possess something of the fundamental qualities of a carefully wrought design. But, broadly speaking, there is this distinction to be observed, and the two methods are suited to two different types of mind.

It is in decorative painting that the note of spontaneous handling is least wanted. Here painting takes its place as a part of architecture, and it will depend on the architecture what type of painting is allowable. In buildings designed and constructed on the severe structural principle of classic design, the personal

note of free handling is not wanted ; the individual expression in the parts is everywhere subordinated to the whole impression. And even in Gothic and Romantic architecture, where the personal notes in the parts is desirable, it will not be shown so much in the handling as in the freer expression in the general design, as little of the handling could be seen from the distance at which decorations are usually viewed. This is how it is that in decorative painting, pupils and assistants can be so much more largely used than with easel pictures. The master's work is more or less ended when the design has been thoroughly worked out and the working cartoons made. The actual execution must be carried out under his supervision, but not necessarily with his own hand ; any more than it is necessary for the architect to build his building with his own hands.

The fascinating quality of deft spontaneous handling has exercised an enormous influence over painters in modern times. It is very seductive, and like all brilliance, is blinding in its influence, and allows one to pass much that is second rate while carried away by the sheer brilliance of the execution. It is like a witty epigrammatic remark that carries a much greater conviction than its truth may justify. But its maximum effect in painting is rather short-lived, as it owes so much to the freshness of the paint. When this is subdued by the quieting influence of time, the work has to rely much more on the truth and beauty inherent in its arrangement. The blinding influence of brilliant handling being largely removed by time, the pictures have to rely more on the qualities that give distinction to those of quieter execution, that were

once so amazingly outshone by the brilliantly painted ones. That is how it has often happened in recent years, when pictures that years ago quite staggered one by the brilliancy of their execution, have been seen again, that they are found to have lost so much of their effect. While pictures of a quieter manner, one had not much noticed when first seen, have been found to have lost little and even to have gained by the hand of time. I don't mean pictures that were positively dull in handling, which of course have no lasting qualities and will not improve by time. Age will not add vitality to paint that has been killed in the labour of painting. But there are many painters whose handling is quite fresh, although not of that astonishing brilliancy that catches the eye in a crowded exhibition and makes the hit of the year.

This quality of brilliant handling was carried to such a pitch at the end of the nineteenth century that something had to happen, and the inevitable reaction has set in with the ultra-modern movement. In place of the smart brilliancy of the *fin de siècle*, we now have uncouth handling and naif primitivism, painters seeming to aim at the elimination of all graces of handling from their work. This swinging from one extreme to the other is necessary, I suppose, to keep the course of art properly poised ; but they are carried to tiresome lengths in these noisy days.

Whatever manner is adopted should not be forced; your temperament will naturally lead you to one suited to your needs, if you are true to yourself and your inner light.

Whether your picture is going to be painted in the entirely spontaneous method, or the more carefully

considered, some sort of preliminary sketch will be necessary. But in the former case a pencil scribble is often sufficient, as this kind of painting is usually done direct from nature and relies much on the inspiration of the moment, and one is best left as free as possible. Gainsborough was a great master of this free manner of painting, and the commencement of a portrait, now in the National Gallery (Plate 55), well illustrates his bold manner of throwing his subject on the canvas. It is likely that he made a rough pencil scribble of the general arrangement, but it does not look as if he made anything more elaborate. Although in the case of the " Perdita " in the Wallace Collection he made a very complete sketch, which is at Windsor. Every painter varies in his method, and seldom paints two canvases on identically the same plan.

It is in the painting of carefully worked-out compositions that there is more to be said about method, as they are more methodically painted.

But something should be said in the first place about subject matter, and the predilection for what are called classical subjects that painters who adopt the carefully wrought out manner so often have.

Many people are puzzled by the fascination that the characters of mythology have held for artists. The habit of looking at pictures as illustrations is so strong, that they cannot understand why artists so continually paint illustrations of what to them seem stupid old stories, having very little connection with modern life. They go through the galleries of the world, and find on every hand paintings of mythological characters in every conceivable costume, and lack of

costume, and are puzzled to know why artists for ever harp back to these ancient subjects.

A picture is not an illustration, but an embodiment in the language of æsthetic expression of something from the inner life of the artist. And before he can give expression to this inner life he has to find concrete symbols into which he can infuse it, in order that it may take visible form. Ancient mythology presents us with a series of concrete symbols that are universally recognised; a series capable of being infused with the inner life of the artist and giving it visible form. The characters of classic mythology, and of all mythology, stand so remote from any mundane associations that they offer the freest subject matter for the expression of abstract realities.

Imaginative pictures such as these are directly inspired from within, while the picture painted directly from nature, or from the recollection of something seen, are inspired from without. But the difference between these two classes of pictures is not so great as is usually supposed, as the source of both is the same, the inner life of the artist. For the picture that is inspired from without (from something seen) does not exist already made outside the artist; it is only a picture in so far as his æsthetic perception re-creates it in a new form.

A painter is moved to paint something he sees, because it has set up a correspondence with something in his inner life, that he is urged to express in the æsthetic terms of a picture.

The imaginative picture is only the same process working the other way about; the matter is the same

in both cases. What this matter is, what is the true subject matter of art, has provoked endless discussion. The æsthetic experience that a work of art conveys and that may be said to be its real subject matter is a very mysterious thing. It is associated in its outward expression with certain form and tone and colour arrangements that affect us, and are seemingly governed by definite instinctively felt laws which we are only as yet groping after. While, on the other hand, I think it is intimately related to the deeper notes in our being. To the materially minded the concrete work of art may be the only thing that matters, but I hold that this cannot be produced in any fine form without having its roots in something very deep in the nature of the artist. The spirit of man is not finely moved to create a work of art unless it is deeply touched. And the emotional stimulus that is behind a fine picture cannot be sustained over the long process of the painting, unless its roots are deep in the nature of the artist. These deep feelings may have served their purpose when they have inspired the æsthetic expression that is a work of art, and may be of little interest to art criticism afterwards. But they are of very great importance to the artist. And I am inclined to think that the difference in the art of one age and another is more in the quality of this inner life than in the executive ability of the artists. In ages that are favourable to the production of fine art, this inner emotional life is of a sustained and full quality. Artists are, as it were, the safety-valves of this head of emotional steam in the times in which they live, and give expression to it in their work. At times such as the

present, when this inner life is so disturbed and troubled, and so much concerned with material things that it is apt to be shallow, the artist is thrown back upon his own individual feelings, unsupported by any sustained weight of emotional life in the community, ripe for expression. You therefore find artists frittering away their energies in experimenting with amusing and new manners of expression; trying to make up with original manner, for the lack of original matter. There is too much striving for an aggressive and self-centred individuality, and not enough of the artist's losing himself in the deeper currents of the emotional life of his time. It is this " herd matter," as I believe psychologists would call it, that gives the weight and significance to great art. And to my mind it is what distinguishes among moderns an artist like Rodin from his contemporaries. There were many sculptors in France who possessed his accomplishment; but what gave him so much more significance, was the fact that he expressed in sculpture that deep spirit of awakening consciousness in the masses, which is the outstanding characteristic of modern times. For the first time in history the masses can read and write, and are becoming the power in the land, and beginning to think. In his first notable work, called " The Age of Bronze," this spirit is embodied in the figure of a man, his clenched fist on his head and a puzzled look on his face. A slowly awakening consciousness. Then there is the " John the Baptist." Not the refined spiritual John the Baptist of tradition, but a rough, uncouth figure clumsily striding forth with one hand pointing down and one hand pointing up. To me the

deep note in this figure is the feeling of the upward march of the mass of common people who for so long had been the under dogs. Then the " Bourgeois de Calais." A low, uncouth crowd, but performing a noble act of self-sacrifice. This was a commission, and the subject was no doubt given to the artist, and it is interesting to see how he has twisted it into harmony with the deep emotional note that moved him. The originals of this act of self-sacrifice were gentlemen of Calais and not men of the lowest type. And Rodin has had to do violence to historic fact to give it the significance it has as an expression of the heroic in the uncouth. And lastly, " Le Penseur." " But this is not a thinker," a candid artist friend said to me when it was first exhibited, " but a brute." To me it embodies the same " herd matter " that was at the basis of the other works we have enumerated. The masses beginning to think ; an expression of the labour movement. It is this deep emotional note of the time, bigger than the individual Rodin, that gave to his best work its powerful appeal. I don't mean that all this was consciously done by the artist, and it is quite likely he was consciously unaware of it ; works of art are not the result of " taking thought." All the artist has to do is to keep himself in the simple receptive attitude of mind and follow the lead of the deepest promptings of his inner nature.

The selection of a subject is a thing he has little control over. His subconscious complex (or whatever you like to call it) urges him, very often at long intervals, to paint a certain picture. At first the vision is dim, but gradually it takes more definite form in his

PLATE 57

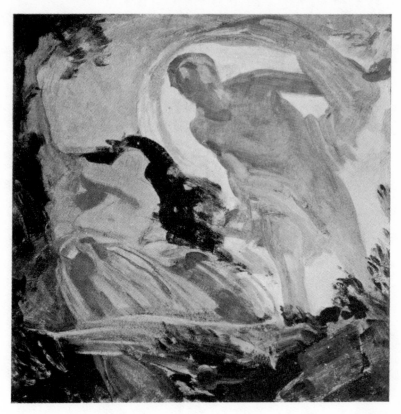

PRELIMINARY SKETCH FOR DAPHNIS AND APOLLO

PLATE 58

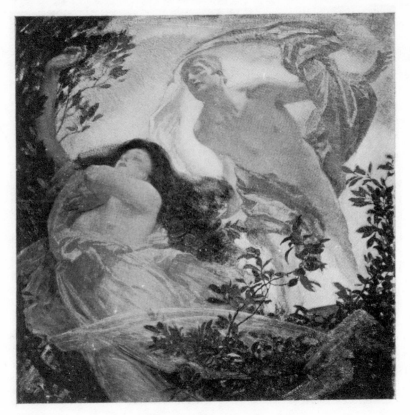

DAPHNIS AND APOLLO

consciousness. He should early acquire the habit of setting down something, however vague, of any such ideas as they occur. These motives for pictures are probably very intimately connected with the inner workings of his life; and it would be interesting to trace the emotional life of a great artist from the evidence of his pictures. The student should keep many of these subject sketches going, and eventually some may develop sufficiently to justify a picture.

Let us assume that the yearning of his nature has been attracted by the myth of Apollo and Daphne. That symbol of unsatisfied desire which is one of the deep notes of the time; the ideal that is always out of reach. And that he has been struck with the analogy there is between this myth and the daily miracle of the sun for ever chasing the dawn that dissolves before it; which was possibly the original origin of the myth. After various preliminary scribbles and sketches carried on possibly over a long period, he eventually arrives at a sketch he thinks worth painting. He then sets about making studies from the life for his picture. Never make studies from nature for imaginative pictures (that is, pictures produced from within outwards) until you have a very definite idea of what you want. You won't get any suggestions from the models that are of any use; and you will be surprised how stupid they will often look when posed. But if you have a clear idea of what you want, the model can be a great help in giving the figure you have in your mind a more complete realisation. Drawing studies for a picture is a very different thing from drawing studies from a model in a life class. And you may have to make many

studies from different models before you make a drawing that is of any use.

Some artists make a full-sized cartoon for the picture ; setting up the full-sized figures from the studies by means of square lines drawn over the study, and then copying the figure on the cartoon by means of similar squares drawn to the different scale. But others prefer to square the studies straight on to the original canvas. The whole thing should be drawn out and the disposition of the main lines and masses completed to your satisfaction before any painting is commenced. Some, however, prefer a freer method, spending less time on the preliminary setting out of the drawing and rubbing the whole effect in loosely in colour at the start, nowhere committing themselves to any very definite contours. The danger of this method is that you may easily get your picture too loaded with paint. It is to avoid this that the early painting should be rubbed in. That is, with as thin a film of solid paint as will just stain the canvas. This leaves the pleasant " tooth " of the canvas undisturbed for your finishing work. It is difficult to get much quality on a heavily loaded canvas, unless a broken surface of dry paint is adopted all over. This is a method that many modern painters use with success, but only with pictures of a very light key ; solidly painted darks are always ugly if they are loaded with paint. But as far as the permanency of a picture is concerned, the most direct method of arriving at the result aimed at is the best.

The thing to avoid is unnecessary paint on the canvas. It is not always possible to get what you want

with perfect economy of means. But this is the thing you should aim at. So that it is not wise to leave too much fumbling to be done on the original canvas. After one or two paintings, the canvas gets filled up and a smooth horny surface is got that is very difficult to do anything with. When this happens it is often advisable to get the paint off down to the canvas again, either by means of some strong paint solvent or a hot flat-iron ; a very messy job, and not always satisfactory. Another way to get a new ground to paint upon when the canvas is loaded, is to scrape the surface and then prime the piece to be painted with white; put on in rather a dry state with a hard brush (the oil having been got out of it as far as possible by putting it on blotting-paper overnight), painting it on with the brush marks showing and going in all directions. This will of course have to be left to dry very thoroughly before it is painted on. It should be left for a fortnight at least, and preferably for a month, and may need a little scraping if the surface is too rough.

The first lay-in of a picture should be in the simplest possible masses. Always work from a simple to a complex. If the simple basic structure of your picture is right, everything else will drop into its place. Nothing is more annoying than to find after you have finished one of your pet passages, that it has to be all shifted on account of not being in exactly the right place. Concentrate on the big simple design until you have this right, before going on any further.

The primitive manner of painting was always founded on a completely finished outline basis, the manner of painting consisting in painting the different

parts individually bit by bit, each part being often completed in one painting. Many students are returning to this simple manner, which has much to be said for it from the emphasis it gives to line expression. The edges standing out clearly without atmosphere tell with their full emotional force. Consequently this manner of painting demands the utmost expressiveness in the contour drawing. The original primitive paintings of the Renaissance were done in egg tempera, and this is a better medium than oil paint for this form of expression. Oil paint is too heavy, and does not show at its best in this primitive formula. Whereas tempera is at its best ; and in the work of Botticelli, the most accomplished of the primitives, was carried to great perfection. The primitives usually underpainted their flesh with terra vert, on which yellow ochre and reds were thinly painted, the underpainting showing through and modifying them to produce the half tones. Into this the lights were solidly painted, often by hatching, and also the darks. Draperies also were underpainted. In the unfinished tempera painting by Michael Angelo, in the National Gallery, No. 809, you will see the terra vert ground for the flesh and the drapery of the Madonna shaded in black, on which blue would have been glazed had it been finished.

When oil painting was first introduced it was used in very much the same manner as tempera had been, the technique was still largely a tempera one. And it was a long time before a technique was evolved that embodied the particular qualities of oil paint. It is quite likely that the two mediums were for some time combined, the first painting being in tempera, which

was afterwards scumbled or glazed with oil paint and finished in a solid manner. Tempera has advantages as an underpainting, and takes glazes and scumbles of oil paint beautifully. It looks as if Paul Veronese laid in his compositions with some sort of tempera medium and afterwards glazed this with oil colour and worked into it, finishing with solid oil paint.

Many seventeenth-century painters used canvases primed with some dark warm colour. Very brilliantly flashing lights can be got by this means; but the dark ground in time shows through the more thinly painted parts and darkens the picture, except the more solidly painted lights. You can generally tell pictures painted in this manner by the way everything has darkened except the solidly painted lights, which stand out unduly. In these days when it is the fashion to paint shadows more solidly this drawback might not be so great. And there are advantages in painting on a ground that can be left showing if need be. A white ground has to be entirely covered up; not that this is always done in these days. I remember being asked quite innocently by a lady who had expressed great admiration of a popular artist's exhibition, why he always painted people in the snow. He had used paint more as a draughtsman would use chalk or pastel in little touches, leaving white spots of uncovered canvas all over the work, which the good lady had mistaken for snowflakes. If these spots had been of some neutral colour that harmonised with the work the effect would have been less disturbing. For rapid sketches it is always an advantage to have a ground prepared of some colour that can be left in the middle tones if

necessary, as it saves time in covering the canvas. The best toned canvas, as I have explained elsewhere, is not a solidly primed tone, but made of a white canvas that has been thinly tinted with turpentine and colour.

The young artist, impatient to get on to the more interesting final painting, is very apt to rush on before the plan of his picture is sufficiently considered, with the result that he gets in the same sort of muddle a builder would if he rushed on with some of his finishing structure before his foundations were settled. When a picture is hopelessly muddled in this way, simplify, get back to a simple stage of tone masses, and get them right in disposition before going on with anything else. If this stage is right the basis of the whole matter is there, and you can go on finishing the parts as far as possible in the order of their importance.

Resist the temptation to continually alter your composition in the course of the work. One tires of the original idea, and thinks any change an improvement, whereas it may well be the reverse. The chances are that you have merely tired of your original idea ; in which case it is better to put the work aside for a time. Only make a serious alteration after very careful consideration.

Do not work without vision, without seeing ahead what you want to do. You will find that after working for some time on a part, that the vision of what you wanted to do gets dull. Stop, and go on with some other part, where you see what you want to do. Or if you do not see anything, stop, and take up another picture, or rest. After a change of work your eye will see clearly what is wrong, and what is wanted. Always

turn your unfinished work to the wall, so that you see it with a fresh eye when you come to work on it again.

An unnatural look breaks the harmony of the whole. There must be a unity of naturalness in the picture, even when the treatment is not a naturalistic one. Whatever note is set up must be sustained throughout. In symbolical subjects a treatment remote from actuality must be sustained, one in which symbolic figures can exist naturally. What is called a naturalistic treatment is only one of the many conventions that an artist can employ. And it is one that often unduly masks the significant form, tone, and colour on which the real expressiveness of a picture depends.

Style, or the manner of expression in the arts, is inextricably mixed up with and grows out of the matter that is expressed ; which, if strong enough, will naturally dictate to the artist the fit manner of its expression.

In the type of picture that depends upon the spontaneity of execution the artist will usually work from nature. But in the type of picture created from within outwards, of which we have been chiefly speaking, it is a mistake to work direct from nature. Such pictures are always best painted by the aid of studies ; when the artist is left free to fuse into his work what he has in his imagination. Direct contact with nature, with her multitudinous suggestiveness, will be apt to crowd out the original idea of the picture, and confuse the work.

The habit of working from studies should be more often encouraged in our schools and not left to be acquired afterwards, as is too often the case. The

habit of working only direct from nature, becomes in time so deep rooted, that it is difficult to acquire facility with any other method.

One has an uncomfortable feeling, after the very uncongenial task of writing about the creative side of one's craft, and trying to find the logic behind things done by intuition, that one's labour is vain. On thinking it over, I cannot remember occasions when such knowledge as I may have received from books has been of much use in my own practice. The difficulty is that nobody understands what you mean until they stumble upon it in their own experience, and then remember what they were told. But alas ! when it is no longer of any use to them. At the time it might have been a help, it was outside their experience, and therefore outside their comprehension. The analysis of painting comes after the creative effort has produced something, and is the luxury of an artist's more idle moments, rather than a necessary part of his equipment as a painter. It cannot be too much insisted upon that the creative faculties are not in the conscious intellect, are not the result of " taking thought." To be of the right quality they must come unsought, surging up from some unknown tract of the inner mind, and nourished more by the affections than the intellect. A painting may be perfect as far as any known principles of form, tone, and colour are concerned, and yet lack the vital something, that is the most important element in the whole thing. There is

always this something that escapes the cold process of analysis in all life, and consequently in the arts which express vital experiences. One needs the winged words of the poets to convey such things ; you cannot write of art, except in terms of the sister art of letters. All that one who has not this poet's magic can do is to write of the science of the means of expression as far as he can ; but it looks cold stuff when written. Painting must be studied by familiarising oneself with the best pictures, and realising in one's own experience the vital truth of the matter. And by keeping oneself in the simple, childlike, sensitive attitude of mind before all nature, drinking in from this fountain head the impressions that will nourish and stimulate what creative faculty one has. It is when the creative impulse has lost some of its impetus in the exacting process of the work, that knowledge may come to your aid and help you along a bit. After all, it was by assimilating all that Perugino was able to teach him that Raphael was enabled to start where his master left off; and soar much higher than he could have done had he not started so high up. And this is not an age of faith, but a self-conscious age of intellectual analysis, that wants to know before it feels equipped to venture. But it is little enough one can know in the case of the vital things of artistic expression. One of these days we may know more about the mysterious effect that Lines, Tones, and Colours have upon us, as of sound in music, and what is the connection between the experience of Beauty and our feeling for ultimate realities. In the meantime we cannot do better than rest content with Keats that—

OIL PAINTING

"Beauty is truth, truth beauty—that is all
Ye know on earth, and all ye need to know."

To which creed he might have added goodness. For truth, beauty, and goodness, are the three things that uplift, and by which man soars upwards to the radiance of ultimate things; are in fact that radiance as it reveals itself through the life of thought, of feeling, and of action. For are not truth, beauty, and goodness, but three aspects of the one ultimate reality?

INDEX

INDEX

Craftsmanship, 19, 20, 31-2, 91 ; Vermeer the perfect craftsman, 91

DANTE ALIGHIERI, 62
Decorative painting, 76-7, 98, 202, 259-261
Delft, 70
Democracy, influence of on art, 11
Design, functions of in relation to form, tone and colour, 49, 50
Details, proper time for, 88-9
Diploma Gallery, *see* Royal Academy
Dirt, 142, 245
Don Quixote (Opera), 103
Drapery, 130, 165, 189, 191, 200, 270
Drawing,
abstract, 35 ; as basic training, 48-9, 53-4 ; exercises, 93, 138 ; from the antique, 139 ; painters need for facility, 163 ; preliminary, 268
Dulwich Gallery, 153, 192
Dutch Painters, 70, 74, 177, 240

EAST, The, 58, 98
Eastlake, Charles Locke, F.R.I.B.A., 219
Edges,
details, 71 ; fused, 72 ; qualities of, 81 ; treatment, 86-7 ; brushes for, 87 ; chief work on, 90 ; of colour masses, 97, 124 ; sharp, 102 ; different coloured, 125 ; coloured, 133 ; lost, 125
Effects, building up of, 90
Egg, yolk of, 255
Egyptian Art, 40, 43-5
Egyptian drawing, manner of 43-5
Eighteenth-century painters, 230
Emotional stimulus, 264-5
England, 76, 105
English Painters, 107
Etching compositions (Velasquez), 186
Euston Station, 77
Exercises in painting,
preliminary, 55, 79 ; subjects for, 79, 80 ; first steps of, 83-5 ; elementary, 86-90 ; principles of, 90 ; in monochrome, 93 ; in colour, 134-8 ; in colour composition, 208

FASHIONS,
effect of changing, 20 ; tyranny of, 210
Fête Champêtre (Giorgione), 189, 190
Figure work, 141, 228, 231
Fire, 184
Flannel, damp, 255
Flat-iron (hot), 269
Flemish Painters, 74
Flesh-painting, 119, 125, 143-4, 230-3, 270
Flight into Egypt, The (Poussin), 192
Florence, 98, 122
Florentine Art, 163, 177
Flowers, 95, 134-5
Focus, 91 ; visual, 101,111 ; Vermeer's bad f., 130 ; varieties of, 137-8, 163-5, 176, 189 ; Velasquez, 168-9
Form,
definition of, 50, 54-5 ; values, 55, 66 ; study of, 57 ; emphasis (horizontal strokes), 84 ; softness, 84 ; Tone and Colour, 27, 49, 50, 52-3, 56, 66, 70, 76, 181, 184
Forms, little and big, proper sequence of, 89
Fra Angelico (Giovanni da Fiesole), 62, 98
France, 265
French Schools of Art, 52
Free manner, 260 ; Gainsborough's, 262
Fry, Prof. Roger Elliott, vi, 16, 17

GAINSBOROUGH, THOMAS, R.A., 176-7, 222, 230, 232, 262

Gauguin, Paul, 63
Giorgione (Barbarelli, Giorgio), 69, 188-9
Giotto (Di Bondone, Anglotto), 97
Girl seated at the Virginal, 91
Girl standing at the Virginal, 71, 73, 74, 117
Gladstone (Millais), 205
Glazing, 79, 123-4, 129
Glitter, treatment of, 92, 168
" Grand Manner " in art, 10, 38
Grass, 234
Greek sculpture, archaistic period of, 9
Greek Tragedy, 202
Grosvenor Gallery, 14
Grounds, treatment in relation to backgrounds 85 ; painting, 242-5 ; toned, 242-3

HALF-TONES, 86, 119, 231-3
Hals, Franz, 177-9, 240
Harmony, Laws of, 195-7
Heads,
on painting, 141,144-180; selection of colours, 145 ; Velasquez' method, 145 ; hair, 146-7, 151, 158; brushes for hair, 151 ; noses, 149, 152, 154-5, 158 ; ears, 149 ; cheek-bones, 148, 156 ; eye-sockets, 148, 152 ; foreheads, 146, 151-2 ; eye-lids, 152 ; mouths, 154-5 ; modelling, 158 ; Brown School, 160 ; half-tones, 161 ; brush-control, 162 ; Gainsborough's, 176
Hemy, Charles Napier, R.A., 255
Holl, Frank, 225
Holland, 10, 43, 74
Holy Family (Reynolds), 199
Hoogh, Pieter de, 71
Horny surface, 224-5, 269
House-painters, 64, 218
Hunt, William Holman, O.M., 68, 122, 226, 233

IDEALISM, principles of, 65-6
Ideals of the East, The (book), 58
" Ideas," 2, 3
Imaginative pictures, 263, 267
Impasto, 166, 255
Impressionism, 21-4, 26, 28, 42-3, 45-8, 62, 105-6, 110, 116, 118, 125, 132, 136, 194
Impressionist colour, 105-110
Indépendants, Salon des (Paris), 27
India, 98
Ingres, J. A. D., 50, 107
Interiors, 245
Italian Manner, Influence on Velasquez, 166
Italian Painting, 97
Italian School, Early, 220
Italian Schools of Painting, 69
Italy, 10, 12, 166

JAPANESE ART, 45, 69, 98-9
John the Baptist (Rodin), 265
Joubert, 11
Julia, Silvia, Valentine and Proteus (Hunt), 68

KEATS, John, 275-6

LANDSCAPE (Corot), 198
Landscape work, 121, 228 ; English, 234
Last Supper (Leonardo da Vinci), 200
Laurie, Prof. A. P., 219, 227
Lay-in, supreme importance of first, 81, 269
Lecture theatres, decoration in, 76
Lewis, Percy Wyndham, vi, 33-4
Life,
painting from the, 139-180 ; antique figures, 139 ; live models, 139 ; varieties of colour, 140 ; in two colours, 141 ; Italian models, 141 ; selection of colours, 143 ;

278

INDEX

flesh forms, 191 ; female figures, 192 ; flesh colouring, 203
Light, expression of, 46–7 ; strongly-lit effects, 79 ; vitality of, 116 ; flashing, 271
Light and Shade, discovered, 43
Lights, 85
London, 68, 198
Lotto, Lorenzo, 69
Louvre, The, 158, 164
" Lyric expression " (of colour), 109

M*ADONNA AND CHILD WITH TWO SAINTS* (Giorgione), 188–9
Madrid, 164–5, 188–9, 233
Manet, Edouard, 206
Man with the Glove, The, (Titian), 158
Manzo (disciple of Velasquez), 153
Masaccio, Thomas, 43, 98
Mass expression, 80–1 ; tone masses, 83 quieter, 133
Materials,
 Amber varnish, 73, 224–5
 Bitumen, 230
 Chromes, 234
 Collodion, 227
 Copal medium, 224–5
 Copal varnish, 121, 123, 224
 Formaline, 227
 Gesso priming, 254, 256
 Linseed Oil, 83, 220, 225
 Mastic varnish, 224–5
 Petroleum spirit, 124, 146, 221, 223, 225
 Poppy oil, 83, 146, 221, 223, 225
 Roberson's medium, 256
 Solvents, 269
 Turpentine spirit, 83, 124, 146, 176, 219, 221–3, 225
 Varnishes, oil and spirit, 224–6, 229
Materials for a History of Oil Painting, 219
Materials of the Painter's Craft, 219
Matisse, Henri, 15, 17
Mediterranean blue, 124
Meneñas, Las (Velasquez), 163–4, 166
Men, treatment of old, 178
Michael Angelo (Michelangelo Buenarroti), 270
Middle Ages, 16
Midsummer Night's Dream, A, 59
Millais, Sir J. E., P.R.A., 69, 205
Models, *see* Life
Modern Art, 30, 36
Modern Colour Designing, 206, 209
Monet, Claude, 107–8, 116, 206
Monochrome, 82, 94, 135, 139, 140, 197, 204, 209, 230, 255 ; used by Reynolds, 173–4 ; used by Corot, 198 ; absolute monochrome, 198 ; schemes, 207
Montecelli, 50
Moonlight Subjects, 198
Moreau, Gustave, 17
Mosaics, 218
Mrs. Graham as a Servant (Gainsborough), 176, 231
Mrs. Lowndes-Stone Norton (Gainsborough), 176
Music, tone-values of, 67
Musical instruments, 190
Muted Notes, in painting, 75, 200–1
Mysticism, in relation to Art, 65
Mythology, 262–3

N*ATIONAL GALLERY,* 71, 73, 75, 91, 102, 108, 170, 188, 198–9, 201, 205, 207, 213, 220, 231, 262, 270
Natural appearances, study of, 58
Naturalistic School, 121 ; n. movement, 194 ; n. treatment, 273
Nature, as Artist's key-board, 59, 60 ; objective, 64

New Gallery, 14
Night scenes, 75
Nineteenth-century Movements, 10, 28–9, 75

O*KAKURA,* 58
" Orchestration " in painting, 103, 114
Originality, 63
Outline, device of dark, 192

P*ACHECO,* Francisco, 160
Paint,
 consistency of, 83 ; control of on brush, 84 ; manners of applying, 125 ; rubbing-in, 150, 230 ; unnecessary, 268
Painting,
 as basic training, 48–9 ; solid, 67 ; various methods of, 79, 116, 132 ; dab-by-dab method, 95, 132 ; middle-tone method, 96 ; into wet paint, 120 ; analysis of, 274–6
Palette knife, 83
Palettes, 21, 77, 82, 93–4, 106, 109, 114, 120, 142–3, 219, 228, 230–3 ; balance, 245 ; old masters', 245 ; clean, 246 ; knife, 246 ; uniform paint position, 246 ; author's colours for, 247
Palma (town), 69
Panels, brilliant white, 242–3
Parallel streaks, 84
Paris, 13, 63, 76
Parthenon sculptures, 79
Pastel, 271
Patty-pans, 247–8
Peace (Rubens), 160
Penseur, Le (Rodin), 266
Perception, artistic, 57, 60–5, 106, 138
Perdita (Gainsborough), 262
Permanency, 227, 242
Persia, 98
Persian Carpets, 182
Perugino, *see* Vanucci
Pettit, 137
Philip IV, King of Spain, 153, 165–6, 170–3
Philosopher, The (Rembrandt), 75
Photographic process, limitations of, 83
Picasso, Pablo Ruiz, vi, 15
Picture painting, 259–276
Pointillism, 25
Portrait of a Young Girl (Vermeer), 130
Portrait of an Englishwoman (Wyndham Lewis), 34
Portraits, large, 247
Portraits, requirements of, 182
Pope Innocent X (Velasquez), 166
Post-Box Colour, 199
Post-Impressionism, 25, 36, 59, 64, 194
Post-Impressionist Exhibitions, 17
Poster Design, 196, 202
Poussin, Nicolas, 192
Practice and Science of Drawing, The, v
Prado, The, 70, 102, 145, 160, 172, 188–9, 233
Pre-Raphaelite Method, 127, 130, 243
Pre-Raphaelite Movement, 10, 68–9, 121–2
" Precious " Note, The, 199
Press, The, 13, 18–9
Primitives, 28, 43, 62, 97, 99, 100, 109, 110, 163, 270
Protestant Religion, 74
" Puce period," The, 206
Puvis de Chavannes, Pierre, 68, 76, 207

R*ADNOR,* Lord, 166
Rainbow colours, 106–8, 113–4
Raphael, Sanzio, 38, 275
Realistic Movement, 10
Realism, 65–6
Religious paintings, 97
Rembrandt Van Ryn, 75, 121, 178–9, 186 use of light and dark masses by, 75

279

INDEX

A CATALOG OF SELECTED
DOVER BOOKS
IN ALL FIELDS OF INTEREST

A CATALOG OF SELECTED DOVER
BOOKS IN ALL FIELDS OF INTEREST

CONCERNING THE SPIRITUAL IN ART, Wassily Kandinsky. Pioneering work by father of abstract art. Thoughts on color theory, nature of art. Analysis of earlier masters. 12 illustrations. 80pp. of text. 5⅜ × 8½. 23411-8 Pa. $2.95

LEONARDO ON THE HUMAN BODY, Leonardo da Vinci. More than 1200 of Leonardo's anatomical drawings on 215 plates. Leonardo's text, which accompanies the drawings, has been translated into English. 506pp. 8⅜ × 11¼.
24483-0 Pa. $11.95

GOBLIN MARKET, Christina Rossetti. Best-known work by poet comparable to Emily Dickinson, Alfred Tennyson. With 46 delightfully grotesque illustrations by Laurence Housman. 64pp. 4 × 6¾. 24516-0 Pa. $2.50

THE HEART OF THOREAU'S JOURNALS, edited by Odell Shepard. Selections from *Journal*, ranging over full gamut of interests. 228pp. 5⅜ × 8½.
20741-2 Pa. $4.50

MR. LINCOLN'S CAMERA MAN: MATHEW B. BRADY, Roy Meredith. Over 300 Brady photos reproduced directly from original negatives, photos. Lively commentary. 368pp. 8¾ × 11¼. 23021-X Pa. $14.95

PHOTOGRAPHIC VIEWS OF SHERMAN'S CAMPAIGN, George N. Barnard. Reprint of landmark 1866 volume with 61 plates: battlefield of New Hope Church, the Etawah Bridge, the capture of Atlanta, etc. 80pp. 9 × 12. 23445-2 Pa. $6.00

A SHORT HISTORY OF ANATOMY AND PHYSIOLOGY FROM THE GREEKS TO HARVEY, Dr. Charles Singer. Thoroughly engrossing non-technical survey. 270 illustrations. 211pp. 5⅜ × 8½. 20389-1 Pa. $4.95

REDOUTE ROSES IRON-ON TRANSFER PATTERNS, Barbara Christopher. Redouté was botanical painter to the Empress Josephine; transfer his famous roses onto fabric with these 24 transfer patterns. 80pp. 8¼ × 10⅞. 24292-7 Pa. $3.50

THE FIVE BOOKS OF ARCHITECTURE, Sebastiano Serlio. Architectural milestone, first (1611) English translation of Renaissance classic. Unabridged reproduction of original edition includes over 300 woodcut illustrations. 416pp. 9⅜ × 12¼. 24349-4 Pa. $14.95

CARLSON'S GUIDE TO LANDSCAPE PAINTING, John F. Carlson. Authoritative, comprehensive guide covers, every aspect of landscape painting. 34 reproductions of paintings by author; 58 explanatory diagrams. 144pp. 8⅜ × 11.
22927-0 Pa. $5.95

101 PUZZLES IN THOUGHT AND LOGIC, C.R. Wylie, Jr. Solve murders, robberies, see which fishermen are liars—purely by reasoning! 107pp. 5⅜ × 8½.
20367-0 Pa. $2.00

TEST YOUR LOGIC, George J. Summers. 50 more truly new puzzles with new turns of thought, new subtleties of inference. 100pp. 5⅜ × 8½. 22877-0 Pa. $2.50

THE MURDER BOOK OF J.G. REEDER, Edgar Wallace. Eight suspenseful stories by bestselling mystery writer of 20s and 30s. Features the donnish Mr. J.G. Reeder of Public Prosecutor's Office. 128pp. 5⅜ × 8½.

24374-5 Pa. $3.95

ANNE ORR'S CHARTED DESIGNS, Anne Orr. Best designs by premier needlework designer, all on charts: flowers, borders, birds, children, alphabets, etc. Over 100 charts, 10 in color. Total of 40pp. 8¼ × 11. 23704-4 Pa. $2.50

BASIC CONSTRUCTION TECHNIQUES FOR HOUSES AND SMALL BUILDINGS SIMPLY EXPLAINED, U.S. Bureau of Naval Personnel. Grading, masonry, woodworking, floor and wall framing, roof framing, plastering, tile setting, much more. Over 675 illustrations. 568pp. 6½ × 9¼. 20242-9 Pa. $9.95

MATISSE LINE DRAWINGS AND PRINTS, Henri Matisse. Representative collection of female nudes, faces, still lifes, experimental works, etc., from 1898 to 1948. 50 illustrations. 48pp. 8⅜ × 11¼. 23877-6 Pa. $3.50

HOW TO PLAY THE CHESS OPENINGS, Eugene Znosko-Borovsky. Clear, profound examinations of just what each opening is intended to do and how opponent can counter. Many sample games. 147pp. 5⅜ × 8½. 22795-2 Pa. $3.50

DUPLICATE BRIDGE, Alfred Sheinwold. Clear, thorough, easily followed account: rules, etiquette, scoring, strategy, bidding; Goren's point-count system, Blackwood and Gerber conventions, etc. 158pp. 5⅜ × 8½. 22741-3 Pa. $3.50

SARGENT PORTRAIT DRAWINGS, J.S. Sargent. Collection of 42 portraits reveals technical skill and intuitive eye of noted American portrait painter, John Singer Sargent. 48pp. 8¼ × 11¼. 24524-1 Pa. $3.50

ENTERTAINING SCIENCE EXPERIMENTS WITH EVERYDAY OBJECTS, Martin Gardner. Over 100 experiments for youngsters. Will amuse, astonish, teach, and entertain. Over 100 illustrations. 127pp. 5⅜ × 8½. 24201-3 Pa. $2.50

TEDDY BEAR PAPER DOLLS IN FULL COLOR: A Family of Four Bears and Their Costumes, Crystal Collins. A family of four Teddy Bear paper dolls and nearly 60 cut-out costumes. Full color, printed one side only. 32pp. 9¼ × 12¼.

24550-0 Pa. $3.50

NEW CALLIGRAPHIC ORNAMENTS AND FLOURISHES, Arthur Baker. Unusual, multi-useable material: arrows, pointing hands, brackets and frames, ovals, swirls, birds, etc. Nearly 700 illustrations. 80pp. 8⅜ × 11¼.

24095-9 Pa. $3.75

DINOSAUR DIORAMAS TO CUT & ASSEMBLE, M. Kalmenoff. Two complete three-dimensional scenes in full color, with 31 cut-out animals and plants. Excellent educational toy for youngsters. Instructions; 2 assembly diagrams. 32pp. 9¼ × 12¼. 24541-1 Pa. $4.50

SILHOUETTES: A PICTORIAL ARCHIVE OF VARIED ILLUSTRATIONS, edited by Carol Belanger Grafton. Over 600 silhouettes from the 18th to 20th centuries. Profiles and full figures of men, women, children, birds, animals, groups and scenes, nature, ships, an alphabet. 144pp. 8⅜ × 11¼. 23781-8 Pa. $5.95

25 KITES THAT FLY, Leslie Hunt. Full, easy-to-follow instructions for kites made from inexpensive materials. Many novelties. 70 illustrations. 110pp. 5⅜ × 8½.
22550-X Pa. $2.50

PIANO TUNING, J. Cree Fischer. Clearest, best book for beginner, amateur. Simple repairs, raising dropped notes, tuning by easy method of flattened fifths. No previous skills needed. 4 illustrations. 201pp. 5⅜ × 8½. 23267-0 Pa. $3.50

EARLY AMERICAN IRON-ON TRANSFER PATTERNS, edited by Rita Weiss. 75 designs, borders, alphabets, from traditional American sources. 48pp. 8¼ × 11.
23162-3 Pa. $1.95

CROCHETING EDGINGS, edited by Rita Weiss. Over 100 of the best designs for these lovely trims for a host of household items. Complete instructions, illustrations. 48pp. 8¼ × 11. 24031-2 Pa. $2.95

FINGER PLAYS FOR NURSERY AND KINDERGARTEN, Emilie Poulsson. 18 finger plays with music (voice and piano); entertaining, instructive. Counting, nature lore, etc. Victorian classic. 53 illustrations. 80pp. 6½ × 9¼. 22588-7 Pa. $2.25

BOSTON THEN AND NOW, Peter Vanderwarker. Here in 59 side-by-side views are photographic documentations of the city's past and present. 119 photographs. Full captions. 122pp. 8¼ × 11. 24312-5 Pa. $7.95

CROCHETING BEDSPREADS, edited by Rita Weiss. 22 patterns, originally published in three instruction books 1939-41. 39 photos, 8 charts. Instructions. 48pp. 8¼ × 11. 23610-2 Pa. $2.00

HAWTHORNE ON PAINTING, Charles W. Hawthorne. Collected from notes taken by students at famous Cape Cod School; hundreds of direct, personal *apercus*, ideas, suggestions. 91pp. 5⅜ × 8½. 20653-X Pa. $2.95

THERMODYNAMICS, Enrico Fermi. A classic of modern science. Clear, organized treatment of systems, first and second laws, entropy, thermodynamic potentials, etc. Calculus required. 160pp. 5⅜ × 8½. 60361-X Pa. $4.50

TEN BOOKS ON ARCHITECTURE, Vitruvius. The most important book ever written on architecture. Early Roman aesthetics, technology, classical orders, site selection, all other aspects. Morgan translation. 331pp. 5⅜ × 8½. 20645-9 Pa. $6.95

THE CORNELL BREAD BOOK, Clive M. McCay and Jeanette B. McCay. Famed high-protein recipe incorporated into breads, rolls, buns, coffee cakes, pizza, pie crusts, more. Nearly 50 illustrations. 48pp. 8¼ × 11. 23995-0 Pa. $2.00

THE CRAFTSMAN'S HANDBOOK, Cennino Cennini. 15th-century handbook, school of Giotto, explains applying gold, silver leaf; gesso; fresco painting, grinding pigments, etc. 142pp. 6⅛ × 9¼. 20054-X Pa. $3.95

FRANK LLOYD WRIGHT'S FALLINGWATER, Donald Hoffmann. Full story of Wright's masterwork at Bear Run, Pa. 100 photographs of site, construction, and details of completed structure. 112pp. 9¼ × 10. 23671-4 Pa. $7.95

OVAL STAINED GLASS PATTERN BOOK, C. Eaton. 60 new designs framed in shape of an oval. Greater complexity, challenge with sinuous cats, birds, mandalas framed in antique shape. 64pp. 8¼ × 11. 24519-5 Pa. $3.95

THE BOOK OF WOOD CARVING, Charles Marshall Sayers. Still finest book for beginning student. Fundamentals, technique; gives 34 designs, over 34 projects for panels, bookends, mirrors, etc. 33 photos. 118pp. 7¾ × 10⅝. 23654-4 Pa. $3.95

CARVING COUNTRY CHARACTERS, Bill Higginbotham. Expert advice for beginning, advanced carvers on materials, techniques for creating 18 projects— mirthful panorama of American characters. 105 illustrations. 80pp. 8⅜ × 11.
23135-1 Pa. $2.95

300 ART NOUVEAU DESIGNS AND MOTIFS IN FULL COLOR, C.B. Grafton. 44 full-page plates display swirling lines and muted colors typical of Art Nouveau. Borders, frames, panels, cartouches, dingbats, etc. 48pp. 9⅜ × 12¼.
24354-0 Pa. $6.95

SELF-WORKING CARD TRICKS, Karl Fulves. Editor of *Pallbearer* offers 72 tricks that work automatically through nature of card deck. No sleight of hand needed. Often spectacular. 42 illustrations. 113pp. 5⅜ × 8½. 23334-0 Pa. $3.50

CUT AND ASSEMBLE A WESTERN FRONTIER TOWN, Edmund V. Gillon, Jr. Ten authentic full-color buildings on heavy cardboard stock in H-O scale. Sheriff's Office and Jail, Saloon, Wells Fargo, Opera House, others. 48pp. 9¼ × 12¼.
23736-2 Pa. $4.95

CUT AND ASSEMBLE AN EARLY NEW ENGLAND VILLAGE, Edmund V. Gillon, Jr. Printed in full color on heavy cardboard stock. 12 authentic buildings in H-O scale: Adams home in Quincy, Mass., Oliver Wight house in Sturbridge, smithy, store, church, others. 48pp. 9¼ × 12¼. 23536-X Pa. $4.95

THE TALE OF TWO BAD MICE, Beatrix Potter. Tom Thumb and Hunca Munca squeeze out of their hole and go exploring. 27 full-color Potter illustrations. 59pp. 4¼ × 5½. (Available in U.S. only) 23065-1 Pa. $1.75

CARVING FIGURE CARICATURES IN THE OZARK STYLE, Harold L. Enlow. Instructions and illustrations for ten delightful projects, plus general carving instructions. 22 drawings and 47 photographs altogether. 39pp. 8⅜ × 11.
23151-8 Pa. $2.95

A TREASURY OF FLOWER DESIGNS FOR ARTISTS, EMBROIDERERS AND CRAFTSMEN, Susan Gaber. 100 garden favorites lushly rendered by artist for artists, craftsmen, needleworkers. Many form frames, borders. 80pp. 8¼ × 11.
24096-7 Pa. $3.95

CUT & ASSEMBLE A TOY THEATER/THE NUTCRACKER BALLET, Tom Tierney. Model of a complete, full-color production of Tchaikovsky's classic. 6 backdrops, dozens of characters, familiar dance sequences. 32pp. 9⅜ × 12¼.
24194-7 Pa. $4.50

ANIMALS: 1,419 COPYRIGHT-FREE ILLUSTRATIONS OF MAMMALS, BIRDS, FISH, INSECTS, ETC., edited by Jim Harter. Clear wood engravings present, in extremely lifelike poses, over 1,000 species of animals. 284pp. 9 × 12.
23766-4 Pa. $9.95

MORE HAND SHADOWS, Henry Bursill. For those at their 'finger ends," 16 more effects—Shakespeare, a hare, a squirrel, Mr. Punch, and twelve more—each explained by a full-page illustration. Considerable period charm. 30pp. 6½ × 9¼.
21384-6 Pa. $1.95

SURREAL STICKERS AND UNREAL STAMPS, William Rowe. 224 haunting, hilarious stamps on gummed, perforated stock, with images of elephants, geisha girls, George Washington, etc. 16pp. one side. 8¼ × 11.　　　24371-0 Pa. $3.50

GOURMET KITCHEN LABELS, Ed Sibbett, Jr. 112 full-color labels (4 copies each of 28 designs). Fruit, bread, other culinary motifs. Gummed and perforated. 16pp. 8¼ × 11.　　　24087-8 Pa. $2.95

PATTERNS AND INSTRUCTIONS FOR CARVING AUTHENTIC BIRDS, H.D. Green. Detailed instructions, 27 diagrams, 85 photographs for carving 15 species of birds so life-like, they'll seem ready to fly! 8¼ × 11.　　　24222-6 Pa. $3.00

FLATLAND, E.A. Abbott. Science-fiction classic explores life of 2-D being in 3-D world. 16 illustrations. 103pp. 5⅜ × 8.　　　20001-9 Pa. $2.00

DRIED FLOWERS, Sarah Whitlock and Martha Rankin. Concise, clear, practical guide to dehydration, glycerinizing, pressing plant material, and more. Covers use of silica gel. 12 drawings. 32pp. 5⅜ × 8½.　　　21802-3 Pa. $1.00

EASY-TO-MAKE CANDLES, Gary V. Guy. Learn how easy it is to make all kinds of decorative candles. Step-by-step instructions. 82 illustrations. 48pp. 8¼ × 11.

23881-4 Pa. $2.95

SUPER STICKERS FOR KIDS, Carolyn Bracken. 128 gummed and perforated full-color stickers: GIRL WANTED, KEEP OUT, BORED OF EDUCATION, X-RATED, COMBAT ZONE, many others. 16pp. 8¼ × 11.　　　24092-4 Pa. $3.50

CUT AND COLOR PAPER MASKS, Michael Grater. Clowns, animals, funny faces...simply color them in, cut them out, and put them together, and you have 9 paper masks to play with and enjoy. 32pp. 8¼ × 11.　　　23171-2 Pa. $2.95

A CHRISTMAS CAROL: THE ORIGINAL MANUSCRIPT, Charles Dickens. Clear facsimile of Dickens manuscript, on facing pages with final printed text. 8 illustrations by John Leech, 4 in color on covers. 144pp. 8⅜ × 11¼.

20980-6 Pa. $5.95

CARVING SHOREBIRDS, Harry V. Shourds & Anthony Hillman. 16 full-size patterns (all double-page spreads) for 19 North American shorebirds with step-by-step instructions. 72pp. 9¼ × 12¼.　　　24287-0 Pa. $5.95

THE GENTLE ART OF MATHEMATICS, Dan Pedoe. Mathematical games, probability, the question of infinity, topology, how the laws of algebra work, problems of irrational numbers, and more. 42 figures. 143pp. 5⅜ × 8½.

22949-1 Pa. $3.50

READY-TO-USE DOLLHOUSE WALLPAPER, Katzenbach & Warren, Inc. Stripe, 2 floral stripes, 2 allover florals, polka dot; all in full color. 4 sheets (350 sq. in.) of each, enough for average room. 48pp. 8¼ × 11.　　　23495-9 Pa. $2.95

MINIATURE IRON-ON TRANSFER PATTERNS FOR DOLLHOUSES, DOLLS, AND SMALL PROJECTS, Rita Weiss and Frank Fontana. Over 100 miniature patterns: rugs, bedspreads, quilts, chair seats, etc. In standard dollhouse size. 48pp. 8¼ × 11.　　　23741-9 Pa. $1.95

THE DINOSAUR COLORING BOOK, Anthony Rao. 45 renderings of dinosaurs, fossil birds, turtles, other creatures of Mesozoic Era. Scientifically accurate. Captions. 48pp. 8¼ × 11.　　　24022-3 Pa. $2.50

JAPANESE DESIGN MOTIFS, Matsuya Co. Mon, or heraldic designs. Over 4000 typical, beautiful designs: birds, animals, flowers, swords, fans, geometrics; all beautifully stylized. 213pp. 11⅜ × 8¼. 22874-6 Pa. $7.95

THE TALE OF BENJAMIN BUNNY, Beatrix Potter. Peter Rabbit's cousin coaxes him back into Mr. McGregor's garden for a whole new set of adventures. All 27 full-color illustrations. 59pp. 4¼ × 5½. (Available in U.S. only) 21102-9 Pa. $1.75

THE TALE OF PETER RABBIT AND OTHER FAVORITE STORIES BOXED SET, Beatrix Potter. Seven of Beatrix Potter's best-loved tales including Peter Rabbit in a specially designed, durable boxed set. 4¼ × 5½. Total of 447pp. 158 color illustrations. (Available in U.S. only) 23903-9 Pa. $12.25

PRACTICAL MENTAL MAGIC, Theodore Annemann. Nearly 200 astonishing feats of mental magic revealed in step-by-step detail. Complete advice on staging, patter, etc. Illustrated. 320pp. 5⅜ × 8½. 24426-1 Pa. $5.95

CELEBRATED CASES OF JUDGE DEE (DEE GOONG AN), translated by Robert Van Gulik. Authentic 18th-century Chinese detective novel; Dee and associates solve three interlocked cases. Led to van Gulik's own stories with same characters. Extensive introduction. 9 illustrations. 237pp. 5⅜ × 8½. 23337-5 Pa. $4.95

CUT & FOLD EXTRATERRESTRIAL INVADERS THAT FLY, M. Grater. Stage your own lilliputian space battles.By following the step-by-step instructions and explanatory diagrams you can launch 22 full-color fliers into space. 36pp. 8¼ × 11. 24478-4 Pa. $2.95

CUT & ASSEMBLE VICTORIAN HOUSES, Edmund V. Gillon, Jr. Printed in full color on heavy cardboard stock, 4 authentic Victorian houses in H-O scale: Italian-style Villa, Octagon, Second Empire, Stick Style. 48pp. 9¼ × 12¼. 23849-0 Pa. $4.95

BEST SCIENCE FICTION STORIES OF H.G. WELLS, H.G. Wells. Full novel *The Invisible Man,* plus 17 short stories: "The Crystal Egg," "Aepyornis Island," "The Strange Orchid," etc. 303pp. 5⅜ × 8½. (Available in U.S. only) 21531-8 Pa. $4.95

TRADEMARK DESIGNS OF THE WORLD, Yusaku Kamekura. A lavish collection of nearly 700 trademarks, the work of Wright, Loewy, Klee, Binder, hundreds of others. 160pp. 8¾ × 8. (EJ) 24191-2 Pa. $5.95

THE ARTIST'S AND CRAFTSMAN'S GUIDE TO REDUCING, ENLARGING AND TRANSFERRING DESIGNS, Rita Weiss. Discover, reduce, enlarge, transfer designs from any objects to any craft project. 12pp. plus 16 sheets special graph paper. 8¼ × 11. 24142-4 Pa. $3.95

TREASURY OF JAPANESE DESIGNS AND MOTIFS FOR ARTISTS AND CRAFTSMEN, edited by Carol Belanger Grafton. Indispensable collection of 360 traditional Japanese designs and motifs redrawn in clean, crisp black-and-white, copyright-free illustrations. 96pp. 8¼ × 11. 24435-0 Pa. $4.50

CHANCERY CURSIVE STROKE BY STROKE, Arthur Baker. Instructions and illustrations for each stroke of each letter (upper and lower case) and numerals. 54 full-page plates. 64pp. 8¼ × 11. 24278-1 Pa. $2.50

THE ENJOYMENT AND USE OF COLOR, Walter Sargent. Color relationships, values, intensities; complementary colors, illumination, similar topics. Color in nature and art. 7 color plates, 29 illustrations. 274pp. 5⅜ × 8½. 20944-X Pa. $4.95

SCULPTURE PRINCIPLES AND PRACTICE, Louis Slobodkin. Step-by-step approach to clay, plaster, metals, stone; classical and modern. 253 drawings, photos. 255pp. 8⅛ × 11. 22960-2 Pa. $7.50

VICTORIAN FASHION PAPER DOLLS FROM HARPER'S BAZAR, 1867-1898, Theodore Menten. Four female dolls with 28 elegant high fashion costumes, printed in full color. 32pp. 9¼ × 12¼. 23453-3 Pa. $3.95

FLOPSY, MOPSY AND COTTONTAIL: A Little Book of Paper Dolls in Full Color, Susan LaBelle. Three dolls and 21 costumes (7 for each doll) show Peter Rabbit's siblings dressed for holidays, gardening, hiking, etc. Charming borders, captions. 48pp. 4¼ × 5½. (USCO) 24376-1 Pa. $2.50

NATIONAL LEAGUE BASEBALL CARD CLASSICS, Bert Randolph Sugar. 83 big-leaguers from 1909-69 on facsimile cards. Hubbell, Dean, Spahn, Brock plus advertising, info, no duplications. Perforated, detachable. 16pp. 8¼ × 11.
24308-7 Pa. $3.50

THE LOGICAL APPROACH TO CHESS, Dr. Max Euwe, et al. First-rate text of comprehensive strategy, tactics, theory for the amateur. No gambits to memorize, just a clear, logical approach. 224pp. 5⅜ × 8½. 24353-2 Pa. $4.50

MAGICK IN THEORY AND PRACTICE, Aleister Crowley. The summation of the thought and practice of the century's most famous necromancer, long hard to find. Crowley's best book. 436pp. 5⅜ × 8½. (Available in U.S. only)
23295-6 Pa. $6.95

THE HAUNTED HOTEL, Wilkie Collins. Collins' last great tale; doom and destiny in a Venetian palace. Praised by T.S. Eliot. 127pp. 5⅜ × 8½.
24333-8 Pa. $3.00

ART DECO DISPLAY ALPHABETS, Dan X. Solo. Wide variety of bold yet elegant lettering in handsome Art Deco styles. 100 complete fonts, with numerals, punctuation, more. 104pp. 8⅛ × 11. 24372-9 Pa. $4.50

CALLIGRAPHIC ALPHABETS, Arthur Baker. Nearly 150 complete alphabets by outstanding contemporary. Stimulating ideas; useful source for unique effects. 154 plates. 157pp. 8⅜ × 11¼. 21045-6 Pa. $5.95

ARTHUR BAKER'S HISTORIC CALLIGRAPHIC ALPHABETS, Arthur Baker. From monumental capitals of first-century Rome to humanistic cursive of 16th century, 33 alphabets in fresh interpretations. 88 plates. 96pp. 9 × 12.
24054-1 Pa. $4.50

LETTIE LANE PAPER DOLLS, Sheila Young. Genteel turn-of-the-century family very popular then and now. 24 paper dolls. 16 plates in full color. 32pp. 9¼ × 12¼. 24089-4 Pa. $3.95

KEYBOARD WORKS FOR SOLO INSTRUMENTS, G.F. Handel. 35 neglected works from Handel's vast oeuvre, originally jotted down as improvisations. Includes Eight Great Suites, others. New sequence. 174pp. 9⅝ × 12¼.

24338-9 Pa. $7.50

AMERICAN LEAGUE BASEBALL CARD CLASSICS, Bert Randolph Sugar. 82 stars from 1900s to 60s on facsimile cards. Ruth, Cobb, Mantle, Williams, plus advertising, info, no duplications. Perforated, detachable. 16pp. 8¼ × 11.

24286-2 Pa. $3.50

A TREASURY OF CHARTED DESIGNS FOR NEEDLEWORKERS, Georgia Gorham and Jeanne Warth. 141 charted designs: owl, cat with yarn, tulips, piano, spinning wheel, covered bridge, Victorian house and many others. 48pp. 8¼ × 11.

23558-0 Pa. $1.95

DANISH FLORAL CHARTED DESIGNS, Gerda Bengtsson. Exquisite collection of over 40 different florals: anemone, Iceland poppy, wild fruit, pansies, many others. 45 illustrations. 48pp. 8¼ × 11.

23957-8 Pa. $2.50

OLD PHILADELPHIA IN EARLY PHOTOGRAPHS 1839-1914, Robert F. Looney. 215 photographs: panoramas, street scenes, landmarks, President-elect Lincoln's visit, 1876 Centennial Exposition, much more. 230pp. 8⅞ × 11¾.

23345-6 Pa. $9.95

PRELUDE TO MATHEMATICS, W.W. Sawyer. Noted mathematician's lively, stimulating account of non-Euclidean geometry, matrices, determinants, group theory, other topics. Emphasis on novel, striking aspects. 224pp. 5⅜ × 8½.

24401-6 Pa. $4.50

ADVENTURES WITH A MICROSCOPE, Richard Headstrom. 59 adventures with clothing fibers, protozoa, ferns and lichens, roots and leaves, much more. 142 illustrations. 232pp. 5⅜ × 8½.

23471-1 Pa. $3.95

IDENTIFYING ANIMAL TRACKS: MAMMALS, BIRDS, AND OTHER ANIMALS OF THE EASTERN UNITED STATES, Richard Headstrom. For hunters, naturalists, scouts, nature-lovers. Diagrams of tracks, tips on identification. 128pp. 5⅜ × 8.

24442-3 Pa. $3.50

VICTORIAN FASHIONS AND COSTUMES FROM HARPER'S BAZAR, 1867-1898, edited by Stella Blum. Day costumes, evening wear, sports clothes, shoes, hats, other accessories in over 1,000 detailed engravings. 320pp. 9⅜ × 12¼.

22990-4 Pa. $10.95

EVERYDAY FASHIONS OF THE TWENTIES AS PICTURED IN SEARS AND OTHER CATALOGS, edited by Stella Blum. Actual dress of the Roaring Twenties, with text by Stella Blum. Over 750 illustrations, captions. 156pp. 9 × 12.

24134-3 Pa. $8.95

HALL OF FAME BASEBALL CARDS, edited by Bert Randolph Sugar. Cy Young, Ted Williams, Lou Gehrig, and many other Hall of Fame greats on 92 full-color, detachable reprints of early baseball cards. No duplication of cards with *Classic Baseball Cards.* 16pp. 8¼ × 11.
23624-2 Pa. $3.50

THE ART OF HAND LETTERING, Helm Wotzkow. Course in hand lettering, Roman, Gothic, Italic, Block, Script. Tools, proportions, optical aspects, individual variation. Very quality conscious. Hundreds of specimens. 320pp. 5⅜ × 8½.

21797-3 Pa. $5.95

HOW THE OTHER HALF LIVES, Jacob A. Riis. Journalistic record of filth, degradation, upward drive in New York immigrant slums, shops, around 1900. New edition includes 100 original Riis photos, monuments of early photography. 233pp. 10 × 7⅞. 22012-5 Pa. $9.95

CHINA AND ITS PEOPLE IN EARLY PHOTOGRAPHS, John Thomson. In 200 black-and-white photographs of exceptional quality photographic pioneer Thomson captures the mountains, dwellings, monuments and people of 19th-century China. 272pp. 9⅜ × 12¼. 24393-1 Pa. $13.95

GODEY COSTUME PLATES IN COLOR FOR DECOUPAGE AND FRAM-ING, edited by Eleanor Hasbrouk Rawlings. 24 full-color engravings depicting 19th-century Parisian haute couture. Printed on one side only. 56pp. 8¼ × 11. 23879-2 Pa. $3.95

ART NOUVEAU STAINED GLASS PATTERN BOOK, Ed Sibbett, Jr. 104 projects using well-known themes of Art Nouveau: swirling forms, florals, peacocks, and sensuous women. 60pp. 8¼ × 11. 23577-7 Pa. $3.95

QUICK AND EASY PATCHWORK ON THE SEWING MACHINE: Susan Aylsworth Murwin and Suzzy Payne. Instructions, diagrams show exactly how to machine sew 12 quilts. 48pp. of templates. 50 figures. 80pp. 8¼ × 11. 23770-2 Pa. $3.95

THE STANDARD BOOK OF QUILT MAKING AND COLLECTING, Marguerite Ickis. Full information, full-sized patterns for making 46 traditional quilts, also 150 other patterns. 483 illustrations. 273pp. 6⅞ × 9⅜. 20582-7 Pa. $5.95

LETTERING AND ALPHABETS, J. Albert Cavanagh. 85 complete alphabets lettered in various styles; instructions for spacing, roughs, brushwork. 121pp. 8¾ × 8. 20053-1 Pa. $3.95

LETTER FORMS: 110 COMPLETE ALPHABETS, Frederick Lambert. 110 sets of capital letters; 16 lower case alphabets; 70 sets of numbers and other symbols. 110pp. 8⅞ × 11. 22872-X Pa. $4.50

ORCHIDS AS HOUSE PLANTS, Rebecca Tyson Northen. Grow cattleyas and many other kinds of orchids—in a window, in a case, or under artificial light. 63 illustrations. 148pp. 5⅜ × 8½. 23261-1 Pa. $2.95

THE MUSHROOM HANDBOOK, Louis C.C. Krieger. Still the best popular handbook. Full descriptions of 259 species, extremely thorough text, poisons, folklore, etc. 32 color plates; 126 other illustrations. 560pp. 5⅜ × 8½. 21861-9 Pa. $8.50

THE DORÉ BIBLE ILLUSTRATIONS, Gustave Doré. All wonderful, detailed plates: Adam and Eve, Flood, Babylon, life of Jesus, etc. Brief King James text with each plate. 241 plates. 241pp. 9 × 12. 23004-X Pa. $8.95

THE BOOK OF KELLS: Selected Plates in Full Color, edited by Blanche Cirker. 32 full-page plates from greatest manuscript-icon of early Middle Ages. Fantastic, mysterious. Publisher's Note. Captions. 32pp. 9⅜ × 12¼. 24345-1 Pa. $4.50

THE PERFECT WAGNERITE, George Bernard Shaw. Brilliant criticism of the Ring Cycle, with provocative interpretation of politics, economic theories behind the Ring. 136pp. 5⅜ × 8½. (EUK) 21707-8 Pa. $3.95

THE RIME OF THE ANCIENT MARINER, Gustave Doré, S.T. Coleridge. Doré's finest work, 34 plates capture moods, subtleties of poem. Full text. 77pp. 9¼ × 12. 22305-1 Pa. $4.95

SONGS OF INNOCENCE, William Blake. The first and most popular of Blake's famous "Illuminated Books," in a facsimile edition reproducing all 31 brightly colored plates. Additional printed text of each poem. 64pp. 5¼ × 7.
22764-2 Pa. $3.50

AN INTRODUCTION TO INFORMATION THEORY, J.R. Pierce. Second (1980) edition of most impressive non-technical account available. Encoding, entropy, noisy channel, related areas, etc. 320pp. 5⅜ × 8½. 24061-4 Pa. $5.95

THE DIVINE PROPORTION: A STUDY IN MATHEMATICAL BEAUTY, H.E. Huntley. "Divine proportion" or "golden ratio" in poetry, Pascal's triangle, philosophy, psychology, music, mathematical figures, etc. Excellent bridge between science and art. 58 figures. 185pp. 5⅜ × 8½. 22254-3 Pa. $4.50

THE DOVER NEW YORK WALKING GUIDE: From the Battery to Wall Street, Mary J. Shapiro. Superb inexpensive guide to historic buildings and locales in lower Manhattan: Trinity Church, Bowling Green, more. Complete Text; maps. 36 illustrations. 48pp. 3⅜ × 9¼. 24225-0 Pa. $2.50

NEW YORK THEN AND NOW, Edward B. Watson, Edmund V. Gillon, Jr. 83 important Manhattan sites: on facing pages early photographs (1875-1925) and 1976 photos by Gillon. 172 illustrations. 171pp. 9¼ × 10. 23361-8 Pa. $9.95

HISTORIC COSTUME IN PICTURES, Braun & Schneider. Over 1450 costumed figures from dawn of civilization to end of 19th century. English captions. 125 plates. 256pp. 8⅜ × 11¼. 23150-X Pa. $7.95

VICTORIAN AND EDWARDIAN FASHION: A Photographic Survey, Alison Gernsheim. First fashion history completely illustrated by contemporary photographs. Full text plus 235 photos, 1840-1914, in which many celebrities appear. 240pp. 6½ × 9¼. 24205-6 Pa. $6.00

CHARTED CHRISTMAS DESIGNS FOR COUNTED CROSS-STITCH AND OTHER NEEDLECRAFTS, Lindberg Press. Charted designs for 45 beautiful needlecraft projects with many yuletide and wintertime motifs. 48pp. 8¼ × 11.
(EDNS) 24356-7 Pa. $2.50

101 FOLK DESIGNS FOR COUNTED CROSS-STITCH AND OTHER NEEDLE-CRAFTS, Carter Houck. 101 authentic charted folk designs in a wide array of lovely representations with many suggestions for effective use. 48pp. 8¼ × 11.
24369-9 Pa. $2.25

FIVE ACRES AND INDEPENDENCE, Maurice G. Kains. Great back-to-the-land classic explains basics of self-sufficient farming. The one book to get. 95 illustrations. 397pp. 5⅜ × 8½. 20974-1 Pa. $6.50

A MODERN HERBAL, Margaret Grieve. Much the fullest, most exact, most useful compilation of herbal material. Gigantic alphabetical encyclopedia, from aconite to zedoary, gives botanical information, medical properties, folklore, economic uses, and much else. Indispensable to serious reader. 161 illustrations. 888pp. 6½ × 9¼. (Available in U.S. only) 22798-7, 22799-5 Pa., Two-vol. set $17.00

DECORATIVE NAPKIN FOLDING FOR BEGINNERS, Lillian Oppenheimer and Natalie Epstein. 22 different napkin folds in the shape of a heart, clown's hat, love knot, etc. 63 drawings. 48pp. 8¼ × 11. 23797-4 Pa. $2.25

DECORATIVE LABELS FOR HOME CANNING, PRESERVING, AND OTHER HOUSEHOLD AND GIFT USES, Theodore Menten. 128 gummed, perforated labels, beautifully printed in 2 colors. 12 versions. Adhere to metal, glass, wood, ceramics. 24pp. 8¼ × 11. 23219-0 Pa. $3.50

EARLY AMERICAN STENCILS ON WALLS AND FURNITURE, Janet Waring. Thorough coverage of 19th-century folk art: techniques, artifacts, surviving specimens. 166 illustrations, 7 in color. 147pp. of text. 7⅞ × 10¾. 21906-2 Pa. $9.95

AMERICAN ANTIQUE WEATHERVANES, A.B. & W.T. Westervelt. Extensively illustrated 1883 catalog exhibiting over 550 copper weathervanes and finials. Excellent primary source by one of the principal manufacturers. 104pp. 6⅞ × 9¼.
24396-6 Pa. $3.95

ART STUDENTS' ANATOMY, Edmond J. Farris. Long favorite in art schools. Basic elements, common positions, actions. Full text, 158 illustrations. 159pp. 5⅜ × 8½. 20744-7 Pa. $3.95

BRIDGMAN'S LIFE DRAWING, George B. Bridgman. More than 500 drawings and text teach you to abstract the body into its major masses. Also specific areas of anatomy. 192pp. 6½ × 9¼. 22710-3 Pa. $4.50

COMPLETE PRELUDES AND ETUDES FOR SOLO PIANO, Frederic Chopin. All 26 Preludes, all 27 Etudes by greatest composer of piano music. Authoritative Paderewski edition. 224pp. 9 × 12. (Available in U.S. only) 24052-5 Pa. $7.50

PIANO MUSIC 1888-1905, Claude Debussy. Deux Arabesques, Suite Bergamesque, Masques, 1st series of Images, etc. 9 others, in corrected editions. 175pp. 9⅜ × 12¼. 22771-5 Pa. $6.95

TEDDY BEAR IRON-ON TRANSFER PATTERNS, Ted Menten. 80 iron-on transfer patterns of male and female Teddys in a wide variety of activities, poses, sizes. 48pp. 8¼ × 11. 24596-9 Pa. $2.25

A PICTURE HISTORY OF THE BROOKLYN BRIDGE, M.J. Shapiro. Profusely illustrated account of greatest engineering achievement of 19th century. 167 rare photos & engravings recall construction, human drama. Extensive, detailed text. 122pp. 8¼ × 11. 24403-2 Pa. $7.95

NEW YORK IN THE THIRTIES, Berenice Abbott. Noted photographer's fascinating study shows new buildings that have become famous and old sights that have disappeared forever. 97 photographs. 97pp. 11⅜ × 10. 22967-X Pa. $7.50

MATHEMATICAL TABLES AND FORMULAS, Robert D. Carmichael and Edwin R. Smith. Logarithms, sines, tangents, trig functions, powers, roots, reciprocals, exponential and hyperbolic functions, formulas and theorems. 269pp. 5⅜ × 8½. 60111-0 Pa. $4.95

HANDBOOK OF MATHEMATICAL FUNCTIONS WITH FORMULAS, GRAPHS, AND MATHEMATICAL TABLES, edited by Milton Abramowitz and Irene A. Stegun. Vast compendium: 29 sets of tables, some to as high as 20 places. 1,046pp. 8 × 10½. 61272-4 Pa. $21.95

REASON IN ART, George Santayana. Renowned philosopher's provocative, seminal treatment of basis of art in instinct and experience. Volume Four of *The Life of Reason*. 230pp. 5⅜ × 8. 24358-3 Pa. $4.50

LANGUAGE, TRUTH AND LOGIC, Alfred J. Ayer. Famous, clear introduction to Vienna, Cambridge schools of Logical Positivism. Role of philosophy, elimination of metaphysics, nature of analysis, etc. 160pp. 5⅜ × 8½. (USCO)
20010-8 Pa. $2.95

BASIC ELECTRONICS, U.S. Bureau of Naval Personnel. Electron tubes, circuits, antennas, AM, FM, and CW transmission and receiving, etc. 560 illustrations. 567pp. 6½ × 9¼. 21076-6 Pa. $9.95

THE ART DECO STYLE, edited by Theodore Menten. Furniture, jewelry, metalwork, ceramics, fabrics, lighting fixtures, interior decors, exteriors, graphics from pure French sources. Over 400 photographs. 183pp. 8⅜ × 11¼.
22824-X Pa. $7.95

THE FOUR BOOKS OF ARCHITECTURE, Andrea Palladio. 16th-century classic covers classical architectural remains, Renaissance revivals, classical orders, etc. 1738 Ware English edition. 216 plates. 110pp. of text. 9½ × 12¾.
21308-0 Pa. $11.95

THE WIT AND HUMOR OF OSCAR WILDE, edited by Alvin Redman. More than 1000 ripostes, paradoxes, wisecracks: Work is the curse of the drinking classes, I can resist everything except temptations, etc. 258pp. 5⅜ × 8½.
20602-5 Pa. $4.50

THE DEVIL'S DICTIONARY, Ambrose Bierce. Barbed, bitter, brilliant witticisms in the form of a dictionary. Best, most ferocious satire America has produced. 145pp. 5⅜ × 8½. 20487-1 Pa. $2.95

ERTÉ'S FASHION DESIGNS, Erté. 210 black-and-white inventions from *Harper's Bazar*, 1918-32, plus 8pp. full-color covers. Captions. 88pp. 9 × 12.
24203-X Pa. $7.95

ERTÉ GRAPHICS, Erté. Collection of striking color graphics: *Seasons, Alphabet, Numerals, Aces* and *Precious Stones*. 50 plates, including 4 on covers. 48pp. 9⅜ × 12¼. 23580-7 Pa. $6.95

PAPER FOLDING FOR BEGINNERS, William D. Murray and Francis J. Rigney. Clearest book for making origami sail boats, roosters, frogs that move legs, etc. 40 projects. More than 275 illustrations. 94pp. 5⅜ × 8½. 20713-7 Pa. $2.50

ORIGAMI FOR THE ENTHUSIAST, John Montroll. Fish, ostrich, peacock, squirrel, rhinoceros, Pegasus, 19 other intricate subjects. Instructions. Diagrams. 128pp. 9 × 12. 23799-0 Pa. $5.95

CROCHETING NOVELTY POT HOLDERS, edited by Linda Macho. 64 useful, whimsical pot holders feature kitchen themes, animals, flowers, other novelties. Surprisingly easy to crochet. Complete instructions. 48pp. 8¼ × 11.
24296-X Pa. $1.95

CROCHETING DOILIES, edited by Rita Weiss. Irish Crochet, Jewel, Star Wheel, Vanity Fair and more. Also luncheon and console sets, runners and centerpieces. 51 illustrations. 48pp. 8¼ × 11. 23424-X Pa. $2.75

YUCATAN BEFORE AND AFTER THE CONQUEST, Diego de Landa. Only significant account of Yucatan written in the early post-Conquest era. Translated by William Gates. Over 120 illustrations. 162pp. 5⅜ × 8½. 23622-6 Pa. $3.95

ORNATE PICTORIAL CALLIGRAPHY, E.A. Lupfer. Complete instructions, over 150 examples help you create magnificent "flourishes" from which beautiful animals and objects gracefully emerge. 8⅛ × 11. 21957-7 Pa. $3.50

DOLLY DINGLE PAPER DOLLS, Grace Drayton. Cute chubby children by same artist who did Campbell Kids. Rare plates from 1910s. 30 paper dolls and over 100 outfits reproduced in full color. 32pp. 9¼ × 12¼. 23711-7 Pa. $3.50

CURIOUS GEORGE PAPER DOLLS IN FULL COLOR, H. A. Rey, Kathy Allert. Naughty little monkey-hero of children's books in two doll figures, plus 48 full-color costumes: pirate, Indian chief, fireman, more. 32pp. 9¼ × 12¼.

24386-9 Pa. $3.50

GERMAN: HOW TO SPEAK AND WRITE IT, Joseph Rosenberg. Like *French, How to Speak and Write It.* Very rich modern course, with a wealth of pictorial material. 330 illustrations. 384pp. 5⅜ × 8½. 20271-2 Pa. $4.95

CATS AND KITTENS: 24 Ready-to-Mail Color Photo Postcards, D. Holby. Handsome collection; feline in a variety of adorable poses. Identifications. 12pp. on postcard stock. 8¼ × 11. 24469-5 Pa. $2.95

MARILYN MONROE PAPER DOLLS, Tom Tierney. 31 full-color designs on heavy stock, from *The Asphalt Jungle,Gentlemen Prefer Blondes,* 22 others.1 doll. 16 plates. 32pp. 9⅜ × 12¼. 23769-9 Pa. $3.95

FUNDAMENTALS OF LAYOUT, F.H. Wills. All phases of layout design discussed and illustrated in 121 illustrations. Indispensable as student's text or handbook for professional. 124pp. 8⅛.× 11. 21279-3 Pa. $4.50

FANTASTIC SUPER STICKERS, Ed Sibbett, Jr. 75 colorful pressure-sensitive stickers. Peel off and place for a touch of pizzazz: clowns, penguins, teddy bears, etc. Full color. 16pp. 8¼ × 11. 24471-7 Pa. $3.50

LABELS FOR ALL OCCASIONS, Ed Sibbett, Jr. 6 labels each of 16 different designs—baroque, art nouveau, art deco, Pennsylvania Dutch, etc.—in full color. 24pp. 8¼ × 11. 23688-9 Pa. $3.95

HOW TO CALCULATE QUICKLY: RAPID METHODS IN BASIC MATHEMATICS, Henry Sticker. Addition, subtraction, multiplication, division, checks, etc. More than 8000 problems, solutions. 185pp. 5 × 7¼. 20295-X Pa. $2.95

THE CAT COLORING BOOK, Karen Baldauski. Handsome, realistic renderings of 40 splendid felines, from American shorthair to exotic types. 44 plates. Captions. 48pp. 8¼ × 11. 24011-8 Pa. $2.50

THE TALE OF PETER RABBIT, Beatrix Potter. The inimitable Peter's terrifying adventure in Mr. McGregor's garden, with all 27 wonderful, full-color Potter illustrations. 55pp. 4¼ × 5½. (Available in U.S. only) 22827-4 Pa. $1.75

BASIC ELECTRICITY, U.S. Bureau of Naval Personnel. Batteries, circuits, conductors, AC and DC, inductance and capacitance, generators, motors, transformers, amplifiers, etc. 349 illustrations. 448pp. 6½ × 9¼. 20973-3 Pa. $7.95

SOURCE BOOK OF MEDICAL HISTORY, edited by Logan Clendening, M.D. Original accounts ranging from Ancient Egypt and Greece to discovery of X-rays: Galen, Pasteur, Lavoisier, Harvey, Parkinson, others. 685pp. 5⅜ × 8½.
20621-1 Pa. $11.95

THE ROSE AND THE KEY, J.S. Lefanu. Superb mystery novel from Irish master. Dark doings among an ancient and aristocratic English family. Well-drawn characters; capital suspense. Introduction by N. Donaldson. 448pp. 5⅜ × 8½.
24377-X Pa. $6.95

SOUTH WIND, Norman Douglas. Witty, elegant novel of ideas set on languorous Mediterranean island of Nepenthe. Elegant prose, glittering epigrams, mordant satire. 1917 masterpiece. 416pp. 5⅜ × 8½. (Available in U.S. only)
24361-3 Pa. $5.95

RUSSELL'S CIVIL WAR PHOTOGRAPHS, Capt. A.J. Russell. 116 rare Civil War Photos: Bull Run, Virginia campaigns, bridges, railroads, Richmond, Lincoln's funeral car. Many never seen before. Captions. 128pp. 9⅜ × 12¼.
24283-8 Pa. $7.95

PHOTOGRAPHS BY MAN RAY: 105 Works, 1920-1934. Nudes, still lifes, landscapes, women's faces, celebrity portraits (Dali, Matisse, Picasso, others), rayographs. Reprinted from rare gravure edition. 128pp. 9⅜ × 12¼.
23842-3 Pa. $8.95

STAR NAMES: THEIR LORE AND MEANING, Richard H. Allen. Star names, the zodiac, constellations: folklore and literature associated with heavens. The basic book of its field, fascinating reading. 563pp. 5⅜ × 8½. 21079-0 Pa. $7.95

BURNHAM'S CELESTIAL HANDBOOK, Robert Burnham, Jr. Thorough guide to the stars beyond our solar system. Exhaustive treatment. Alphabetical by constellation: Andromeda to Cetus in Vol. 1; Chamaeleon to Orion in Vol. 2; and Pavo to Vulpecula in Vol. 3. Hundreds of illustrations. Index in Vol. 3. 2000pp. 6⅛ × 9¼. 23567-X, 23568-8, 23673-0 Pa. Three-vol. set $37.85

THE ART NOUVEAU STYLE BOOK OF ALPHONSE MUCHA, Alphonse Mucha. All 72 plates from *Documents Decoratifs* in original color. Stunning, essential work of Art Nouveau. 80pp. 9⅜ × 12¼. 24044-4 Pa. $8.95

DESIGNS BY ERTE; FASHION DRAWINGS AND ILLUSTRATIONS FROM "HARPER'S BAZAR," Erte. 310 fabulous line drawings and 14 *Harper's Bazar* covers, 8 in full color. Erte's exotic temptresses with tassels, fur muffs, long trains, coifs, more. 129pp. 9⅜ × 12¼. 23397-9 Pa. $8.95

HISTORY OF STRENGTH OF MATERIALS, Stephen P. Timoshenko. Excellent historical survey of the strength of materials with many references to the theories of elasticity and structure. 245 figures. 452pp. 5⅜ × 8½. 61187-6 Pa. $9.95

Prices subject to change without notice.

Available at your book dealer or write for free catalog to Dept. GI, Dover Publications, Inc., 31 East 2nd St. Mineola, N.Y. 11501. Dover publishes more than 175 books each year on science, elementary and advanced mathematics, biology, music, art, literary history, social sciences and other areas.